Paul Cézanne

Titles in the series Critical Lives present the work of leading cultural figures of the modern period. Each book explores the life of the artist, writer, philosopher or architect in question and relates it to their major works.

In the same series

Paul Cézanne

Jon Kear

REAKTION BOOKS

Published by
Reaktion Books Ltd
Unit 32, Waterside
44–48 Wharf Road
London N1 7UX, UK

www.reaktionbooks.co.uk

First published 2016
Transferred to digital printing 2022
Copyright © Jon Kear 2016

Printed and bound in the USA by University of Chicago Press

A catalogue record for this book is available from the British Library

ISBN 978 1 78023 573 8

Contents

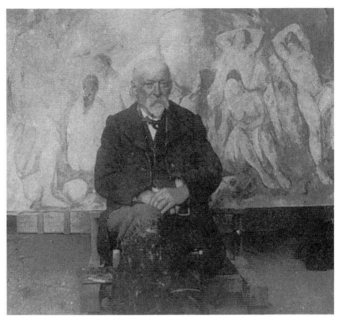

Paul Cézanne, in 1904, sitting in front of his *Les Grandes Baigneuses*, photograph by Émile Bernard.

Introduction: The Myth of Cézanne

In 1904 Émile Bernard, a leading Symbolist painter and critic, made
the long trip from Paris to Cézanne's studio in Aix-en-Provence
to interview him for an article he was to publish later that year.[1]
During his stay he took several photographs of Cézanne. In the
most emblematic of these, Cézanne poses in the dim light of
his austere studio at Les Lauves, his clasped hands resting on his
paint-spattered trousers, before a large work propped on an easel:
an elderly artist framed by the fantasia of youthful female nudes on
the canvas behind him. The painting was one of three ambitious
and idiosyncratic large paintings collectively known as *Les Grandes
Baigneuses* (The Bathers) that preoccupied his later years. These
show female bathers set on the edge of a stream, basking in the sun
or about to enter the water. Cézanne worked intermittently on more
than one canvas at once, making extensive changes as he went along.
The one in the photograph is the version from the Barnes Foundation
in Philadelphia before it underwent several crucial changes. Cézanne
had already been labouring a decade on it by then, and it would
remain, as its companion paintings would, incomplete at his death.
Viewed together as an ensemble, it is clear how interconnected
these paintings are and how they were conceived as alternate
responses to the possibilities and problems posed by the subject.
Preliminary oil sketches indicate that he planned to extend the series.

The large scale of these paintings and the fact that he worked
on them for such a protracted period indicate the special value

Cézanne accorded them. He often remarked to visitors to his studio that these paintings were to be the testing ground for his theories, and it was as such that they were understood by the audience for his painting. They were to become indelibly associated with his legacy. The Barnes version, the first of the series, was clearly intended to be a *chef-d'oeuvre*, and was conceived on the eve of his re-entry into public exhibition after a long exile from exhibiting in Paris, though it was not shown in his lifetime.

In 1907 a major retrospective of 56 pictures at the Salon d'Automne in two rooms of the Grand Palais included two of the late *Grandes Baigneuses*, almost certainly the London and Philadelphia versions, which became the focus of discussion of the artist. By then Cézanne was dead, having succumbed to pneumonia the previous autumn, aged 67. Already suffering from the degenerative effects of diabetes over the previous sixteen years, he had collapsed in a rainstorm after a day painting in the fields of Aix and lay unconscious and exposed to the elements for several hours. Despite appearing to recover, within days he had passed away.

In the course of the twentieth century Cézanne has subsequently been regarded as the father of modern painting and integral to the canon of modernism.[2] The *Grandes Baigneuses* are touchstones of modern painting and provoked a series of emulations by avant-garde artists. The problems Cézanne's work posed for its original audience have been forgotten.[3] But for his contemporaries, Cézanne's pictures were works whose meanings and implications, whether they were successes or failures, were matters to be struggled over and contested. While it was generally agreed that his art had moved beyond the limits of Impressionism, Cézanne was an artist whose person and work posed more questions than answers and none did so more than his *Grandes Baigneuses*. It was not clear what intentions underlay these disquieting paintings, nor how they related to the other works and working practices of the painter.[4] While his landscapes, portraits and still-lifes, as his letters

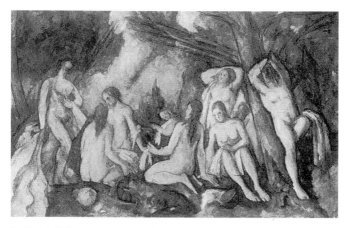

Les Grandes Baigneuses, 1895–1906, oil on canvas.

attest, revealed a commitment to an empirical approach to painting *sur le motif* (in nature), his bathers seemed the antithesis of all this: strange reveries rendered without models that freely reworked the old masters he had studied in the Louvre, yet in a way that seemed quite contemporary in mood and sensibility. *Les Grandes Baigneuses* appeared at once to reach back to the past, not merely to the old masters but to something more primordial and archaic, and at the same time to be ultra-modern. These works posed many questions about the artist and the conceptual framework of his late painting.

Our knowledge of these later years, like so much of his life, is limited. There are many gaps in his correspondence and years where little is known of his private life and movements. What we know is generally through the reminiscences of fellow artists, critics and early biographers. But those who wrote about him rarely knew him well. Few artists have been subject to so much rumour and speculation and few oeuvres to such contradiction in interpretation. This book is therefore not only about Cézanne's art and life, but about what can and cannot be known about Cézanne and the myths and interpolations that have entered into the literature of the artist.

Cézanne lived a quiet life in relative isolation in Aix-en-Provence and devoted his time indefatigably to painting. What glimpses we get of him in the last twenty years of his life, through his correspondence and the recollections of those who encountered him, reveal a man fiercely protective of his privacy and one with few close friends. In contrast to the ostentatious persona he cultivated as a young man in Paris in the 1860s, which gained him an enduring reputation, he kept a low profile in his native Aix, despite being a wealthy landowner whose family was well known in the town. Notwithstanding his fiery and unpredictable temperament, and his susceptibility towards neurosis, those that visited him were surprised to find him mostly congenial, if a little guarded, and quite willing to talk at length and even demonstrate his method of painting. When Bernard – with some difficulty – finally tracked the artist down, his reputation as a biographical journalist led Cézanne initially to view him with suspicion. It was only when Bernard made clear that he was a painter as well as a biographer that he was welcomed. Cézanne was distrustful of all those he believed sought to get their *grappins* (hooks) in him, as he put it. His trust was hard-won and reserved mainly for those he had known since youth. While he enjoyed the company of younger artists, regarding them as 'more intelligent' than his contemporaries, he remained wary of his newfound admirers. He exhibited by turns exuberant warmth, polite correction and irascibility with those like Bernard who wrote about him, all of which indicates the distance he felt existed between the preoccupations of these artists in Paris and his own understanding of his art. 'You'll forgive me for always coming back to the same point,' he writes in a letter to Bernard towards the end of his life:

But I believe in the logical development of what we see and feel through the study of nature, never mind about the techniques (*les procédés*). Techniques are merely the means of making the

public feel what we ourselves feel, and of making us intelligible. The greats whom we admire have done the same thing.[5]

Eight days earlier he had vented his irritation at Bernard's aestheticism and theories of painting to his son.

I'm sending you a letter from Emilio Bernadinos, most distinguished aesthete, whom I'm sorry not to have under my thumb in order to inculcate in him the sane, comforting and sole correct idea, of art developing in contact with nature ... he produces nothing but old fashioned rubbish that smacks of the dreams of art prompted not by excitement at nature but by what he has seen in museums, and even more by a philosophical turn of mind that comes from knowing too well the masters he admires ... Clearly one must experience things for oneself and express oneself as best one can. I'm always going over the same thing, but arranged in this way my life allows me to isolate myself from the hoi polloi.[6]

His correspondence with Bernard reveals his antipathy to what he saw as the artist's over-indebtedness to and misuse of the old masters, his lack of attention to nature and his misrepresentation of Cézanne's own artistic concerns, despite his obsessive reiteration of them from letter to letter.
'With you I won't dwell on aesthetic considerations. Yes, I approve of your admiration for the greatest of the Venetians, let us celebrate Tintoretto,' he writes to him before qualifying what he saw as the differences between their understanding of the legitimate instruction of the old masters for the contemporary artist:

Your need to find a moral and intellectual support in works that will never be surpassed keeps you constantly on the alert, always searching for sure means that will lead you to experience

before nature your (own) means of expression, and when you find them you may be sure you will . . . rediscover before nature the means employed by the four or five great Venetians.[7]

For Cézanne the lesson of the old masters was not that they should be emulated or slavishly deferred to, but was rather that each had brought a unique sensibility to the understanding of nature. While Bernard saw the grand tradition as a determinant set of artistic laws and compositional conventions to continually refer back to, for Cézanne the best of that tradition had revealed a way of seeing nature anew. Towards the end of his life he was intensely conscious of his legacy and fearful of being, as he saw it, misinterpreted. To Georges Rouault, he expressed his doubts about the way the idiosyncratic nature of his art would be transformed into a general model of painting, a *Cézannisme* that would then be imitated.

Don't set store either by those who spout my name or argue over my wretched corpse, after my death, but rather by the worst, the most imperfect of my works . . . If they give me an ovation, don't believe it; if they try to found a school in my name, tell them they never understood . . .[8]

Despite the intensely subjective nature of his art, Cézanne lamented that his personal life was discussed in relation to his painting. He told Joachim Gasquet:

All my life I have worked to earn my living, but I thought one could paint well without attracting attention to one's private life. Certainly an artist wishes to improve himself intellectually as much as possible, but the man should remain obscure. The pleasure must be found in the study (of the work).[9]

But as he anticipated, the reception of his painting focused on the artist's enigmatic personality. The authors who initially shaped the understanding of his art – Bernard, Georges Lecomte, Gustave Geffroy, Maurice Denis, Ambroise Vollard and Gasquet – all had much to say about his painting, but each believed that coming to terms with the artist's personality was crucial to understanding the work he produced and sought to explain the character and consciousness that shaped Cézanne's art. This was no simple matter. When in company, Cézanne could play to the gallery, and those who did not know him well were often taken in by his naïf persona and old-fashioned and exaggerated provincial ways. He could come across as little more than a 'country bumpkin', a sort of 'puppet figure, testy, naïve, ridiculous'.[10] His shifts of mood and speech, from melancholic and timid to splenetic and violent, as Bernard put it, were notorious. Nevertheless, each author in his own fashion confidently made claim to the artist, ostensibly revealing 'the real Cézanne' obscured by the many proliferating myths of him.

Cézanne's distrust of biography seems to have been one of the main reasons for his ambivalence about the attention he was receiving in Paris. Cézanne was born into the dawn of the age of the great flourishing of biography, reflecting the period's great belief in bourgeois individualism and in individual will and character as the defining characteristics of society. By the end of the century more biographies were published than in any other period to date, which encouraged people to record and document their lives with the zealousness of would-be curators. Cézanne was well aware of how the cult of artistic personality dominated the increasingly market-driven art world. The century had witnessed a shift from canvases to careers. The changing economic structure, which saw the rise of a fully capitalist market economy, gradually transformed the lives and work of artists as they adjusted from a system of state rewards and civic and private commissions to a new entrepreneurial art market in which self-promotion, stylistic distinctiveness and

interesting personalities were the chief means of establishing a successful artistic career.

By the end of the century biography had come to dominate the fashionable vagaries of art criticism, providing the overarching framework in which discussion of art and artworks took place. Dealers improvised ways of marketing their artists through their 'force of personality', 'artistic genius' and *tempérament* (the psychological character of the artist) that would later become commonplace. This would prove a far more effective marketing strategy than attempting to sell individual works on their own merits. The *culte de moi* so lamented by contemporary critics on the left and right of the political spectrum reflected the fact that art was now fully integrated into a system of capitalist commodification in which the connection between artistic style and artistic personality was progressively the means of selling canvases. Cézanne, who had made will and personality – in short, his artistic *tempérament* – the basis of his challenge to the authority and orthodoxy of the art world of the 1860s and early '70s, later found himself reassessing his understanding of the terms of his painting, aware of how fully assimilated into the new art market economy they had become. Though initially he had sought to challenge artistic impersonality and orthodoxy through his self-fashioned, truculent individualism, he gradually became aware of the limits and problems of this position. The question of how to constitute and differentiate 'authentic' artistic individuality from the various illusory and commercial forms of it that characterized the art world was an increasingly vexing problem. Cézanne's later art was caught between a form of isolation and independence that somehow sought to preserve subjective forms of experience which resisted the bland conformism that underlay the rhetorical character of bourgeois individualism, and reaching out to some ideal of an imagined community to which his art could belong. Although, as we will see, he stressed throughout his life the importance of

tempérament as the basis of art, Cézanne wavered between asserting his individualism and independence, and associating himself more immediately with the cultural traditions and collective memory of Provence. In his later years, painting in the Aixois countryside would become his way of reclaiming a primordial relationship to his native Provence and the imagined wholeness it promised.

Cézanne's suspicions of his biographers and indifference to the attention that his art would receive in his later years was an attempt to resist being entirely absorbed into an art world he had long held in contempt. It was also a realization that the individualized form his art had come to take, though bound to questions of will, personal receptivity and the artist's perception of nature, were unlikely to be given form in the kinds of biography that would be written about him in his own time. If, to some extent, he must have hoped that his newfound fame would see him accorded the place in the history of art that he wanted, more than anything Cézanne wanted to be left alone to paint without distraction. He wanted his paintings to be judged in and for themselves – for what they addressed themselves to in the world around him – rather than to be viewed as mere reflections of his personality.

Moreover, the divisive reception of his work when he began to exhibit again must have reawoken memories of the controversy caused when he exhibited at the Impressionist exhibition of 1874, where his pictures bore the brunt of the most hostile criticism. In 1877, when he exhibited again with the Impressionists, he received a similarly adverse reception despite the best efforts of the critic Georges Rivière and Cézanne's friend Victor Chocquet to explain his work. One of the few early collectors and patrons of his painting, Chocquet spent hours in the gallery defending the portrait Cézanne had painted of him. At each exhibition Cézanne had shown works in all genres, though in each case it was his nudes and figure works that were the focal point. In 1877 he exhibited the strange dreamscapes *Les Pêcheurs* (The Fishermen, *c.* 1873) and his large *Baigneurs au*

repos (Bathers at Rest, 1876–7), his most ambitious picture of bathers to date. The later bathers pictures in many respects represent companion pieces to the latter, revealing how deeply felt the theme was for him and how he continued to think through the possibilities posed in this picture and its meanings for him.

Cézanne's harsh reception at these exhibitions no doubt influenced his decision to distance himself from the art world of Paris and move back permanently to his native Aix. He would eventually cease sending work to the Salon, the annual state-organized exhibition of contemporary art. For much of the intervening twenty years Cézanne was largely forgotten. Many believed him dead or to have given up painting altogether. Théodore Duret initially left him out of his *Histoire des peintres impressionnistes* (1878), the first published history of the movement, though he subsequently added a chapter on him in later editions. Cézanne was a name that occasionally featured in the reminiscences of Impressionist artists and a few collectors, a name that seemed more mythical than real. Above all, he lived on in the fictional incarnations of him. Edmond Duranty immortalized him as the eccentric protagonist of his story 'Le Peintre Marsabiel' (The Painter Marsabiel) of 1867. 'Bald, with a huge beard . . . looking at once young and old', the painter Marsabiel (renamed Maillobert in a later revision) who piles paint 'a centimetre thick' onto his canvas with a spoon and declares with a hyper-Provençal drawl that 'painting can only be done with *temmpérammennte*', was an unmistakable caricature of Cézanne. His notoriety rested chiefly on how he had made a name for himself as something of an *enfant terrible* in his twenties despite failing on thirteen consecutive occasions to get his work shown at the Salon. Duranty's story may even have encouraged Cézanne in aggrandizing still further the bizarre, larger-than-life persona he had constructed for public consumption in the 1860s.[11]

The protagonist of Marius Roux's novel *La Proie et l'ombre* (The Substance and the Shadow, 1878) was also modelled on Cézanne,

further deepening his legend. As Paul Smith has shown, Roux's story updated La Fontaine's fable of delusion, *Le Chien qui lâche sa proie pour l'ombre* (The Dog Who Drops His Prey for its Shadow), to the phantasmagorical world of the laissez-faire capitalism of Napoléon III's Second Empire.[12] In Roux's novel, the Provençal painter Germain Rambert finds himself in a spectral world in which artistic entrepreneurialism, celebrity and the acquisition of wealth have rendered art little more than a mere attribute of commodity fetishism. Ambitious for public acclaim and commercial success, he unscrupulously accommodates himself to this new market-driven context. The Impressionist Rambert is an artist who, like Cézanne, expounds the theory of artistic *tempérament,* insists on the strength of his *sensations* and is a voluble presence at the cafés where, in the evening, his artistic colleagues gather to discuss their theories and opinions about painting. Commonly regarded as a *roman-à-clef,* the novel was more a morality tale. Not only does Rambert betray his artistic integrity in the course of the novel, but he abandons his pregnant mistress for a rich widow whose fortune he hopes will revive his career. A deluded and unprincipled opportunist, Rambert gives up the substance of his artistic ambitions for the self-serving avarice that casts its illusory shadow over the contemporary Parisian art world. By the conclusion, Rambert, ill and insane, is discovered by his brother lurking in the shadows of the Louvre.

The fictional portrait clearly struck a raw nerve. Cézanne was displeased enough to write to Roux, not as the author of *La Proie et l'ombre* – as he expressly put it – but as a fellow Provençal, expressing his wish to dissociate himself from Roux's protagonist. 'I hope', he wrote, 'you will be able to separate my humble persona of an Impressionist painter from the man.'[13] Evidently he regarded the novel's protagonist as a hostile portrait of him by a source who had once been part of his inner circle. Émile Zola's oldest friend, Roux had been an *habitué* of Zola's *jeudi* and *mardi soirées* of the 1860s and the *boeuf nature* dinners that Alexis, Valabrègue and

Zola started in 1875, as well as acting as a go-between for Zola and Cézanne.[14] But though there is no doubt that for a time he was on good terms with Cézanne – particularly toward the end of the 1860s, where his letters make frequent mention of him – by the time he wrote the book, their friendship had long since ceased. It seems likely that the unflattering portrait of Cézanne in the book was motivated by the acrimonious but somewhat obscure break with the painter in 1871.[15] How intimately Roux understood Cézanne, let alone the artistic aims of the artist, is a matter of dispute. In a letter to Zola at the height of his friendship with Cézanne, Roux somewhat exasperatedly described Cézanne as a 'veritable sphinx'.[16]

Another novel published some eight years later by a source more deeply connected to the artist, however, left a deeper, more lasting impression on the image of Cézanne. In December 1885 Zola's *L'Oeuvre* (The Masterpiece) was serialized in the periodical *Gil Blas* and later published in novel form in 1886. Though a composite of Cézanne, Manet and Monet, among others, the protagonist, the tragic and 'aborted painter' Claude Lantier, came chiefly to be associated with Zola's childhood friend. Zola later described the novel as having been inspired by his disappointment in Cézanne for failing to realize his potential and he stated that it was written as a futile attempt to stem the tide of Cézanne's withdrawal into himself and his impossible ideals.[17] Zola's own resemblance to the character of the novelist Pierre Sandoz further encouraged the reception of the novel as a *roman-à-clef*. Like Roux, Zola evidently drew on actual events of the bohemian art world Cézanne had inhabited in the 1860s and '70s, and many of the novel's details would have brought Cézanne to mind for readers acquainted with his reputation. The revolutionary painting of Lantier, an artist of great talent and *tempérament*, who again bears a strong physical resemblance to Cézanne, challenges the conventional painting of its time, but is misunderstood by a public in thrall to academic painting. Obsessed with making a masterpiece, a *grande baigneuse* on the banks

of the Seine conceived on a massive canvas, he struggles over a number of years to realize his ideas successfully and to organize the painting into a meaningful whole. When, after years of rejection, he exhibits a work poignantly depicting the body of his recently deceased son at the Salon, critics mock the picture. The increasingly mentally unstable Lantier turns back to his unfinished masterpiece and descends into a spiral of disillusionment and madness that results in him hanging himself before his *grande baigneuse*.

Despite their melodrama, the impact of these fictionalized representations of Cézanne profoundly shaped perceptions of the artist. Zola's novel in particular had an enduring influence on the way in which Cézanne was understood in his own lifetime and beyond. It fed a growing band of admirers information about a painter with whom little was actually known. Coming from a source so close to the artist and clearly drawing on actual events of the art world of the 1860s, the novel had an aura of unimpeachable authenticity. In an article on Cézanne titled 'Claude Lantier', published in 1895, Arsène Alexandre offered the painter the rare opportunity of reading his own obituary, while Maurice Denis wrote of his first encounter with Cézanne: 'My mind is filled with the visions of Claude in *L'Oeuvre*.'[18] The first biographies of Cézanne also relied heavily on the portrait of Lantier, even where, as in the case of Gasquet, the author knew him personally. Fiction merged with fact, myth became inextricable from reality. But the relation between novels such as *La Proie et l'ombre* and *L'Oeuvre* and Cézanne's actual life is a deeply problematic one, not only in that these novels fictionalize their subject – adding, inventing and omitting details in the process – but that interpreting them simplistically as factual representations of Cézanne's life ignores the broader motives behind such novels. Like Roux, by the 1870s the close relationship Zola had enjoyed with Cézanne had declined. If Roux was settling a score, Zola was closing a chapter on his life tinged with regret and disillusionment.

Moreover, both Roux's and Zola's novels were primarily determined by the narrative conventions of the burgeoning tradition of atelier literature. Balzac's *Le Chef-d'oeuvre inconnu* (The Unknown Masterpiece, 1831), one of the earliest and most enduring examples of the genre, and the Goncourts' *Manette Salomon* (1867) were frequent reference points for these and later variants of the atelier novel, which were as influenced by the compelling vision of these fictions as they were by actual events. Such stories provided a means to discuss the merits or otherwise of contemporary theories of art, and the narratives of Roux and Zola were intended as interventions into current debates about modern painting. Roux's novel was one of several works in the late 1870s that gave fictional or dramatic form to the history of Impressionism. This had proved not to be the passing phenomenon many had initially dismissed it as. The significance of Impressionism was now a matter of heated debate. Henri Meilhac and Léon Halévy's parodic play *La Cigale* (1878, written with the aid of Edgar Degas), Eugène Grangé and Victor Bernard's *Les Impressionnistes, comédie-vaudeville en une acte* (1879) and Philippe Burty's *Grave Imprudence* (1880), which made allusions to paintings of Degas, Monet and Renoir among others, were all performed or published in this period. Zola's novel was in many respects an attempt to explain his waning support for Impressionism, which he felt had failed to realize its potential. But the framework of his novel was broadened to take in Romanticism, the movement he regarded as having left a fatal stain on the evolution of modern art.

Most immediately, these novels by Roux and Zola were updated versions of Balzac's *Le Chef-d'oeuvre inconnu* to the contemporary Parisian art scene. Both novelists appropriated the central dilemma of Balzac's novella, whose protagonist, the enigmatic artist Frenhofer, struggles to complete a masterpiece that has preoccupied him for many years since the death of his mistress and muse,

Catherine Lescault – a work that he declares will prove his artistic theories. In the original source and its subsequent variations, the protagonist's theorizing of a new kind of painting serves only to veil the problems of realization that eventually result in fatal self-doubt. Zola's novel brought new nuances to Balzac's story of tragic genius and anguished creativity, associating its struggle for realization with the contemporary pessimism about the fate of art in the modern world. When Baudelaire had spoken of Manet as the first in the decrepitude of his art, he had given voice to the notion that modern art existed in an era of insuperable decline, in which contingency, formlessness and dissolution had supplanted the old verities of the classical age. Modernity defined in such ephemeral terms was what the painter must somehow give form to. Faced with the problem of finding new ways of giving representation to this, modern painting inevitably existed on the edge of failure.

For Zola, Lantier's artistic struggle was more than a portrait of a painter: it was a portrait of art in an era of degeneration and disequilibrium.[19] At Lantier's funeral, Sandoz says, 'He was the victim of his period.' Artistic degeneracy is matched by physical degeneracy in the novel: Lantier's tragically deformed son and Sandoz's childless marriage are symbols of this. The creative act in L'Oeuvre is haunted by self-conscious doubt and the impending prospect of failure, by conditions of artistic production that compromise all artistic ideals and by the need to go on despite all this. It is in this context that we need to understand Joris-Karl Huysmans' hyperbolic description of Cézanne as 'an artist with diseased retinas who in the exasperated apperception of his sight, discovered the preambles of a new art', or Thadée Natanson's assessment of him as an 'incomplete artist, creator of a work of art that resembles nothing before it'.[20] This narrative of the artist was inextricably associated with his own notorious difficulties of realization. Cézanne was an artist who pointed the way rather than one who had arrived at a particular destination.

It was as an artist haunted by doubt and fear of failure that the image of Cézanne took its most compelling form for his contemporaries. For some, he simply struggled with basic problems of competence, leading to pictures with bizarre and incomprehensible features: the 'crazy lines', as Huysmans put it, compulsively defining and redefining objects, the mutually incompatible points of view and oddly tilted edges. For others, the issue lay with Cézanne's hesitations, the sheer visibility of his indecision laid bare in paint, the rich perceptual complexities and ambiguities present in his work – in short, the vivid presence of the problems of translating his motifs into representational form. To his detractors these were characteristic weaknesses that marked Cézanne's failure, recalcitrant features that reflected more generally the decline of contemporary art. But for his admirers they were precisely what gave originality and meaningfulness to his painting. For Geffroy, it was Cézanne's commitment to communicating the full becoming of nature, its continuous unfolding without beginning or end, which led to the problems of realization in his work. The strength and significance of his painting lay in its intractable nature. But for still others, the matter was far more complicated. Bernard characterized him as an artist who had committed himself to painting nature while paradoxically adopting a style of painting that called into question the whole tradition of mimesis, while Charles Morice argued it was precisely the way in which the signs of Cézanne's artistic limitations, his apparent problems of realization and his artistic genius were all complexly interwoven in Cézanne's art that needed addressing.

The ability of novels like Roux's and Zola's to become so inextricably intertwined with Cézanne therefore rested on the way in which such narratives gave expression to the problems of modern art and the crisis of representation associated with the vivid connections that existed for Cézanne's interpreters between the artist's aspirations and the dilemmas of the protagonists of these

stories. Their fictional dilemmas seemed to mirror those of the artist and articulate their own experience of his painting. Cézanne's difficulty in completing his paintings conjured up the *artiste manqué* (failed artist) of Lantier's dilemma. The protagonist of Zola's novel and, even more especially, the Balzac story that had provided its source material seemed therefore to offer a way of explaining the fascinating but also elusive and enigmatic nature of Cézanne's painting, while also ostensibly filling in the gaps in the authors' knowledge of him. Complicating matters still further was Cézanne's enduring fascination with the source of Zola's story and the way his painting seemed to conjure up associations with it. When Bernard first saw the Barnes *Grandes Baigneuses*, he was struck by its resemblance to the painting Frenhofer aspired to make his masterpiece in *Le Chef-d'oeuvre inconnu*. Bernard asked if Cézanne had read Balzac's story. He replied succinctly: 'I am Frenhofer.'[21]

The impact of Zola's novel therefore lay in the way in which it returned its readers to a problem of realization they saw at the heart of Cézanne's painting. But it was also due in no small measure to the fact that the novel's publication coincided with the moment Cézanne began to acquire an ever-growing interest among younger artists and collectors associated with the Symbolist circles in Paris. These young painters, many of whom had first encountered Cézanne's painting at Julien Tanguy's artists' supplies shop on the rue Clauzel in Montmartre, knew little about the artist. But that didn't stop them speculating. Bernard, much given to invention, even staged a fictionalized encounter between Cézanne and Van Gogh in Tanguy's little shop. The fact that Cézanne spent many years in relative isolation from the artistic scene in Paris fuelled rumours about him. Speculation filled that absence. Cézanne was a blank canvas onto which others projected their fantasies. His admirers tended to see reflected in his art whatever was useful to their own, and their representations of Cézanne were heavily inflected by their imaginings about him.

Consequently, descriptions of Cézanne and his personality varied as widely as accounts of his art. Cézanne's Aixois poet and friend Léo Larguier complained, 'He has been depicted a hundred times . . . none of these portraits is accurate, and those that portray him as shaggy haired and filthy are nasty caricatures.'[22] Rivière and Schnerb, keen to dispel the myths about Cézanne, wrote:

> Legend would have it that Cézanne is a misanthrope, a sort of unapproachable bear. Long before his death, one had heard he had given up painting, that he had to dig up his past works. Those who were better informed could only refer vaguely to the residence of the master, to his lifestyle. An ironist could even have said he was a legend who did not really exist.[23]

The mystery that enshrouded him conferred ever more fascination upon his art.[24] He was at once 'famous and unknown', caught up in a tangled array of images made of a combination of rumour, fictional portrayal and reminiscence. Out of all this, the legend of Cézanne was forged, and it is perhaps unfeasible today to have an unmediated experience of the art or the man outside of the representations that subsequently took hold of him.

Exposure to Cézanne's painting at this time was largely limited to a small selection, mainly of still-lifes, on view at Tanguy's and a few others in the hands of a small band of collectors. Paul Gauguin was one of these, and the *Nature morte avec compotier* (Still-life with Compotier, *c.* 1877) he owned became as a result one of the most famous of Cézanne's paintings. The Symbolist painter and theorist Maurice Denis featured it in the first of his two tributes to the painter, *Hommage à Cézanne* (1900), where it metonymically substituted the presence of Cézanne, whom he did not meet until six years later. Indeed, in the 1880s still-life paintings were initially the focus of discussion of Cézanne's work. Rivière and Schnerb's 'L'Atelier de Cézanne' (1907) recounted the authors' visit to the

artist's studio, where they had the rare privilege of watching
him painting a still-life. Maurice Denis' influential article on the
painter, published in 1907, similarly focused on Cézanne's work
in this genre. To many of his admirers and even to his detractors,
Cézanne's still-lifes were regarded as his most accomplished
painting, drawing praise from critics like Fagus and Mauclair who
were otherwise dismissive, especially of his figure paintings. [25]

No doubt aware of the attention he was receiving, Cézanne
ended his prolonged absence from exhibiting. In 1887 and again
in 1890 he showed a small selection of works at the annual Les xx
exhibition in Brussels. In 1889 *La Maison du pendu, Auvers-sur-Oise*
(later misleadingly titled in English The House of the Hanged Man,
1874), which he had shown at the Impressionist exhibition of 1874,
was exhibited in the retrospective section of art at the Exposition
Universelle in Paris. At the same time he began to receive serious
critical attention. In 1890 Bernard published his first article on
Cézanne in the popular series *Les Hommes d'aujourd'hui*, and Geffroy
published another important article on him in 1894 after the pair
met at Giverny, where Cézanne had visited Monet. These articles
spurred Ambroise Vollard's interest, which had been ignited after
seeing Cézannes at Tanguy's. After setting himself up as a dealer
in 1893, he established a close relationship with Cézanne's son,
who was keen to gain a profit from his father's painting. Through
him, Vollard gradually gained Cézanne's trust. By the mid-1890s
he had established a virtual monopoly on Cézanne's pictures.
Almost two-thirds of Cézanne's paintings passed through Vollard.
In 1895, a year after the Museé Luxembourg had rejected the
Caillebotte bequest of *Baigneurs au repos*, Vollard put on the
first of three one-man shows of Cézanne's work, exhibiting
as many as 150 works in the first of these and alternating the
pictures on show to encourage repeat visits. Though Cézanne
sent works, he played no part in the first show and had no
direct contact with Vollard, although afterwards Vollard, keen

to cement his relationship with the artist, visited Cézanne
in Aix and Paris, where he had his portrait painted.

Realizing the marketing potential of the enigma surrounding
the artist, the show in 1895 was publicized by Vollard only by word
of mouth, adding intrigue to the event. Vollard's marketing and
later memoirs of Cézanne, based on the many conversations he
had with him, played up the image of an eccentric artist prone to
unpredictable behaviour. Cézanne's 'reclusiveness' and enigma
became central to accounts of him. When Cézanne failed to
attend his own exhibition at Vollard's gallery on the rue Lafitte,
this image hardened. Ironically, during these years Cézanne
was spending more and more time in Paris in a studio he rented
there, though few knew of his presence. But the exhibition and
the subsequent ones that Vollard staged of Cézanne's work in
1898 and 1899 seemed to raise more questions than answers
about the artist. The fact that the diverse works on show, in all
genres and from all periods of the artist's life, were exhibited
without dates and out of chronological order meant that the
exhibition gave no clear sense of his evolution as an artist.

Vollard most keenly promoted Cézanne's nudes, placing
some in the window of his gallery and using the image of a
group of female bathers for the catalogue to the Cézanne show
of 1898, as well as making the bathers works centrepieces in the
Salon d'Automne exhibitions. He used this forum to stimulate
public interest further, augmenting the paintings exhibited with
photographs of other works by Cézanne in his possession. He
also staged an exhibition of Cézanne's watercolours at his gallery
in 1905. Cézanne additionally showed work at the Salon des
Indépendants in 1902 and 1905, and his painting was beginning
to be shown in London and Berlin. But it was above all the series
of exhibitions in the years 1904–7 at the Salon d'Automne –
where he was shown in the context of retrospectives of leading
modern masters such as Manet, Puvis de Chavannes, Ingres,

Morisot, Gauguin and Seurat – that were decisive in establishing Cézanne at the forefront of debates about modern painting.

The greater exposure of Cézanne's painting made him an artist on whom everyone had an opinion, and his work was fast attracting collectors, including artist contemporaries such as Monet – who owned fourteen Cézannes – Degas, Gauguin and Matisse. In 1905 Charles Morice published a questionnaire in the Symbolist journal *Le Mercure de France* in which artists were asked, among other questions, 'What opinion do you have of Cézanne?'[26] *Cézannisme* was gathering momentum, spurring a proliferation of emulations of his bathers at subsequent Salons d'Automne exhibitions and des Indépendants exhibitions. The impact of the exhibition of Cézanne's *Grandes Baigneuses* seemed only to deepen and personalize the terms of the debates about his painting, leading artists like Bernard to question their original enthusiasm. These works were the *ne plus ultra* of modern art, invoking the contemporary revival of classical Arcadian pictures associated with Puvis de Chavannes' murals, but refashioned through the massive corporeality of Rubens's and Courbet's iconoclastic nudes of the 1850s. Cézanne had mentioned to Bernard that Courbet had been much on his mind at this time and described Courbet to Geffroy as a 'Michelangelo without elevation'. However, unlike the sexualized bodies of Courbet and Rubens, Cézanne's nudes seem devoid of all sensuality. Breasts, eyes and mouths are all rendered cursorily, while bodies often seem alternately formless or rigid. The body's signifiers of sexuality are so summarily rendered that residual ambiguities remain about the sexual identity of the figures. (Some of the female bathers were originally exhibited as male bathers.) In these pictures, the body acquires a strange, contradictory, amorphous form. Heads and limbs seem to take on a fetishized sexual charge, as though the repressed sexuality of the body were rematerializing itself through a deformed corporealism. As T. J. Clark observes, bodies swell and become flaccid; they take on 'inflated, disproportioned and

amorphous' forms, colliding and interpenetrating each other.[27] The phallic head of the bather emerging from the stream carrying her towel on the left of the Barnes *Grandes Baigneuses,* or the phallic shadow along the abdomen of the figure leaning against the tree on the right-hand side, are prime examples of the insecure gendering present in Cézanne's bathers and the way, more generally, in which the bathers' bodies seem transmuted by latent desire.

The presence of such features has given rise to much discussion in the subsequent literature on the artist. Cézanne's nudes, with their peculiar mixture of unsensual bodies and strange irruptions of sexually charged form, have been the subject of psychoanalytical interpretations of the painter, which have speculated about the deep-seated anxieties that pervade his imagery of women.[28] Both Meyer Schapiro and later Tamar Garb noted the metaphorical displacement of female sexual signifiers from the body to other aspects of the composition, in the form of strong accentuations of phallic and triangular shapes prevailing in these paintings. As Garb has suggested, the prevalence of triangulated shapes in the representation of canopies and drapery alludes suggestively to female genitalia, while the phallic shapes of many of the female bodies in the *Grandes Baigneuses* are picked up in the trunks of the landscapes' trees.[29]

Whether these features of his compositions were signs of unconscious displacement, the personal sexual repression Schapiro attributed to Cézanne's painting, or, as Garb argued, were symptomatic of the general cultural chauvinism of the period, or whether they are consciously intended sexual allusions, is a matter of some dispute. Cézanne sought to create unity in his pictures through the repetition of particular forms extending from the bodies to the landscapes. Likewise, as an avid collector of popular imagery, he would have been aware of the widespread use of ribald visual puns in such imagery. Cézanne's early imagery is littered with such visual puns. Moreover, suggestive associations

between the forms of nature and the forms of the body, and the use of metaphors of nature to connote sexual desire and arousal, featured in much literature at the time, including Zola's novels and Cézanne's own youthful poetry.

It seems undeniable though that whether intentionally or not, some measure of psychical conflict is present in Cézanne's female nudes, an issue I will come back to in the course of this book on several occasions. In the 1860s he was often drawn to violent imagery, including themes of rape and murder. While these themes gradually disappeared from his painting, in the 1870s he produced a series of paintings on the theme of sexual temptation, often casting himself in the role of the painting's protagonist, averting or shielding his gaze from the sight of the woman's naked flesh. In these pictures, the spectacle of the female body offers a threatening and powerful allure: the promise of sexual pleasure but also symbolic castration. The female body is both a site of desire and of repulsion. Cézanne's later paintings, though no longer so immediately tied to such themes, appear equally problematic. The world these ungainly *Grandes Baigneuses* occupy seems peculiarly inward-turning, and the pictures haunted by the aggressive and libidinal impulses present in earlier works. The curiously desolate figure by the tree on the right of the Barnes version seems to encapsulate the guilt and remorse about sexuality that pervades this imagery.

For his contemporaries, too, the *Grandes Baigneuses* seemed to express the artist's deep-seated anxiety about his relations with women. According to Bernard, Cézanne referred to these female bathers as 'bitches'. During the nineteenth century the relationship between art and sexuality became an increasing focus of discussion in artistic discourses. Whether art involved the sublimation or transcendence of sexual desire was a question that came to bear on the understanding of what art fundamentally was, as well as what it was meant to represent and look at the nude. In Balzac's

Le Chef-d'oeuvre inconnu, the contrast between Poussin's understanding of art as a pure, transcendent aesthetic experience and Frenhofer's view of it as an expression of sexual desire demarcates the extreme poles of these positions.

The theme of the conflict between a life of sensual fulfilment and a life devoted to art was well worn by the 1870s, played out again and again in narratives of artists' lives and their painted representations. Examples included Léon Benouville's *Raphael rencontre de La Fornarina* (Raphael Reunited with La Fornarina, 1857) and Jean-Raymond Lazerges' *Le Génie éteint par la volupté ou L'Abus des plaisirs* (Genius Eclipsed by Voluptuousness, or The Abuse of Pleasure, 1849), which showed a troubadour with glazed expression limply holding a lyre with broken strings while a half-nude woman reclining next to him holds aloft a glass of wine in a toast to sensual pleasure. Rubens taking Van Dyck away from his fiancée and Fillipino Lippi falling in love with his model were among the most favoured themes, though it was the life of Raphael, portrayed in many narratives as sacrificing his talent to his unquenchable desire for his lover, that proved the most fascinating and enduring subject matter.[30] The conflict between sensual desire and artistic vocation was also the theme of Wagner's opera *Tannhäuser* (1845), which Cézanne much admired.

Zola likewise took up this theme in his *L'Oeuvre*. The novel, as Aruna D'Souza has argued, explicitly associates Lantier's 'impotence' as a painter with sexual overtones.[31] Lantier is torn between chastity, his 'passion for the physical beauty of women' and the 'insane love for nudity desired but never possessed'.[32] His mistress and later wife, Christine, who occupies the position of lover, mother, wife and model, is both the tangible outlet for his sexual desire and the facilitator of his painting, but ultimately she is the source of tragic conflict in his life and art. She gives birth to their deformed son the day that Lantier's painting *Plein air* is ridiculed at the Salon des Refusés, and although for a time she

exerts a moderating influence over him that temporarily quells his restlessness, passion ultimately distracts him from his art, causing his 'artistic ambitions to shrivel up into nothing'.[33] The relationship deteriorates to the point where she, like Poussin's lover Gillette in *Le Chef-d'oeuvre inconnu*, comes to see painting as a 'terrible rival' for his affections. Cézanne's bathers were to be integral to the artist's legend and legacy and to the construction of him as a biographical subject for his first biographers, who portrayed him as haunted by sexual guilt and repression. These were the pictures that seemed to his contemporaries to provide a way into the recesses of the artist's deepest thoughts and motives, to those motives that were not conscious to himself. They were works that seemed to give form to what was most distinctive and valuable but also most problematic about the artist's work, and the anguished and melancholy spectacle of sexuality they were taken to portray was integral to what made them seem so meaningfully contemporary.

1

Memories of Youth

My earliest memory is this . . . your father must have been about
five years old, he had drawn on the wall with a bit of charcoal a
drawing that represented a bridge, and M. Perron, Th. Valentin's
grandfather, exclaimed on seeing it: 'Why it's the Pont de Mirabeau
[over the Durance].' The future painter was already discernible.[1]

So wrote the artist's sister Marie to Cézanne's son Paul, five years
after the artist's death, supposedly revealing the moment when
Cézanne's future as an artist of the Provençal landscape was already
immanent. Such fables of origination were a well-worn convention
of artists' lives. The apocryphal story Marie tells could be told
of many artists' childhoods. It was, in actuality, to be a long and
difficult struggle before Cézanne the painter would emerge. In his
youth, Cézanne thought his talent lay more on the side of literature
as a poet than as a painter. His letters from this period are littered
with verses, by turns grandiose and comical, often a mock epic
combination of the two, detailing the imagined loves and pursuits
in the countryside of him and his closest friends. Biographical and
autobiographical reminiscences were invariably formed by the
sense of an ending and of the fateful predestination of the future
path that lay ahead. The nineteenth century saw the emergence of
modern conceptions of childhood, casting adrift the negative views
of infancy that had previously prevailed in favour of an image of it
as a time of innocence, emotional development and beauty, an ideal

world of purity and freedom to be set against the complexities and compromises of adulthood and modernity.

This image of childhood as leaving a deep well of lasting impressions on the conscious and subconscious life of the subject, a reservoir of deeply channelled feelings that would continue to determine and haunt the individual in later life, was fostered by the writings of Jean-Jacques Rousseau. Following on from the popular assimilation of his work, it also became part of the self-fashioning of the autobiographies of writers, both professional and non-professional, who made claim to it as part of the new interest and seriousness given over to childhood as the formative period of life. The year 1848 saw the flourishing of a subgenre of *souvenirs d'enfance et de jeuneusse* (memories of childhood and youth), which gradually made its presence felt in the novels of the time.[2] This new conception of childhood and adolescence would strongly influence Cézanne's thinking in later life, encouraging nostalgia for a lost past that he continually sought to revive in his painting. It would also imprint itself on the reminiscences of those who recalled his childhood and youth.

Recovering the early life of the artist is no simple matter. So much of early life goes unrecorded, despite the ever-growing importance attached to it. Moreover, the Aix-en-Provence where Cézanne was born, grew up and spent the majority of his life has changed profoundly. Aix, the capital of Provence, was founded in 123 BC and originally had been a Roman military outpost and the site of thermal baths. Its history continued to be indelibly linked to the history of the Roman Empire. Early travel guides in the nineteenth century made much of its scenic Roman ruins, fountains, reservoirs and aqueducts. For them, it seemed to preserve the vestiges of another time and another France. By mid-century, the sleepy, tranquil town was a majestic backwater – *la belle endormie*, as some called it. For Zola, it was frozen in the arrogant airs of its past. But today it is a major city and tourist resort, changes that were already

beginning to happen in the latter half of the nineteenth century. A large highway now carves a route through its once-tranquil countryside. The secluded woods where Cézanne sought the solitary pleasures of the landscape artist have been assimilated into a tourist trail as 'must-see' sites for visitors to the region. Aix itself has been remade by the Cézanne legend, which in turn has been remade by the resulting tourism. The Montagne Sainte-Victoire is no longer a mountain. It is first and foremost an artist's motif, a metaphor for the artist's struggles, a majestic illustration of Cézanne's paintings. It has become a key site in the history of modern art.

Cézanne was born on 19 January 1839, the eldest of three children. His sister Marie was born two years later and the youngest of the siblings, Rose, twelve years later. His father, Louis-Auguste, was then a merchant operating from a millinery shop that supplied and exported hats on 55 cours Mirabeau, one of the elegant boulevards in the more affluent quarter of the city. In his youth, Cézanne appears to have been close to his sister Marie. Despite being two years younger, she exerted a strong and often-overbearing influence on him that persisted throughout his life and was probably responsible for his late reconversion to Catholicism, having renounced religion in his youth. Marie was her father's favourite daughter: strong-willed, a devout Catholic and outspoken in her moral righteousness. She remained unmarried. As Cézanne's parents entered into old age, she exerted increasing control over the family's affairs, running the estate and household. As her father had, Marie remained wilfully unsupportive of her brother's artistic ambitions. It is said that she possessed only one painting by him, a sketch of the Montagne Sainte-Victoire, which he had forced on her. 'You are in a much better position than I to appreciate the artistic side of his (Paul's) nature and his art', she later wrote to Cézanne's son Paul, 'which I confess is a riddle to me'. Rose, born when Cézanne was already fifteen, had less influence on his early life, though in later years Cézanne would sometimes stay at the large Provençal

farmhouse in Bellevue she shared with her wealthy husband, which was conveniently located for traversing the hills and fields around the Montagne Saint-Victoire and as a base from which to paint.

Cézanne's parents were to exert a profound and complex influence over his imagination during his childhood and early youth, though in diametrically opposed ways. His father, Louis-Auguste, was born in Saint-Zacharie in the Var region of Provence, northeast of Marseille, on 28 June 1798. His family's origins can be traced back to Cesana Torinese near the mountains of Piedmont, from where his forebears migrated during the seventeenth century across the border to Briançon in the Provence-Alpes-Côte d'Azur in southeastern France, though some of the family settled as early as the mid-seventeenth century in Aix. Little is known of Louis-Auguste's early life. His father had been a tailor in Pourrières and he was to find employment initially working for a wool merchant in Aix, before taking an apprenticeship to a Parisian milliner in 1821, aged 22, where he made his trade as a hat salesman. The portraits Cézanne painted of his father obliquely acknowledge this. Louis-Auguste is invariably shown wearing various forms of headgear. Known throughout his life for his opportunism, shrewdness and pragmatism, he had entered into a flourishing trade and had the foresight to invest in rabbit farming, on which the manufacture of felt was then heavily dependent. Within four years he was successful enough to open his own business in Aix, dealing in the sale of the local felt hats we see Cézanne sporting in his early self-portraits. However, Louis-Auguste's fortune ultimately rested more on moneylending than millinery: he made loans to rabbit farmers and other businessmen. The rates of interest he charged often bordered on usury. Where debtors struggled to pay back their loans, Louis-Auguste imposed an aggressive regime of repayment. If they became insolvent he took possession of their lands or businesses.[3] When, in 1848, Aix's sole bank went under, Louis-Auguste, in partnership with Joseph Cabassol, one of the bank's employees, took it over. By

the time their partnership was dissolved in 1870 they had amassed a considerable fortune.

The image that history has passed down to us of Louis-Auguste is a mean-spirited and rather tyrannical figure. Cézanne's letters and the reminiscences of his friends often paint a picture of him as authoritarian, miserly, controlling and intrusive. 'Take C.'s father, banterer (*goguenard*), republican, bourgeois, cold, meticulous, avaricious . . . he refuses luxuries to his wife,' remarks Zola in his notes for *La Conquête de Plassans* (The Conquest of Plassans, 1874).[4] François Mouret, a central character of the novel, was largely based on Louis-Auguste, and Zola sums him up with his usual ascerbic wit: 'What a lovely bourgeois is Mouret, with his curiosity, his greed, his resignation and his grovelling!'[5] It is clear that Cézanne remained fearful of his father throughout his life: 'Me, I go as far as to embrace le papa.' This is the closest we get to any affection expressed for him before his father's death in 1886.

The fears the son harboured for his father were real enough, albeit amplified by the period's image of fatherhood as unbending patriarchal authority. Later these fears were deepened by Cézanne's dependence on his father's modest allowance for his subsistence, which continued for most of his adult life. He would be almost fifty before he was liberated from this dependence by his father's death and his inheritance. But the truth is perhaps more complex: Louis-Auguste could appear by turns arrogant or benign. Zola's unrelenting portrait of his meanness was an exaggeration – as Cézanne was at pains to tell him – born of the conflict of wills that was often seen as characteristic of relations between patriarchs and their sons, and a portrait influenced perhaps by his belief, spurred on by Baille, that Louis-Auguste deeply disapproved of Zola.[6] Zola's antagonism towards Cézanne's father may also have been inflected by the experience of the loss of his own father when he was only seven years old. Despite Louis-Auguste's opposition to his son's artistic career, he continued to support him, and the evolution of

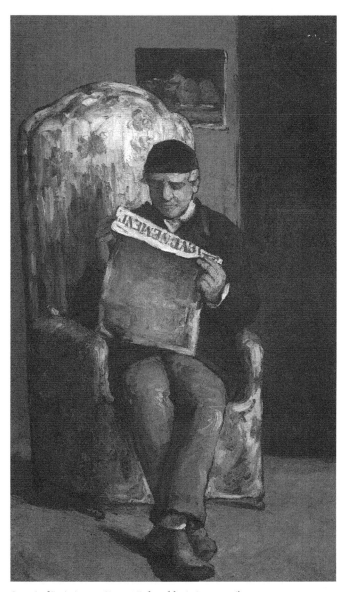

Portrait of Louis-Auguste Cézanne, Father of the Artist, 1866, oil on canvas.

Cézanne's art would have been unimaginable without his father's, albeit modest, financial allowance. Louis-Auguste was, as Cézanne used to refer to him, 'the author of (his) days', and in many respects his influence is felt in myriad ways in the art that Cézanne produced. The experimental nature of Cézanne's painting was premised on the relative freedom he enjoyed from having to find buyers for his painting, or take on commissions. But the consequence was that throughout his life he was fearful of the disapproval and wrath of his father. His youth was, in many respects, a period of struggle, both real and imagined, to meet or break free from his father's expectations of him.

While it would trivialize the rebellion and transgression of Cézanne's early painting to reduce it to originating in a deep-seated resentment of the authority his father held over him, this may well have played some role in predisposing Cézanne to a suspicion of all institutional authority and a lifelong dislike of the tastes and values of the entrepreneurial bourgeoisie. Cézanne's few portraits of his father present him as an assertive presence, but often picture him reading or sleeping, a rare motif in Cézanne's painting reserved almost exclusively for the tender images of his son. Did these images of the father asleep merely reflect Cézanne's opportunism in making a portrait of him while docile – it is difficult to imagine Louis-Auguste as a patient sitter – or did this motif reflect deeper, latent meanings? In these images, his father is caught off guard and the tables turned: the power is all with the aspirant artist who turns his father, so reluctant to see his son become an artist, into the artist's unwitting model. The image of the slumbering father seems redolent with the desire of the son to assert himself over the father, though the fact that images of sleep are otherwise associated with tender feelings in Cézanne's painting hints at the greater complexity of their relationship. In another portrait of 1866, Cézanne pictured his father on a chintz-covered 'throne', reading *L'Événement*, the republican newspaper that Zola wrote reviews for, rather than the

more conservative *Le Siècle* Louis-Auguste favoured. Hovering over his father on the back wall Cézanne placed one of his own thickly painted still-lifes. These were the ways in which parental authority was given form but in a fashion that allowed the son's presence to assert itself.

The eventual sale of the family estate – an eighteenth-century country house with 37 acres (15 ha) located on the fringes of Aix known as the Jas du Bouffan – in 1899, would entail leaving behind his first symbolic statement of his ambitions as an artist for his father, a mural of four seasons. Technically lacking, awkwardly conceived and devoid of the usual themes of his painting during these years, this mural was nevertheless the first symbolic declaration to his family of his aspirations to be an artist. Cézanne had signed the mural in the grand salon of the family manor not in his own name but in that of the leading classical artist of the day, Jean-Auguste-Dominique Ingres. His playful inscription of himself into the identity of Ingres, whose paternal authority loomed so large on the French artistic scene that his death in 1867 was widely seen as a watershed for French art, in a mural painted in the symbolic seat of patriarchal authority smacks of a private joke, a self-assertion through a hybrid combination of parody and pastiche. Though Cézanne's letters prior to the sale of the Jas du Buffan give little away of his feelings, leaving behind the family home and with it the mural in the salon must have intensified his sense of being irreparably severed from the past of his childhood and youth.

If Cézanne's relationship with his father was marked by persistent anxiety, reliance and fear, his relationship with his mother was an intensely idealized one, in keeping with the veneration and exaltation of motherhood so pronounced in this period.[7] The enmity Cézanne felt for his father throughout his life appears to have been strength-ened by his deep, abiding love for his mother, and it is not hard to see why the relationship between father, mother and son has so often been characterized as an unresolved Oedipal drama. Anne-Élisabeth

Honorine Aubert was the source of unconditional affection and moral support. Born in 1814 into a lower-class family (her father was a carpenter) from Marseille, she had initially made a living as a shop girl and then worked as a hat-maker, but very few details of her life are known. She married Louis-Auguste, some fifteen years her senior, on 29 January 1844 in the church of Sainte-Marie-Madeleine. She was thirty years old, but had already been living with him for the past six years and had borne him two children. A pre-nuptial agreement included a contract about the separation of property, in which it was stated that her dowry 'as the result of her savings to date of her earnings as a hatmaker' consisted of a trousseau valued at 500 francs, 1,000 francs in cash and an expected inheritance of a further 1,000 francs.[8] Cézanne was nine years old at the time of their marriage, illegitimate but acknowledged; something not unusual for the time.

No photographs of his mother exist and only one portrait painted of her by her son, *Portrait de la mère de l'artiste* (Portrait of the Artist's Mother, 1869–70), has survived. In one respect, this is not surprising. Only a small number of pictures of his family survive – a few portraits of his sisters and three formal portraits of his father along with a number of sketches – but it is perplexing given her son's devotion to her. Perhaps there were more. But the fact that no others remain may testify to an idealization that could not adequately be expressed, least of all within the objectifying terms of his later painting. The solitary portrait of the mother seems right somehow, his feelings for her precluding representation in a way that it did not for his father.

Despite Cézanne's devotion to his mother, she remains something of an enigma. She seems to have possessed a vivid imagination, sensitivity and intuitive intelligence and had a keen curiosity about art, though she had received only a modest education. Among his family, only she seems to have encouraged his artistic ambitions, imbuing in her son aspirations she no doubt felt had

been thwarted in her own life. She alone took an interest in his earliest drawings, nurturing his preoccupations with art, poetry and nature, and it was she who encouraged him to take instruction at the local art academy. The illustrations in the fashion journal *Le Magasin pittoresque*, to which she subscribed, were used by the young Cézanne for childhood colouring-in exercises, and later he drew upon these prints as source material for a number of paintings in the 1860s. After his death, copies of these journals were found carefully preserved in his studio. Cézanne remained devoted to her throughout his life. In a letter dated 3 February 1902 to Charles Camoin, a Marseille-born artist on close terms with Matisse, he wrote, 'I congratulate you most sincerely on being with your mother, who will be the most reliable moral support for you in moments of sadness and despondency, and the best source from which to take fresh courage to work at your art, which one must seek to achieve not limply or half-heartedly, but in a calm and sustained fashion, which cannot but lead to a state of clear-sightedness.'[9] These words tell us more about Cézanne than his interlocutor. The idealization of mothers and the reviling of fathers was common among the small group of friends Cézanne grew up with in Provence, and one can find similar sentiments expressed in the writings of those closest to him in his youth.

Despite Cézanne's long relationship with Hortense Fiquet, who would eventually become his wife, he continued to spend a great deal of his time living with his mother and sister. He was distrustful by nature, and his mother was his most trusted confidante; he wrote constantly to her when away in Paris, confiding in her the secret of his relationship with Hortense and the existence of their son, born in 1872, both of which he hid desperately from his father. But no letters from his mother have survived. It has been suggested that she remained illiterate for much if not all of her life, though a book discovered in Cézanne's studio at Les Lauves after his death, Jean-François Marmontel's romance *Les Incas, ou la destruction de*

l'Empire du Péru (1777), is inscribed H. Aubert, implying she learned to write her name and probably to read. The signature also shows that she continued to use her maiden name throughout her life. Her relationship with the imperious Louis-Auguste seems to have been an uneasy one, but the marriage, like so many bourgeois marriages, endured through tolerance and patience fostered by habit and dependence. They often lived apart for long periods of the year: during the summer season, she rented a house in L'Estaque off the gulf of Marseille, the house in which Cézanne and Hortense would later take refuge during the Franco–Prussian War.

As the son of an increasingly affluent provincial bourgeois family, Cézanne had a privileged education: academic success was seen as integral to a successful future. From 1844 to 1850 he attended primary school in the rue des Epinaux, where he met Philippe Solari, the son of a stonemason, who would later become a sculptor of some renown and, like so many of Cézanne's childhood acquaintances, would remain a lifelong friend. In 1850 Cézanne was registered at Saint-Joseph's Catholic school as a half-boarder, but when the school was closed two years later he was sent to the prestigious Collège Bourbon in Aix, initially under the same arrangement. Exceptionally tall from a young age, gangly and socially awkward, the young Cézanne cultivated an effusive personality that concealed a somewhat introverted and sensitive nature. His waywardness and 'expansive imagination' were expressed in bursts of 'cheerful and racy' conversation. Cézanne's irascible temper and quick turn of mood that so perplexed his later admirers were evident from early childhood, but his brief fits of anger, once vented, quickly subsided to reveal a milder, more amenable nature.

Cézanne remembered his time and teachers at the Collège Bourbon fondly, despite the appalling food, dank classrooms, uncomfortable benches and lack of heating in the winter. The militaristic school uniform consisted of a blue *képi* (military cap),

a blue tunic with red piping and gold palms on the collar, and white or grey duck trousers. His studies included history, geography, logic, arithmetic and geometry, as well as French literature. However, classics formed the core curriculum of the education Cézanne received, which comprised Latin and Greek translation and Latin rhetoric and conversation. Cézanne was well versed in the writings of Apuleius, Cicero, Livy, Lucan, Lucretius, Ovid, Tacitus and Virgil; references to many classical writers would inevitably appear in his early painting. He was an exceptional student and over the course of his years at the school won annual prizes and honourable mentions in history, arithmetic, geometry, geography, grammar, French literature, physics, chemistry, cosmography, calligraphy and religious instruction – and even on one occasion for painting. Ironically, Émile Zola, the most important companion of his youth, won far more school prizes for painting than Cézanne and feared his friend was the better writer. Towards the end of his life Cézanne would occasionally reflect on whether he had taken the wrong turn and might have made a better poet than painter.[10] He particularly excelled in classics, winning prizes and honourable mentions for Latin translation, verse and conversation, and in Greek translation. (Cézanne's youthful poetry and verse letters to Zola indicate his facility for and delight in puns and wordplay – often shamelessly bawdy – in Latin.) It is said that he charged other students for his translation services. His youthful letters indicate he had committed to heart the verses of many classical poets, and could read and recite Roman poetry fluently in the original. His favourite classical authors were Horace, Virgil and Cicero and his letters freely quote from, pastiche and paraphrase them.

It was at the Collège Bourbon that Cézanne met Zola, establishing an intimate friendship that was to endure until later life. Born in Paris in 1840, Zola was raised in Aix, where his family moved in 1843 when his father, an engineer, sought work there. Zola's father died of pleurisy four years later, leaving his wife to bring up his son on a

modest pension. In contrast to Cézanne, Zola recalled that his schooldays were miserable, no doubt because he was a full boarder on a charitable scholarship. As a Parisian-born Jew with a foreign name, who spoke with a lisp, he never fully integrated into a school whose brutal atmosphere expressed itself in a provincial intolerance towards those they considered 'foreigners' and 'parasites'. Cézanne and Zola had entered the school at the same time, though Zola was in the year below. When Zola was bullied by other schoolboys, Cézanne stuck up for his newfound friend and as a consequence received a thrashing from the other boys. 'The next day, he [Zola] brought me a big basket of apples', he later recalled.[11] Zola commemorated the incident in a thinly veiled passage in his novel *Madeleine Férat* (1868).

Guillaume, however, had one friend at school. As he was about to start his second year, a new pupil entered the same class. He was a big, strong, sturdy boy, who was two or three years older. His name was Jacques Berthier. An orphan, having only an uncle, a lawyer in Véteuil, he had come to the school in that town to complete the humanities course he had begun in Paris . . . On the very day he arrived, he noticed a big rascally boy bullying Guillaume. He raced over and made the boy understand that he would have to reckon with him if he tormented the others like that. Then he took the arm of the persecuted one and walked with him throughout the break, to the outrage of the other boys . . . [Guillaume] developed an ardent friendship for his protector. He loved him as one loves a first mistress, with absolute loyalty and blind devotion . . . Jacques accepted in good part the adoration of his protégé. He loved to show off his strength and be praised. Besides, he was overwhelmed by the fond caresses of Jacques, puny and proud, who crushed the others with his scorn. During the two years they spent at the school they were inseparable.[12]

This passage, with its allusions to the blind devotion, caresses and adorations of the two friends, expresses the intensity of feeling the relationship harboured. The two characters of Jacques and Guillaume share characteristics that merge those of Zola and Cézanne, and although this is in one respect an effect of fictionalizing the incident, the intermingling of their identities in this passage indicates how fundamental Cézanne and Zola were once to each other's sense of identity. While it has been customary to see the two friends as like brothers, in a seminal article on the artist, Meyer Schapiro intimated that this ardent friendship became the focus of youthful love between the two friends.[13] Schapiro drew attention to Cézanne's fascination with Virgil's second Eclogue, where the shepherd Corydon expresses his love of the boy Alexis, which Cézanne mentioned in a letter to Zola he had translated, but after some deliberation held back from his friend, much to Zola's annoyance – 'Since you've translated Virgil's second Eclogue, why don't you send it to me? . . . I'm not a young girl and won't be shocked.'[14] Identifying this Eclogue as the source of an enigmatic picture by Cézanne known as *Le Berger amoureux* (The Amorous Shepherd, *c.* 1876–8), Schapiro argued that this scene of the sexual wooing of women by a shepherd carrying a basket of fruit was a veiled allegory of the event that symbolized Cézanne and Zola's friendship. Perhaps mindful of the mores of his day, Schapiro did not press the point further, but the implication was that the apples were a reminder of a close relationship that, like his attachment to his mother, contributed to Cézanne's ambivalent relationship with women. The male and female bathers pictures, with their ambiguities of gender, might thus be read as conflicted meditations on the nostalgic memory of his youthful bathing in the rivers around Aix with his childhood friend. But these are difficult matters to assess, not least because of how steeped the two friends were in the language of classical prose and Romanticism, both of which encouraged expressions of ardent feeling for friendship that appear

to contemporary eyes to be imbued with homoerotic sentiment. But their correspondence brims with fantasies of female loves, both real and imagined.

However one characterizes the relationship, the apples that dominated Cézanne's still-lifes carried associations of the memory of the bond of lost friendship. In 1886, after the relationship between the two had broken down irreparably, Geffroy remembered Cézanne talking of his wish to 'astonish Paris with an apple'. Though Geffroy took this to be a literal expression of the ambition of Cézanne's later still-lifes, Schapiro, noting that the statement coincided with the publication of Zola's *L'Oeuvre*, argued that it represented Cézanne's desire to win over a friend with whom he had had an inordinately close bond since childhood but who he now felt had betrayed him.

During their schooldays their friendship nevertheless sustained them, but this was to be prematurely interrupted in February 1858, when Zola, accompanied by his grandfather, suddenly departed for Paris. Ten years after her husband's death, Zola's mother had resettled in the rue Monsieur-le-Prince, in the capital's 6th arrondissement, and the following year sent for her son to join her. Cézanne was left without the person who had been his closest confidant and mainstay throughout the formative years of his adolescence. It is clear that the separation caused by Zola's departure to Paris and the picture his friend painted of the capital in his letters deeply affected him. A couple of months afterwards he wrote, 'Since you left Aix, *mon cher*, I've been overwhelmed by a gloomy sorrow . . . I don't seem myself, I feel heavy, stupid and slow . . . I lament your absence.' In verse he continued:

Farewell, my dear Émile,
no, over the flowing stream
I no longer slip as gaily
as in times gone by,
when with agile arms

like reptiles
we swam together
across the calm waters.
Farewell, fine days
seasoned with wine!
Lucky fishing
for prodigious fish!
When in my catch,
in the cool river
my surly line
caught nothing dreadful.[15]

In another letter to Zola, written on 29 July that year, he wrote:

I thoroughly enjoyed that poetic morsel you sent me, I really
liked to see you remember the pine that provides shade for the
riverbank of the Palette, the pine that I love, how I should like
to see you here – damn everything that keeps us apart. If I didn't
restrain myself, I should let off a whole string of *nom de Dieu,
de Bordel de Dieu, de sacrée putain*, etc.; but what's the point of
getting in a rage, that wouldn't get me any further, so I put up
with it.

Yes, as you say in another piece no less poetic – though I
prefer your piece about swimming – you are happy, yes you [are]
happy; but I suffer in silence, my love (for it is love that I feel)
will not come bursting out. A certain ennui is always with me,
and when I forget my sorrow for a moment it's because I've had
a drink. I've always liked wine, but now I like it more. I've got
drunk, I'll get drunker, unless by chance I should succeed, my
God! I despair, I despair, so I'm going to deaden the pain.[16]

Cézanne subsequently failed his *baccalauréat*, despite his talents
as a student and proficiency in Latin. Though he eventually graduated

later that year at his second attempt, he passed only with the grade 'average'. It must have been a massive blow to his confidence.

For the previous five years the two friends had become inseparable. The letters they exchanged during this period of separation are invaluable resources for biographers, providing intimate insights into their hopes, fears, desires and aspirations. As the above quotation indicates, on their holidays and free days they escaped the parochial provincialism of the town and explored the plains and woods around Aix, bathing, basking and swimming naked in the river – becoming modern primitives. In yet another novel in which Cézanne featured, *Madame Meuriot* (1890), Paul Alexis immortalized the intensity and formative nature of Cézanne's childhood relationship with the land. Cézanne, who appears under the name Poldex, experiences the sensuous rapture of nature, oblivious to the social and economic contradictions that beset the adult world he will later inhabit.[17] In their 'wild rambles across the countryside' and 'long reveries under the sky', they were usually accompanied by Baptistin Baille, who also attended the school and would later become professor of optics and acoustics at the École de physique et de chimie industrielles, Paris. More occasionally, Philippe Solari, Marius Roux or Isidore Baille, Baptistin's younger brother, would join them. Together Baille, Cézanne and Zola became known as *les trois inséparables*.[18] Their youth was an imagined golden age in which they reclaimed their fantasies of a primordial classical past and fashioned themselves as Virgilian rustic poets.[19] They lived out and constructed their identity from such Arcadian classical narratives.

Cézanne's many picnic scenes and images of male bathers were his way of revisiting the memories of those days. One of the earliest bathers scenes was a pen drawing on a letter sent to Zola of three male swimmers beside a bank dominated by a flourishing pine tree. It is not surprising that the centrepiece of his submissions to the third Impressionist exhibition in 1877 was his *Baigneurs au*

repos, one of his most ambitious paintings to date. The painting depicts four male figures bathing, stretching and basking in the sun beside a stream. Two are nude, although the figures on the right, closest to the stream, wear fashionable shorts and a hat, and some discarded clothing at the bank of the stream make it a contemporary scene. In the background appears one of Cézanne's earliest representations of the Montagne Sainte-Victoire, the motif that would later become so deeply associated with the artist, and some pine trees, which Cézanne so loved he would sometimes wax lyrical to Zola in his letters about particular trees around the countryside.[20]

Pastoral pictures like these reflect a personal nostalgia for Cézanne's youth and the landscape that he felt he intimately and integrally belonged to. But *Baigneurs au repos* is an enigmatic and strange painting, its atmosphere caught between banal reality and the visionary, as if it were transposed from an imagined

Baigneurs au repos (Bathers at Rest), 1876–7, oil on canvas.

reconstitution of the past or, as T. J. Clark has remarked, it is a dream work.[21] A peculiar dramatic light illuminates patches of the landscape. Compositionally, it is a curiously incongruent and paratactical painting that is made out of separately conceived parts; figures look as though they have been stuck onto the landscape rather than being integrated within it, their bodies a composite of parts that are not quite brought together into a unified whole. As with so many of his bathers pictures, figures seem isolated from each other despite their close proximity, each absorbed in his own private experience of the landscape, his own particular reverie. The most emphatic example of this is the central figure, who seems captivated, Narcissus-like, by his reflection in the water. The curious and implausible conception of the figures extends to their poses. The two figures on the right seem awkwardly and cursorily rendered, but the two left-hand figures seem most perplexing: the background figure is arched in a phallic pose that echoes the shape of the tree adjacent to him; in the foreground, the prone figure seems curiously effeminate and insecurely gendered.

Cézanne's persistence with a subject-matter, the male nude, which had long gone out of fashion in contemporary art, is surely indicative of how its meanings for him were tied to reviving the memories of a moment when he felt freest and happiest. Certainly, it is significant that in contrast to his female nudes these later male versions seem largely devoid of the former's fraught atmosphere, which often retains a residual sense of the voyeurism and intrusive disturbances that inhabited Cézanne's earliest versions of this theme. Therefore it is no surprise that the subject of bathing should be reprised with such force in the 1890s, when his relationship with Zola had effectively ended.

Those days when they immersed themselves in the Provençal countryside had been formative in other respects: their communions with nature involved long discussions of their favourite poets and authors. Cézanne had a particular fondness for the pastoral

poetry of classical authors, especially Virgil, whose verses he took delight in translating and whose voice leaves a deep impression on Cézanne's own poems and paintings. As an heir to the Rousseauesque tradition, his tastes also extended to the great Romantic writers of contemporary French literature, which he regarded as confluent with these classical sources. The walls of the youthful Cézanne's bedroom were littered with not only the sayings of classical authors like Horace, but those of Victor Hugo and Alfred de Musset. Zola later reminisced:

> Our loves, in those days, were above all the poets. We didn't stroll alone but had books in our pockets and game bags. For a year, Victor Hugo reigned among us . . . He had captured us with his high style and powerful rhetoric . . . Then, one morning, one of us brought along a volume of Musset . . . For us reading Musset was our heart's awakening . . . Our cult of Victor Hugo received a terrible blow . . . Alfred de Musset alone was enthroned in our game bags.[22]

Musset's autobiographical novel, *La Confession d'un enfant du siècle* (The Confession of a Child of the Century, 1836), and his musings on love and eroticism fired their imagination. Likewise, his impromptu mini-plays derived from episodes of old romance stories established a dramatic precedent much emulated by *les trois inséparables*. Musset's poem 'Ballade à la lune' was a particular favourite of theirs. Soon pastiche Hugo gave way to pastiche Musset in Cézanne's poems. Musset's death in 1857 only intensified their fascination with him. The year Musset died, Baudelaire published *Les Fleurs du mal*, a collection of poems that Cézanne boasted he could recite from memory. Eventually, Baudelaire would eclipse the memory of Musset.

The romantic little literary community of *les trois inséparables* was to play a pivotal role in shaping the imagination of Cézanne's

early life, providing him with crucial moral support through the early vexations of his life and art. Reminiscences of their early youth endured far beyond these years, providing him with an imagery repertoire that continually found expression in his work. 'I can't close my eyes without revisiting the days of that happy age', wrote Zola.[23] This was in many respects an effect of the retrospective nostalgia that the new understanding of childhood and youth fostered, creating a rose-tinted view of the past as unencumbered by wants or cares, but it also reflected the perception of the loss of something dear to him.

This structure of feeling was particularly strong for the relationship between Cézanne and Zola. There is no doubt that each was initially reliant on the other in nurturing his artistic gifts, and Zola, the more level-headed and confident of the two, was constantly called upon to shore up his friend's insecurity. Their literary and artistic ambitions during the 1860s in Paris offer parallel lines of development both conceptually and in practice that still, despite much scholarship, remain to be fully explored. But as time wore on the relationship was to become a troubled one. They were temperamentally very different and those differences were increasingly visible to each of them as the years rolled by. This was a friendship of contrasting and even quite opposed personalities, an alliance forged out of adversity, and was strongest when there was a common cause that bound them. Cézanne remained dependent in many respects on Zola, continuing to confide in and count on him for financial loans long after his friend's need of him had waned. By contrast, Zola's letters, even from early on but especially later, often display an irritation and a frustration with Cézanne that speak of an ever-deepening sense of disappointment and disenchantment. As Zola reaped the economic and social rewards of becoming a successful critic and novelist, his friendship with Cézanne became more and more a matter of toleration, a friendship sustained on memories of the past rather than something vital to him.

By the late 1870s Zola had lost confidence in him, and in the more rarefied social circles in which Zola mixed Cézanne appeared at best eccentric, at worst an embarrassment. But in their youth they remained bound by a common vision of what they loved, what they opposed and what they imagined they would achieve in the future. It is impossible to imagine Cézanne becoming an artist without the encouragement and faith Zola had shown in him.

Cézanne's artistic aspirations began in earnest in 1857 when he enrolled in classes at the École spéciale de gratuite de dessin, located in the Musée d'Aix, and where his classmates included Jean-Baptiste Chaillan, Joseph Chautard, Joseph Villevieille, Numa Coste and Achille Empéraire. Cézanne much admired Achille's personality and his bold style. Like Édouard Manet, Achille went on to study with Thomas Couture, whose artists' manual Cézanne studied during his youth. The two were eventually to become close friends when they later studied together at the Académie Suisse in Paris. But at this point in time Cézanne still did not see himself primarily as a painter, clinging to his ambitions as a poet. Louis-Auguste showed no interest in either of his son's talents. As did many bourgeois parents, he intended his son to have a 'proper profession', and pressured him to study law. 'The Law, the horrible Law, with all equivocations / Will make my life a misery for three years!' Cézanne later wrote in one of the many verse letters sent to Zola.[24] He found a willing ear for his lament: Zola's mother had the same ambitions for her son, but he failed his *baccalauréat* and remained resolutely wedded to his literary ambitions. To supplement his meagre earnings as an aspiring author and critic, he was forced to work in a shipping firm and then in the sales department of Hachette, a publisher, who eventually fired him after the publication of his 'sordid' autobiographical novel *La Confession de Claude* (Claude's Confession, 1865) attracted police attention. Although Cézanne persevered, scraping through the first round of legal exams, by April 1860 he adamantly refused to

continue. All that remains of his studies is some notes on bailiffs covered with sketches.[25]

The Aix École taught only drawing, mainly of the figure based on the study of copies of antique statuary in the museum collection (period photographs of the museum's hall of antiquities show the plaster casts after antique statuary that Cézanne was set to copy), or in the life class, based on male models in classical poses. The drawing master, the redoubtable Joseph Gilbert, was a traditionalist and a strict disciplinarian; Cézanne later referred to him as another domineering father figure and 'bad painter'. Life classes varied seasonally, running from 7 to 9 pm in the winter, but from 6 to 8 am in the summer. Additionally, Cézanne painted in the countryside, as was encouraged in academic training, though largely as an exercise in disciplining students in sketching.

The surviving studies by Cézanne from these years, although generally competent, are dry, laboured and unexceptional works, showing constraint and difficulties in articulating and animating the body. Nevertheless, after two years at the École, he achieved second prize in the annual rounds of competition for a life-size oil study of a head after a live model. This seems to have emboldened him, and the following year he was talking of going to Paris, where any ambitious aspiring artist would need to go to continue his studies. He was spurred on by Zola, whose letters sought to lure him to the capital with seductive tales of bohemian Parisian life. Knowing his friend's romantic tastes in literature, Zola teased him with images of artistic success and artists' models of easy virtue:

Here the models are consumable, even if they are not all that fresh. You draw them by day and make love to them by night . . . they are certainly most accommodating, especially in the hours of darkness. The fig leaf is unknown in the studio; undressing

there is totally liberated. The love of art veils any over-excitement at all the nudity. Come, and you'll see.[26]

However, the surviving correspondence between Zola and Cézanne over this critical period, despite containing many gaps, indicates Zola's frustration at his friend's caution and uncertainty about his future. Though much of Cézanne's correspondence with him takes the form of fanciful poems on familiar themes of their youth – love, illusion, reverie and so forth – they also convey Cézanne's equivocations about the future and his fears that his ambitions were deluded.

Beneath the shallow surface of his ebullient verses, Cézanne's self-doubt about his abilities as a painter shines through. Ironically, it was this quality of his sensibility, his immense capacity for doubt, that, as Merleau-Ponty argued, would be the foundation on which his legacy as an artist rested, but for the moment it threatened its very beginnings.[27] Zola, who knew better than anyone how to manipulate his friend, alternately encouraged, reassured or goaded him, often using Cézanne's own words to chide him.

You sent me some verses that breathe a sombre sorrow. The speed of life, the brevity of youth, and death, there on the horizon: that would be enough to make us tremble if we thought about it. But isn't it an even more sombre picture if in the course of swift life, youth, the springtime of life is entirely missing, if at twenty we had not experienced happiness . . .

Another phrase in your letter pained me. It's this: 'the painting I like, although I am unable to bring it off, etc. etc.' You! Unable to bring it off: I think you are wrong about yourself. As I've told you before: in the artist there are two men, the poet and the worker. One is born a poet and one becomes a worker. And you who have the spark, who possess something that can be

acquired, you complain; when to bring it off you have only to move your fingers, to become a worker.[28]

Making matters worse, in February 1860 Cézanne received news that his number had been picked in the lottery for those eligible for the draft for military service. In July his father purchased an exemption, as was the custom among the wealthier classes. But a second obstacle soon confronted his plans. Though Louis-Auguste was beginning to come round to his son's ambitions to further his artistic studies in Paris, he sought confirmation from Gilbert about his son's plans. Gilbert did not approve, arguing that Cézanne was not ready to leave the École. Nevertheless, despite his caution, Louis-Auguste, worn down by his son's persistence, eventually agreed to fund an open-ended stay in Paris on a monthly allowance of 125 francs a month. In October Baille communicated to Zola that Cézanne would be in Paris by the following March. But Cézanne continued to prevaricate. In a letter once again beckoning him to Paris, Zola writes reassuring Cézanne and provides him with a future itinerary of how he would spend his time if and when he came to the city:

> You pose an odd question. Of course one can work here, as anywhere, given willpower. Moreover, Paris has something else, museums in which you can study from the masters from eleven till four. Here is how you can organize your time. From six to eleven you'll go to an atelier and paint from the live model; you'll have lunch, then from midday till four, you'll copy the masterpiece of your choice either in the Louvre or the Luxembourg. That will make nine hours of work; I think that's enough and that, with such a regime, it won't be long before you do something good. You see that leaves us all the evenings . . . Then on Sundays we will take off and go to some places around Paris; there are some charming spots, and, if we are so moved

you can knock off a little canvas of the trees under which we'll have lunched.[29]

In a letter to Baille, dated 22 April 1861, Zola wrote, 'I've seen Paul!!! I've seen Paul . . . do you understand the full melody of those three words? He came this morning, Sunday (21 April 1861), to call me several times on the stairs. I was half asleep. I opened the door trembling with joy and we embraced hard.'[30] Cézanne's years as an artist in Paris had commenced.

2

An Artist of *Tempérament*

Cézanne arrived in Paris accompanied by his father in the spring of 1861. He found lodgings at 39 rue d'Enfer in the 14th arrondissement and subsisted on a modest but manageable allowance from Louis-Auguste. His father expected him to further his artistic education by enrolling at the École des beaux-arts, the leading academic training school, but it seems Cézanne was unsuccessful on two attempts at the entry exam and quickly thereafter regarded formal training as stifling originality, a common complaint of the time among artists of all tendencies. By 1863 criticism of the rigid and formulaic instruction at the École des beaux-arts led to reforms, with the introduction of more informal training methods and the appointment of younger professors. By then Cézanne had other plans. 'Professors are all bastards, eunuchs and assholes; they have no guts whatsoever!' he later told his dealer Ambroise Vollard.[1] Shortly after arriving in Paris, he had enrolled at the Académie Suisse on the quai des Orfèvres, one of the increasing number of free cooperatives that catered to the burgeoning numbers of artists making careers in Paris. Its founder, Charles Suisse, had been a model for Jacques-Louis David and Antoine-Jean Gros, among others, and now rented a rundown studio to artists for a small monthly subscription. Life models were provided, but there were no conditions of entry or instruction. More a forum than an *école*, the atelier attracted artists from all schools and all levels and encouraged lively discussion among its *habitués*. What

Photograph of Paul
Cézanne, *c.* 1861.

education there was came from the collective interaction of students
and artists learning from each other and debating the merits
of different artistic approaches. Cézanne spent his mornings
there from 6 until 11 am, often lunching with Zola and drawing
in the afternoons with Joseph Villevieille, a one-time pupil of the
Aixois landscape painter François Marius Granet and the nearest
Cézanne came to having a drawing master in Paris, or studying
at the Louvre and the Museé Luxembourg. It was at Suisse's studio
that he first made the acquaintance of many of the artists who
would become influential figures for him. Eugène Delacroix, Jean-
Baptiste Corot, Gustave Courbet and Édouard Manet, among others,
had frequented the atelier, and it was here also that he met, for
example, Claude Monet, Armand Guillaumin, Antoine Guillemet,

Francisco Oller, Achille Empéraire and Camille Pissarro. Cézanne's first letters home give the impression that he was struggling to come to terms with the eclectic collision of styles at the salon; he mentions Meissonier and Doré as chief among the artists who impressed him, but the artists and discussions he encountered at the Académie Suisse quickly set him on a quite different path.

But Cézanne failed to settle in Paris, overwhelmed and alienated by this harsh new environment, so different from the provincial Aix in which he had grown up. His strong Provençal accent and ebullient personality set him apart even in the bohemian atmosphere of the Académie Suisse, where he earned the sobriquet *L'Écorché* (The Flayed Man). He began to withdraw. Soon Zola was complaining that he hardly saw Cézanne anymore.[2] Continuing doubts about his own talent and lack of progress gnawed away at his confidence. After only six weeks he was talking of returning home, and an aborted portrait of Zola, which preoccupied him throughout June (a commission designed to bring him back into the fold), triggered the first of a number of crises. Work on the portrait had commenced in June and continued over the next month, but Cézanne was never content with its progress. Eventually he began again, and then requested a final sitting. When Zola turned up he found his friend packing his suitcase.

> Then he said quietly to me, 'I leave tomorrow'. 'And your portrait?' I said. 'Your portrait,' he answered, 'I have just crushed it. I worked at it again this morning, and as it became worse and worse, I annihilated it. I'm going.'[3]

After five months Cézanne returned home dejected. A short stint as a clerk in his father's bank, however, led to an immediate volte-face. He enrolled in evening classes at the Aix Académie, where he resumed his friendship with Numa Coste, Joseph Huot and Solari, and steeled himself for returning to Paris. By November

the following year he was back living at the rue des Feuillantines, near the Panthéon in the 5th arrondissement, where he remained for two years. He resumed his studies at the Académie Suisse and registered to copy at the Louvre as a student of the writer and critic Ernest Chesneau, an early supporter of Manet and an authority on Delacroix.

The absence of a recognized master to tutor him undoubtedly influenced the direction Cézanne's art took. Most artists would supplement their training in drawing at an *école* with enrolling in a master's studio, where they would receive instruction in painting. Instead Cézanne's art developed largely unaided and unfettered by the authority a master might have exerted over it. If he had a master at all, it was the example of Delacroix, the great French Romantic artist, whose painting remained influential on him throughout his life. Delacroix's death in 1863 saw his reputation grow ever stronger. That year Baudelaire published his *L'Oeuvre et la vie d'Eugène Delacroix* (The Life and Work of Eugène Delacroix), which decisively shaped the reception of the artist in the succeeding years. Late in life, Cézanne enthused about Baudelaire's account of Delacroix, but it is likely that he knew of it at first or second hand well before. In September of the same year Cézanne made a rare, faithful copy of Delacroix's *Dante et Virgile aux enfers* (Dante and Virgil in Hell, or The Barque of Dante, 1822), which he could see at the Musée Luxembourg. Already by the 1860s Cézanne had made preliminary drawings for an homage to Delacroix, and by 1878–80 he had painted a watercolour on which the eventual *Apotheosis of Delacroix* (*c.* 1890–94, which makes reference to Delacroix's *Lamentation*, 1843–4), was based.[4] The persistence of this picture over three decades testifies to the lasting influence Delacroix exerted on him and the difficulty Cézanne had in realizing it. Cézanne later told Gasquet: '[Delacroix] is one of the giants. He has no need to blush if that's what we call him, even in the same breath as Tintoretto and Rubens . . . His palette is still the most beautiful in France.'[5]

By comparison, Cézanne had little time for the 'bloodless' art of Delacroix's great rival Ingres, whom he later dismissed as 'only a very minor painter', and felt growing disillusionment and antagonism towards the contemporary artistic scene in Paris.[6]

As this indicates, Delacroix's significance for Cézanne lay in the link he provided between contemporary art and that of the old masters, particularly the art of Rubens, Spanish seventeenth-century painting and the Venetians, the foremost influences on him in the 1860s. Delacroix's painting was an art of *sensation*, colour and synthesis. In 1863 Ernest Chesneau wrote: 'The great artists do not have a specialism; all that is in nature and in the man is expressed by them.'[7] Delacroix was exemplary in this respect, working in all genres, as Cézanne would. But if Delacroix was an artist in whom the classical and modern co-existed, it was not by way of simply repeating the past. Delacroix had renewed the classical tradition in a form that fitted the disquiet and turbulence of his times, rather than the insipid and bland version of the classical offered by the beaux-arts. He had distilled from the canon a line of influence that incorporated the movement, robustness and force of Rubens, Cézanne's favourite painter, and the sensuousness, visual poetry and vibrant colour of the Venetian tradition. While others sought to be modern through their choices of contemporary subject-matter, Delacroix freely ranged across classical myth and contemporary literature without constraint and without reducing painting to illustration.

What Delacroix therefore made possible for Cézanne during these years was an art that could address the classical past, but in a form shot through with the sensibility of an artist of his times. For Baudelaire, the 'bizarre beauty' of Delacroix's work, and the conflicted emotions and contradictions that inhabited it, were what made it so modern. The ambiguity and contradictions of emotional tone, the violence and mystery of Delacroix's work and its charting of the complex emotional depths of the human mind

unrestricted by moral presupposition all left a lasting impression on Cézanne. These were enigmatic images that, while drawing on literary and poetic themes, defied simple translation into words and left the viewer lost in an emotional vortex of uncertain feelings. It was this thinking of the as-yet-unthought that Baudelaire saw as the hallmark of Delacroix's genius. *Dante et Virgile aux enfers* was all this incarnate, a textbook for the young painter. It was what made realizable the romantic fantasy, violence and eroticism of works like *L'Enlèvement* (The Abduction, 1867) and more besides. Delacroix was above all a paradigm of the painter who stamps his will and originality on his art and the public by force of *tempérament*.

This context of late Romanticism and the vocal critiques of French art as rule-bound and moribund, and thus requiring renewal, guided Cézanne's ideas about his art. The references he and others made to painting at this time stressed the need for the artist to reject academic formulae, which still implicitly conditioned much contemporary art, in favour of seeking a more personalized and individual approach

L'Enlèvement (The Abduction, 1867), oil on canvas.

based on the expression of feeling. The promotion of greater self-expression in painting turned on the need for the painter to emancipate himself from the accumulated knowledge and principles of the art of the past and to cultivate 'naiveté', to 'unlearn' or set aside preconceived rules and conventions and the habits of orthodox working practices in order to 'see afresh' and express his individuality.[8] 'Naiveté' signified the deconditioning and defamiliarization of inherited ways of seeing – the difficult labour of stripping away of working habits and preconceptions. Only through such wilful forgetting would the basis of human creativity be expressed in a spontaneous and unfettered fashion. These principles took shape most forcefully in the writings of Thoré, Stendhal, Baudelaire and later in Duranty and Zola, all writers Cézanne admired and was conversant with.[9] In his seminal essay 'Le Peintre de la vie moderne', Baudelaire wrote:

> Genius is no more than childhood recaptured at will, childhood now equipped with the mature physical means to express itself, and with an analytical mind that enables it to bring order into the sum of experience, involuntarily amassed.[10]

Baudelaire's essays on Delacroix had sought to understand the nature of his painting in similar terms and isolate the personal traits he regarded as expressing themselves in his technical handling and choice of subject.[11] Hippolyte Taine also associated artistic creativity with the regaining of the primitive, sensuous richness and vitality of the world of childhood before memory, prejudice and habit had tamed and habitualized the subject's perception of the world. In these terms, authentic art involved the reaching back to forms of unadulterated experience in early life in order to overcome the dulling of the senses that resulted from the imposition of instrumental, practical thought processes acquired through later socialization. Through this recovery of a

primordial relation to the world, art could express an imaginative openness to the world's complexity that was inevitably closed off in adulthood. Hippolyte Taine's collected lectures on art and aesthetics, *Philosophie de l'art* (Philosophy of Art, 1865), left an enduring impression on both Cézanne and Zola. Zola cited it as one of the most influential texts on him and even wrote to Taine asking if he would allow an artist friend, presumably Cézanne, to attend his much-acclaimed lectures at the École des beaux-arts. Taine introduced another associated term that Cézanne would customarily interchange with *tempérament*: *sensation originale*, which he argued was the basis of the authentic work of art and what revealed the moral character and artistic genius of the artist. The *sensation originale* communicated not only the artist's consciousness but his whole psychology and being.

> This *sensation*, so vital and personal, does not remain passive; the whole thinking and feeling machine receives it, reverberates with it . . . Under a powerful and primitive impulse, the mind works to reimagine and transform the object, sometimes illuminating and elevating it, sometimes twisting and distorting it.[12]

Taine's exposition of these principles in his *Voyage en Italie* (Voyage to Italy, 1866), probably deepened the growing admiration of Cézanne for the sensual colour, carnality and enigmatic subjects of Venetian artists such as Titian and Tintoretto. Taine's belief that creative temperaments tend to magnify and distort their *sensations* through inner necessity may well have influenced the bold, idiosyncratic style that Cézanne adopted.[13]

These concerns with *sincérité*, *naïveté* and *tempérament* were not restricted to a particular group of painters, nor were the meanings of what was understood by the term *tempérament* univocal. For the idealist Baudelaire, *tempérament* was primarily bound up

with the imaginative faculties and will, but Stendhal, Taine and Zola provided a more physiological and empirical basis for its understanding. For them, *tempérament* was more closely associated with qualities such as race, milieu, historical moment and physical constitution, to factors that operated below the threshold of consciousness. The classically educated Cézanne was aware that the conception of *tempérament* stretched back to ancient Greek philosophy and physiology, where it was associated with particular human types and conditions. Stendhal's two-volume history of painting in Italy (1817) had developed a six-class typology of *tempérament* to reveal the moral character of the illustrious artists of the Italian tradition. It was a much-loved text for Cézanne, though it is unclear how familiar he was with it during his early years in Paris; he told Zola he read it 'badly' in 1869 but may have encountered some of its ideas at first or second hand much earlier. Regardless, the notion that *tempérament* and race were determining characteristics of an artist's work had become commonplace by the 1860s.

Despite differences of conception, the idea of *tempérament* as the basis of artistic authenticity marked a new emphasis on the role of subjectivity that became integral to judgements of artistic merit. Stendhal had argued that 'Every painter must see nature in his own way', while Alfred Johannot asserted that all that was valuable and unique in an artist's work was determined by his *tempérament* and each subject the artist chose gained interest in terms of what it reflected about his personality.[14] According to this viewpoint, the subject-matter of an artist was, as Delacroix put it, the artist himself: 'You search for a subject? Everything is your subject, the subject is you yourself, your impressions, your emotions before nature.'[15] Zola also made *tempérament* the focus of his artistic criticism: 'A work of art is a corner of creation viewed through *tempérament*.'[16] He even went so far as to state his distaste for the term 'art' and his rejection of it in favour of a study of the expression of the artist's personality.

I wish that one should be alive, that one should create with originality . . . with one's own eyes and *tempérament*. What I seek above all in a picture is a man, not a picture. A work of art is never other than a combination of a man, the variable element, and nature, the fixed element . . . Make something true [to nature] and I applaud. But above all make it individual and living and I applaud more strongly.[17]

For Zola, it was originality that made the work live, and what lay at the heart of originality was the mode of expression of the artist's unique *tempérament*. The publication of his collected Salon reviews in 1866, *Mon Salon*, was dedicated to Cézanne. If Zola's criticism did not entirely reflect the views of his friend, it was certainly heavily influenced by them.

Cézanne conceived of his art in just such personal terms and believed that the hallmark of artistic authenticity and fundamental source of creativity was the painter's will expressed through strength of *sensation*. Despite crucial changes in style, subject-matter and working practices, he continuously emphasized his aim of finding his own personal way of seeing and painting. In a letter to Charles Camoin in 1903 he wrote: 'Only primordial strength, that is *tempérament*, can bring someone to the goal he is driven to attain.'[18] To Émile Bernard, he stated:

We must not . . . be satisfied with retaining the beautiful formulas of our illustrious predecessors. Let us go forth to study beautiful nature, let us try to free our minds from them, let us strive to express ourselves according to our personal *tempérament*. Time and reflection . . . modify little by little our vision, and at last comprehension comes to us.[19]

By the end of Cézanne's life this conception of artistic *tempérament* was by no means conceived as static or given, as the last part of the

quotation confirms, but rather as something gradually revealing itself over time, in and through the dialogues with other artists and nature that occurred through the act of painting. The intuitive and dialectical relationship between painting and nature in the late works reveal this searching enquiry in all its manifold and multifold complexity. But during the 1860s Cézanne's conception of artistic *tempérament* was simpler, more vulgarly deterministic and more incendiary. Cézanne made a distinction between painting like his own that was *bien cuillarde* and that of other painters *qui n'était pas cuillarde.*[20] The word *cuillarde* derives from the word *couilles*, meaning testicles or, more accurately, 'balls'. Describing the style of his painting in the mid-1860s as *cuillarde* encapsulates the masculinized inflections that terms like *tempérament* and *sensation* carried for him and his peers. The idea that contemporary French art lacked strong virile qualities of design went hand in hand with the view that the art of the period had become fettered and emasculated by inherited artistic conventions.

This *cuillarde* manner, with its coarse, heavy impasto brushwork and liberal use of the palette knife, was clearly indebted to Courbet, whom Zola, in a rare brief reference to his friend in an article in *Le Voltaire*, isolated along with Delacroix as the two main influences on Cézanne. However, Cézanne also drew heavily on the rugged style associated with nineteenth-century Provençal artists such as Émile Loubon, Paul Guigou, Prosper Grésy, Marius Engalière, Honoré Daumier and Adolphe Monticelli, whose accent on bold handling and vibrant colour had fashioned a distinctively regional manner, something Zola did not approve of, encouraging his friend to purify his work of 'Provençalisms'.[21] Marseille, where Cézanne was to spend much of his time in the late 1860s and '70s, was the centre of a renaissance in Provençal painting, literature and music.[22] From 1845 Loubon, a leading figure in the new wave of Provençal landscape painters, was director of the École des beaux-arts and Musée Marseille. The following year he founded the Société

des amis des arts de Marseille, charged with improving the museum collection and launching a series of ambitious exhibitions intended to revive *méridional* painting. In 1861 Loubon organized a vast exhibition of Provençal art in Marseille that displayed over 1,263 paintings and eighty pieces of sculpture.[23]

Cézanne's style and iconography often made reference to works hanging in Provençal museums.[24] His attraction to Baroque and Rococo painting also affiliated his art to traditions long associated with Provence.[25] A flowering of Provençal culture had occurred in the seventeenth and eighteenth centuries that had given birth to a distinctive *École d'Aix*, whose leading artists, Louis Finson, Jean Daret and Pierre Puget, had looked to the masters of the Baroque for the foundations of their style. The last remained an especially important example for Cézanne throughout his career. In drawing on these traditions, Cézanne was identifying himself within a specific construction of the *méridional* cultural lineage, one that was seen both within and outside Provence as newly invigorated. His time in Paris appears to have deepened his regional self-consciousness, and his inner circle of friends during these years was predominantly made up of Provençal painters and writers.

Cézanne's art went hand in hand with the creation of an artistic persona as curious and excessive as the art he was to produce over this decade. To separate the two would be to misunderstand the way each depended on the other. But neither should one take this persona at face value. Cézanne's painting was to be deeply personalized during these years, though this is not to see the work as simply reflecting his life. Rather, the creation of an exuberant, wilful and larger-than-life persona was something that in many respects determined the life Cézanne led.[26] This hypertrophied self-image had a meaning in embodying the principles on which his art rested. Cézanne's painting, with its emphasis on will, *tempérament*, personal feeling and force of *sensation*, thus went hand in hand with the making of an artistic persona that gave form

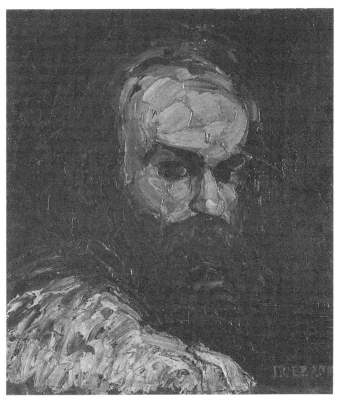

Self-portrait, 1866, oil on canvas.

and character to these attributes, one that set him apart from the fashionable Parisian *salonniers* and the bourgeois art of successful academic artists. But Cézanne's late Romanticism in the 1860s would paradoxically point to the limits of this tendency and its full absorption into the entrepreneurial capitalism of the art market.

We can see the formation of this artistic persona emerging in the many self-portraits he painted in the 1860s and '70s. In the earliest surviving of these, from 1861–2, Cézanne, in keeping with many of the painters in the artistic circles with which he was associated,

fashioned a suitable artistic persona for himself as a bohemian outsider. This portrait establishes many of the essential features of his self-imagery that he would rework over the succeeding years. His coarse appearance and the confrontation of the viewer with a hostile gaze rarely encountered before in the tradition of portraiture are features that would prevail in much of his self-portraiture until the mid-1870s, and serve to communicate a particular kind of artistic *tempérament*. These portraits are not without contradictions, for in them we see Cézanne dressing up and dressing down, searching out and testing the limits of his artistic identity.

When some of these early portraits were shown at the Salon d'Automne retrospective in 1907, they prompted the odious Max Nordau to remark,

> Cézanne has one thing in his favour which prepossesses us for him, i.e., his uprightness. It is his nature that ugliness has for him an attraction. He sees only what is abnormal, unpleasant, and repulsive in actual life . . . If he portrays a human being, the latter has a distorted face, apparently paralysed on one side, and a deeply depressed or stupid expression. Every model that submits himself to him is put in some sort of convict's dress . . . This man with the trouble-distorted countenance and the greasy felt hat and overcoat is perhaps a starveling from Bohemia, a broken-down creature, ruined artist or writer? Most certainly not. He is a well-to-do person of independent means . . . he does not treat himself any better than his other victims. He has painted portraits of himself which would be grossly libelous if another had painted them. In truth he is not vain, for he sees himself as he represents himself in these pictures.[27]

The insistent strangeness and ostentation of Cézanne's appearance was something much remarked on by those close to him. Renoir described him as looking 'like a porcupine' and was struck by the

contrast between his uncouth language, which carried more than an occasional hint of menace, and the exaggerated politeness of his manners, regardless of the class and status of the person he was addressing (his courtesy to domestic servants, which seemed to some commentators to border on deference, was noted, not without irritation, by several commentators).[28] Immense pride was combined with deep doubt ('my hair and beard are longer than my talent', he told Numa Coste) and a humility bordering on self-deprecation, passion with indifference, extravagance with timidity, overweening ambition with contempt for success. It was amid these stark contradictions that the elusive Cézanne dwelled.[29]

Mostly, however, it was his appearance that lingered in the memories of those who encountered him. Lucien Pissarro, the son of Camille, later remembered Cézanne calling on his father in the mornings when they painted together in Auvers wearing

A visored cap, with long black hair straggling down his back, yet bald in front. He had large black eyes that rolled in their sockets at the least excitement. He used to walk armed with a long pikestaff that frightened the peasants a little.[30]

In Aix, too, his long beard and eccentric dress were much remarked on. But it was for Paris that this artistic persona was created. It was here that the image of the artist as revolutionary, as bohemian and as provincial outsider had meaning. It was here too that the association of anarchic appearance and anarchic art became intelligible, where the artist of *tempérament* and unfettered individualism could be juxtaposed against the bourgeois institutionalization of art. In his notes for *Le Ventre de Paris* (The Belly of Paris, or The Fat and the Thin, 1873), Zola unmistakably drew on his somewhat inelegant and eccentric friend for his description of the artist Claude Lantier, later to be the protagonist of *L'Oeuvre*.

A slim young man, with big bones and a big head. His face was bearded, and he had a very delicate nose and narrow sparkling eyes. He wore on his head a rusty, battered, black felt hat, and was buttoned up in an immense overcoat, which had once been a soft chestnut hue, but which rain had now discoloured and streaked with long greenish stains. Somewhat bent, and quivering with a nervous restlessness which was doubtless habitual with him, he stood there in a pair of heavy laced shoes and the shortness of his trousers allowed a glimpse of his coarse blue hose.[31]

Elsewhere Zola described him as stooped, twitchy and prone to angry outbursts. In the 1860s he could often be seen dressed with a Provençal *taillole*, a red sash that he shows himself wearing in his *L'Eternal Féminin* (The Eternal Feminine, *c.* 1877), which suggests that the painting may be a reflection back on his work from the previous decade. Duranty recalled him entering La Nouvelle-Athènes, a café on the place Pigalle where Manet's circle regularly gathered in the 1870s, wearing 'a costume of olden times: blue dungarees, a white linen jacket covered with the marks of brushes and other implements, battered old hat'. Acknowledging the provocative associations that such bohemian style could evoke in the austere and repressive period of the post-Commune Third Republic, he added half-admiringly, half-mockingly, 'He had a certain success. But these are dangerous times.' The point of all this excess lay precisely in the way this image of otherness was a kind of improvised performance constructed ad hoc in opposition to the world of Paris in which Cézanne found himself.[32]

Cézanne's vocal and ostentatious individualism of course looked back all too readily to the recent example of Courbet, whose exaggerated provincialism and revolutionary politicization of his art had so upset the refined tastes of the Parisian bourgeoisie in the 1850s. Courbet cultivated an artistic persona that acquired a

mythical dimension. With his obstinate rustic patois, excessive narcissism, Assyrian beard, bluster, naivety, beery philosophy, air of revolt and determination to live 'the life of a savage', he cut a 'bizarre' but intoxicating figure – a 'monster become God', as Zola put it. Alexandre Dumas *fils* described him in his own inimitable fashion:

> From what fabulous crossing of a slug with a peacock, from what genital antitheses, from what fatty oozings can have generated this thing called M. Gustave Courbet? Under what gardener's cloche, with the help of what manure, as a result of what mixture of wine, beer, corrosive mucus and flatulent swellings can have grown this sonorous and hairy pumpkin, this aesthetic belly, this imbecilic and impotent incarnation of the Self? Wouldn't one say he was a fierce God, if God – Whom this non-being has wanted to destroy – were capable of playing pranks, and could have mixed Himself up with this?[33]

The mask Courbet wore was elaborate, one designed to provoke, but more than this, as T. J. Clark has written, to be a 'strategy of exposure to Paris, a kind of power over the city's confusion'.[34] It was what allowed Courbet to be where he needed to be, at the heart of the art world in Paris, but without becoming part of it. Courbet would be present but in a way that was different from his contemporaries: he would be its invader, a vulgarian outsider. The mask gave him 'access to everything only a bourgeois knew', the brasseries of Paris, the bohemian subculture of Paris with all its excessive self-regard and self-fashioning, but also its alternate stock of counterculture, the metropole's public and private life, its art world and so on, without seeming to be bourgeois.[35] It was this knowledge that Courbet so preyed upon which he put to work in his painting, creating pictures in the 1840s and '50s that continually disaffirmed the bourgeoisie's understanding of the provinces

and turned the painting of modern life into something far more incendiary than a glorification of the heroism of the bourgeoisie. It was the camouflage that enabled him not only to survive within that social and cultural milieu but to dominate, antagonize and instruct.

Like Courbet, Cézanne constructed a public persona as a marginal and belligerent outsider, though in his case one from Provence. The coarse and rugged style, bold imagery and sexually charged pictures had clear reference points in Courbet's own art. But the second time around, the shock value was diminished, and outside his little band of admirers and supporters the effect was more one of curiosity than of revolution. Cézanne's exaggerated provincial, bohemian otherness had all been seen before. In Courbet's case, the power of this persona and the artistic imagery it supported came from the ability of his pictures continually to jar the nerves of a public whose memories of revolt and social disorder were all too fresh from the revolution and failed republic of 1848, which had ended with the catastrophic coup d'état of Louis Napoléon III and the establishment of the Second Empire's repressive police state.

Courbet's paintings were instructive without being didactic. His imagery probed the fault lines of the ideology of the bourgeoisie by presenting it with images of the countryside that destabilized, negated and demythologized the vision of the world it needed to hold in place. His ability to do so rested on access to the general public through the Salon (as an established artist of undoubted ability and a Salon medal winner, he was guaranteed annual access, censorship aside) and on the support he received from a wealthy, radical bourgeois intelligentsia. By contrast, Cézanne was his own caricature, caught between notoriety, a celebrity of sorts, and failure. His self-publicizing could seem on occasion, even to close friends like Zola, as a kind of inverted commercialism – the seeking out of success at all costs, the artist as a collector's 'curiosity piece'. Lacking the social and political framework within which Courbet's art operated, Cézanne's transgressive painting and hypertrophied

individualism could seem merely an effect of entrepreneurial capitalism, his art collapsing into a phantasmagorical world where celebrity, fame and success eclipsed any deeper ideals, where transgression existed for its own sake and sensational pictures reflected mere gratuitous sensationalism. No wonder the recollections of those who knew him in the 1860s read as so many images drawn from the comedic novels of Daudet. No wonder too Duranty could only see the eccentricity, not what the eccentricity stood for.

Cézanne still lacked an audience for his art, beyond his immediate circle, and a means of obtaining one. Access to the Salon would prove elusive. He amassed an impressive thirteen consecutive rejections until in 1882, through a technicality, he was allowed to exhibit a portrait, most probably *Portrait of Louis-Auguste Cézanne, Father of the Artist, Reading L'Évenement* (1866). As a jury member that year, Guillemet had discretion to include a work of one of his 'pupils'. As far as we know, it was the first and last time Cézanne exhibited at the Salon. The picture went almost unnoticed, receiving its only mention from Théodore Véron, who described it as 'a beginner's work painted at great expense of colour'.[36] A similar fate had befallen the small still-life painting Cézanne exhibited at the Salon des Refusés in 1863, an event that Cézanne hoped would herald the end of the authority of the academic Salon jury, a hope not realized as the Salon was not to be repeated, despite artists petitioning for its return. Cézanne was among those who wrote to Count Nieuwerkerke, Director General of Museums in the Second Empire, in the succeeding years for its restoration. In his second letter to Nieuwerkerke, he wrote, 'I cannot accept the illegitimate verdict of colleagues who have no authority from me to assess my work.'[37] For Cézanne, the authority of the jury was a denial of his right to address the public. The Salon jury, despite its more inclusive composition, was in his view a repressive mechanism that fettered artists' liberty and individuality. He concluded by

reinforcing this point: 'I have no wish to have anything to do with those gentlemen of the jury, any more than they appear to wish to have anything to do with me.'[38] These unanswered words aptly described the agonistic pattern of what followed.

If unsuccessful in submitting works to the Salon, Cézanne's antics on the days set aside for jurying were nevertheless much commented on. In 1865, the year that appears to mark his first submission, he wrote to Pissarro that he was taking his canvases to the 'shack on the Champs Elysées', as he called the Palais de l'industrie (the Salon's annual venue), where he confidently expected to turn 'the Institute red with rage and despair'.[39] Contriving always to turn in his works on the final day in the final hours before the deadline and sometimes delivering them there there in a wheelbarrow, Cézanne made the spectacle of rejection his annual moment of triumph, albeit a pyrrhic one. Each year he could be seen 'carrying his works to the Salon like Jesus Christ carrying his cross', as Jean Prouvaire remarked.[40] When asked by Manet what he intended to send to the Salon of 1866, Cézanne replied, 'a crock of shit'.[41] He encouraged his colleagues to do likewise. The portrait of Antony Valabrègue (the Aixois poet and critic who was one of Cézanne's inner circle) submitted that year, an ambitious picture standing a metre (3 ft) tall, would certainly have astonished the jury. Nothing could have been further from the conventional portraits of the Salon, with their smooth surfaces and subtle psychological insights of character. Valabrègue's portrait, with its mottled and heavy impasto surface – what the sitter described as great masonries of paint laid on thickly with a palette knife – and its outré tonality (all vermilions and ochres) borders on the sculptural. Cézanne brought a representational style derived from popular illustration – the great caricatures of Daumier and Gavarni that he lovingly collected – into a high art setting. Valabrègue remarked of his portrait, 'I am coloured so strongly that I am reminded of the statue of the Curé of Champfleury when it was coated in blackberries.'[42]

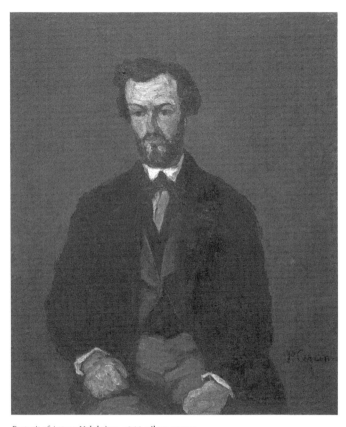

Portrait of Antony Valabrègue, 1866, oil on canvas.

This was 'painting with a pistol', as one academic juror was alleged to have said on seeing it.[43] Despite Daubigny's intervention on his behalf and a public demonstration outside the Palais de l'industrie organized by his followers, Cézanne's painting failed to meet with the jury's approval.

His submissions the following year, *Le Grog au vin* (The Wine Grog) and *Ivresse* (Drunkenness), took the scandalous subjects of sex and intoxication as their subject-matter. Sexual desire,

drunkenness and brawling were themes that would recur in his painting of the period and although such subjects were easily accommodated within representations of classical myth and history painting, the transgression of Cézanne's pictures lay in their coarse treatment and presentation in contemporary settings. Cézanne often revelled in painting subjects that were normally off limits to public exhibition pictures. As Robert Simon has remarked, they drew on the *genre noir* of French culture, with its tales of the grotesque, the catastrophic and the plain bizarre, its imagery often depicting acts of brutality, depravity, decapitation and rape.[44] These were subjects normally restricted to illustrations in sensationalizing *canards* – lowbrow journals, bulletins and pamphlet sheets targeted at the semi-literate working classes. Cézanne's indebtedness to this imagery is evident in violent works like *Le Meurtre* (The Murder, *c.* 1870) and *La Femme Étranglée* (The Strangled Woman, *c.* 1875–6), in which he depicted acts of brutal murder set in a wasteland and in a bourgeois apartment, respectively. Conspicuously absent was the moral framing and causal narrative that contained and made acceptable the representation of such disquieting imagery and gave intelligible meaning to the actions depicted. Instead Cézanne's imagery gratuitously revelled in the spectacle of violence.

These works have too readily been regarded as reflections of Cézanne's angst in his new surroundings, his 'turbulent' state of mind, excessive drinking (Roux cryptically alluded to as much in a letter to Zola) or misogyny.[45] The social–sexual divisions of bohemian culture certainly fostered such chauvinism, yet these pictures were surely intended as responses to Baudelaire's call for a painting of *le drame terrible et mélancolique* (terrible and melancholy drama).[46] They reveal Cézanne's ambition to use lowbrow imagery to tackle subjects that articulated the anxieties and repressions of modern urban bourgeois life. Such imagery and means could seem the only appropriate ones to express the turbulent times they lived in and have clear parallels in the literary

works of Romantic poets and realist novelists. Baudelaire and Zola also drew on the conventions of low literary forms in order to depict comparable acts of lurid violence with a similar explicitness and apparent disregard for conventional moral protocols.

Cézanne's unsuccessful submissions, if not his works, became a cause célèbre. Among critics he became one of the most famous artists as yet unseen by the public in the Second Empire, so much so that when he finally showed paintings at the first Impressionist exhibition of 1874, Jean Prouvaire only half-jokingly described him as an artist 'no jury even in their wildest dreams had ever considered exhibiting'.[47] Antoine-Fortuné Marion wrote to Cézanne's friend Heinrich Morstatt that Cézanne was 'already too notorious and associated with too many revolutionary ideas in art for the jury to have the slightest hesitation in rejecting him'. He went on to state Cézanne's determination to hold his nerve and send unacceptable works to the Salon.[48] This notoriety drew the attention of Théodore Duret, one of the earliest historians of Impressionism, who wrote to Zola requesting an introduction. Zola refused, arguing that Cézanne was still finding himself. But his rebuttal indicated his fear that his friend was in danger of becoming a mere curiosity ('this year's reject', as Duret had put it), whose reputation as a 'complete eccentric' overshadowed rather than illuminated his work.[49] An article by Arnold Mortier in *Le Figaro* in April 1867 had already satirized the bizarre paintings of 'M. Sesame'. Some years later, through Pissarro, Duret eventually got his introduction to the artist he described as a painter of 'five-legged sheep'.

Perhaps the most abiding image we have of Cézanne from these years comes not from the artist's self-imagery but a *portrait-charge* by Henri-Charles Stock, dated 20 May 1870, of the painter on his annual procession to submit his works to the Salon jury. The judgement of the Salon that year was, as always, rejection. The Stock caricature portrays the artist as a 'vertical invader', an unkempt Provençal outsider, heavy-lidded, rambunctious,

Henri-Charles Stock, 'Caricature of Cézanne with two paintings rejected at the Salon of 1870', *Le Salon*, 1870.

ill-attired and sporting an unruly beard, his large looming head covered by an absurdly phallic felt hat. Advancing messianically, he stamps on the newspaper on the ground before him. In his claw-like hands he holds a mahlstick and palette and carries his portrait of Achille Empéraire (1868–70), which is held up like some holy relic, and a now-lost nude closely related to Manet's *Olympia*.[50]

Stock's portrait emphasizes the personal nature of the artist's work by suggesting a series of close formal echoes between his portrait of Cézanne, the mad visionary, and Cézanne's paintings. The angular curves of the nude are picked up in the painter's hat and physiognomy, and the resemblance between his portrait of Achille and Cézanne himself reinforces the analogy, while a large, horizontal nude hangs like an ornament from the gypsy earring he wears on his left ear. The *portrait-charge* was accompanied by a short text and interview in which Cézanne set out the terms of his artistic mission.

Lumen lucet – the light shines – Courbet, Manet, Monet, and all you painters with a palette knife, brush, broom and other tools, you are *dépassé*! I have the honour to present to you your new master: M. Cézannes [sic].

– Cézannes [sic] is from Aix-en-Provence, He is a realist painter and, moreover . . . an earnest one. Listen to him telling me in his pronounced southern accent:

– Yes, my dear M. Stock, I paint as I see, as I feel, – and I have very strong sensations. The others, too, feel and see as I do, but they don't dare . . . they produce Salon paintings . . . I, myself, I dare, M. Stock, I dare . . . I have the courage of my opinions . . . and he laughs best who laughs last.[51]

Cézanne was evidently delighted, sending a copy of it and the accompanying interview to friends and family.[52]

The Stock text provides a clear indication of how Cézanne sought to frame his work in the form of a critical engagement with what he saw as the conformity, impersonality and lack of originality of contemporary art in France. But it also provides us with two important reference points that had come to the fore in the paintings he submitted to the Salon that year. The Empéraire portrait, rendered in a boldly baroque style with strong chiaroscuro reminiscent of his friend's style of painting, depicts his fellow Aixois painter and increasingly close friend over this decade, whose bold Venetian-inspired palette Cézanne emulated. Ten years his senior, Cézanne evidently regarded him as a painter of *tempérament* with a strongly Romantic sensibility, an artist who had successfully kept alive the traditions of Provençal painting. Nina Athanassogolou-Kallmyer has shown that in his conception of the picture, the artist drew on Ingres' depiction of *Napoléon sur le trône impérial* (Napoleon on the Imperial Throne, 1806), and the painting may be conceived as a double portrait, an overt depiction of Empéraire and a veiled one of Napoléon III, punning on the

homophone of Empéraire and Emperor.[53] Above Empéraire's head a stencilled inscription solemnly declares, 'Achille Emperaire, Peintre'. Cézanne's references to the conventions of official court portraiture, which the state had recently revived, suggests an intention to satirize the Imperial regime, while at the same time vaunting a painter he much admired. This was not without precedent. Courbet had included a secret portrait of Napoléon III in his *L'Atelier du peintre* (The Painter's Studio, 1855), shown in 1867 at his one-man show. This may have encouraged Cézanne to do likewise. Moreover, if the work was intended to be in part a satire of *le petit Napoléon*, as Victor Hugo called him, this may explain why the artist drew attention to those aspects of the sitter that indicated his disability and deformity such as his overlarge head and underdeveloped legs and body. But alternatively it may reflect the fact that Empéraire was widely regarded as a tragic figure whose art and personality triumphed over adversity. It is, however, the other painting in the Stock caricature that illuminates most clearly the struggle for artistic identity that characterized this period of Cézanne's art.

If we want to understand the formation of Cézanne's art in the 1860s, we need to examine how it emerged through a sustained critical dialogue, not only with the standard artistic fare at the Salon, but with the artists whose work seemed closest to him. Cézanne had said as much in the Stock interview. Towards the end of the decade, it was above all the person and art of Édouard Manet that became the focus of this critical dialogue. During the late 1860s Cézanne began producing a series of paintings closely related to works Manet exhibited at the start of the decade. These included variations on Manet's *Le Déjeuner sur l'herbe* (Luncheon on the Grass, 1863), the cause célèbre of the Salon des Refusés, and a group of works on the theme of Olympia, which Manet had shown to much notoriety at the Salon of 1865. The importance of this dialogue is indicated by his exhibition of one of these pictures,

Une Moderne Olympia, *c*. 1872–4, oil on canvas.

Une Moderne Olympia (A Modern Olympia, 1872–4), at the first Impressionist exhibition of 1874, Cézanne's first opportunity to exhibit to the public since the Salon des Refusés.

It has generally been assumed that *Une Moderne Olympia* was intended as an homage, though if so it is unlike any other of the many tributes to Manet made by painters in his circle; the picture's tone seems humorous, mocking even. Nor is this consistent with the account Paul Gachet, the son of one of Cézanne's few patrons, gave of its inception. Gachet said it was painted in 1872 after an animated discussion about Manet in which Cézanne had expressed strong criticism of him.[54] Rapidly painted and almost transparent in parts, the painting looks like something quickly assembled for the purposes of concluding an argument. However, recollections may date the picture to earlier than it was actually painted. On

stylistic grounds it was probably painted in 1874, closer to the first Impressionist exhibition where it was exhibited as an esquisse, and possibly made specifically for that show. Manet, regarded by many of the exhibitors as a paradigm of modern painting, had declined the invitation to exhibit with the Impressionists, dissuaded by Fantin-Latour's disparaging view of the enterprise. *Une Moderne Olympia* may have been intended both to point to and to stand in for that absence. Regardless, the dialogue with Manet was already well underway. Cézanne had completed a closely related variation on the subject of Olympia around 1869–70 and begun his many variations on *Le Déjeuner sur l'herbe*. Over the next decade he returned to Olympia in a further series of paintings, mostly watercolours. Other ambitious works executed towards the end of the 1870s, such as *L'Eternal Féminin*, offer more reflections on the subject. Manet's two seminal paintings therefore remained at the forefront of his work for over a decade.

It was Manet's one-man exhibition held during the Exposition Universelle in 1867, where *Le Déjeuner sur l'herbe* and *Olympia* were exhibited, that kindled Cézanne's belated reply. Zola's revised article on Manet, published that year in the *Revue du xixe siècle*, makes plain that *Olympia* retained much of its notoriety as a painting that had redefined the modern nude and that it remained a key picture for those associated with Impressionism.[55] It was this 'chef-d'oeuvre', as Zola described it, that constituted 'The most characteristic example of his talent, his greatest achievement'.[56] Strategically deflecting attention from the controversy surrounding Manet's problematic depiction of prostitution, Zola accentuated the way in which the style of *Olympia* had come to be seen as an equal if not more important characteristic for his admirers. Much of the article was devoted to isolating what Zola saw as the essential attributes of Manet's manner and how these features of the visual organization of the painting expressed the artist's *tempérament*. Zola specifically emphasized Manet's Parisianism, his penchant

for the quiet pleasures of the modern bourgeoisie and secret delight in the 'perfumed and glittering refinement of soirées'.[57] These qualities were manifest, he argued, in the way the whole picture was organized, the visual intelligence that was evident in its formal composition. The delicate relationship of translucent tones, exquisite lines and harsh gracefulness of his style were characteristics that reflected the underlying psychology of the painter. Charm, luminous clarity and elegance were *l'élément inconscient* (the unconscious element) that revealed the artist's essence.[58] Tellingly, he went on to dissociate Manet from the influence of Baudelaire's Romanticism, to which he had an antipathy, arguing that the painter's 'analytic disposition' and the objectifying qualities of his painting were devoid of the poet's mystical reveries and visionary instincts. These were terms that drew clear comparison with Zola's own artistic aims.[59]

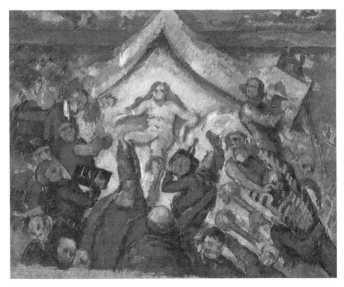

L'Eternel Féminin (The Eternal Feminine), *c*. 1876–8, oil on canvas.

In gratitude, Manet painted a large and ambitious portrait of Zola, exhibited at the Salon the following year. In a picture frame in the background he put a print of his *Olympia* and on the desk a copy of Zola's defence of him. As critics remarked, Manet's portrait reflected more about the artist's approach to painting than about Zola's personality, despite the many defining attributes with which Manet surrounded his sitter. In this respect, it perfectly reflected what Zola had written about modern painting: the modern artwork would be interesting less for what it showed than the way it revealed how the artist's vision was organized and consequently the artist's mentality. Zola's defence of the artist and the portrait Manet responded with served to forge a closer relationship between the writer and the painter, each of whom profited from association with the other. Fantin-Latour later included Zola among Manet's followers in his *Un Atelier aux Batignolles* (A Studio at Les Batignolles, 1870), which showed Manet surrounded by his 'disciples', as one critic remarked.

The emphasis in Zola's essay on *tempérament* as the defining characteristic of human creativity and what set each painter apart from his contemporaries was of course entirely consistent with Cézanne's own views about painting, but the closeness between Zola and Manet was unwelcome. Zola was beginning to enjoy a success that Cézanne had yet to experience, and the changes in his friend's circumstances and the new company he kept did not go down well. Zola's article effectively implied that Manet had achieved what Cezanne had only aspired to. The relative silence, beyond a few passing references, in response to Cézanne's work in Zola's criticism must have irked him, and, as Gachet's comments suggest, Cézanne clearly felt deep reservations about Manet and his work. Cézanne met Manet in 1866 after the latter had praised the 'forceful handling' of some of his pictures that hung in Guillemet's atelier and invited both painters to his studio.[60] The meeting, though cordial, was awkward. Manet, the wealthy, fashionable Parisian dandy, was

everything Cézanne was not. Cézanne was no doubt daunted by the formidable presence of the painter before him and the evident differences between them. He later referred to Manet as too *bon grand* and lacking the *tempérament* of the truly great painters. His tones, he told Vollard, were 'splotched', and he unfavourably compared the cool objectivity of *Le Déjeuner sur l'herbe* with the vivid colour and sensuality of its Venetian source, Giorgione's *The Pastoral Concert* (*c.* 1509). In subsequent meetings between them, Cézanne seemed at pains to antagonize Manet. Reminiscences of his coarse and insulting behaviour at the Café Guerbois, where Manet's circle gathered, the bellicose nature of his contributions to their discussions and his abrupt departures became the stuff of legend. These were the ways in which Cézanne took his place within this milieu while nevertheless asserting his distance.[61] Monet recalled Cézanne's memorable entrance one evening at the Café Guerbois:

> [Cézanne] threw a suspicious glance at the assembled company. Then opening his jacket with a movement of the hips worthy of a zinc-worker he hitched up his pants, and ostentatiously readjusted the red sash around his waist. After that he shook hands all round.

But when it came to Manet's turn, Cézanne removed his hat, smiled broadly and stated 'I won't offer you my hand Monsieur Manet, I haven't washed for a week.'[62] Cézanne complained to Guillemet of the studious bourgeois refinements of Manet and his set, their sophisticated wit and repartee. 'Parisian wit bores me stiff,' he remarked, despite his own renowned fondness for guileful wordplay, and dismissed Manet's circle tersely as a lot of 'bastards . . . decked out like lawyers'.[63]

By far the most straightforward of Cézanne's paintings after *Olympia* is the now-lost nude featured in the caricature by Stock.

This image of a naked woman with her angular and pronounced belly and buttocks, so similar to popular illustrations of lower-class prostitutional imagery, was commonly referred to by Guillemet as 'the wife of the sewerage collector'.[64] The painting's conception suggests Cézanne was initially interested in the way in which Manet had demystified the portrayal of the courtesan by combining imagery associated with high-class prostitution with conventions affiliated with lower-class prostitution.[65] But as further variations emerged, the dialogue with Manet became far more complex and ambivalent. The resulting works acknowledge the role he had played in developing compositional strategies that were to be central to Cézanne's painting in the 1870s, yet take issue with particular features of Manet's work, freely reworking the terms of their source material by subjecting the painting to a series of displacements, substitutions, erasures and inversions.

Technically, Cézanne's *Une Moderne Olympia* is very freely and robustly rendered; a greater breadth and amplitude is evident in comparison with its source, as if this restaging was now re-contextualized in a theatrical setting, with changes also apparent in the vibrant colour and style of drawing. The most interesting alteration though is the introduction into the picture of what in Manet's painting is only an implied presence, the client or painter/ beholder. This crucial change – of inserting the artist's presence into the picture – defuses the sexually charged relationship between painting and viewer in the original; instead of the viewer implicated in the fantasy, the viewer spectates the artist's fantasy. In what is recognizably a self-portrait, the role of the client is taken by the artist himself. Cézanne features as the protagonist in a number of closely related works around this period, including many of his variations on *Le Déjeuner sur l'herbe*, as in *Une Pastorale* (1870), where he is shown in reverie on the bankside flanked by two imaginary Rubenesque nudes. In *Une Moderne Olympia*, Cézanne depicts himself as a dandy, as if adopting the position of the beholder of

Manet's *Olympia* required exchanging his usual bohemian manner of dress for the black frock coat and grey trousers favoured by fashionable Parisian haute-bourgeoisie like Manet and his circle.

In its changes, *Une Moderne Olympia* has something of the character of a re-presentation of the original *mise-en-scène*, the painter assuming the identity of Manet, half tongue-in-cheek, perhaps; Cézanne's narcissistic appropriation of the position of Manet drawing attention to and substituting himself for the latter's implied presence. The inclusion of the painter or beholder amounts to a belated completion of the picture, a restitution of sorts, making the meaning of the absence of the implied viewer, client or artist in Manet's picture visible. But in so doing, Cézanne estranges his version from its source, not only through the alteration of the relation of the viewer to the prostitute's body, but in transforming the cool, impersonal and objectifying qualities of Manet's painting into something more fervid, fantastical and bizarre. *Une Moderne Olympia* is at once more equivocal and dreamlike than its source, a visionary painting that seems to teeter on the cusp of comical absurdity, as if pushing the pictorial rhetoric of Manet's picture to its limits. Suggestive visual puns abound – the client's erect cane, the vessel on the table and the figure's top hat – all of which draw attention to their combination of hollow ellipse and phallic shape, the latter casting a phallic shadow across the couch where the client or artist sits.

These characteristics of the painting were not lost on its original viewers at the Impressionist exhibition of 1874. Most critics compared *Une Moderne Olympia* unfavourably with its source, regarding it as an example of the worst excesses of Impressionism. Louis Leroy sardonically remarked that Manet's *Olympia* was a masterpiece of drawing, accuracy and finish in comparison to Cézanne's.[66] Jules-Antoine Castagnary had it in mind when he characterized Impressionism as a tendency in contemporary painting toward solipsism:

From idealization to idealization, they will end up with a degree of romanticism that knows no bounds, where nature is merely a pretext for dreams, and where the imagination becomes unable to formulate anything other than personal, subjective fantasies, without trace of general reason, because they are without control and without the possibility of verification in reality.[67]

For others, the painting was more perplexing. Cardon wrote: 'One questions whether there is in this an immoral mystification of the public or it is the result of a psychological alienation that one cannot but deplore.'[68] But it was Marie de Montifaud who provided the most interesting commentary on the picture:

Sunday's public decided to laugh at this fantastic figure presented in an opium-filled sky to an opium smoker. The apparition of a little rose-coloured, naked flesh that is thrust upon him, in the cloudy empyrean, a kind of demon, who presents herself as an incubus, like a voluptuous vision, this corner of artificial paradise has overwhelmed the bravest, it must be said, and M. Cézanne appears to be nothing other than a kind of fool, painting while agitated with delirium tremens. People have refused to see, in this creation inspired by Baudelaire, an impression caused by oriental vapours that had to be rendered under the bizarre sketch of the imagination. The incoherence of it, does it not have the quality, the particular character of laudatory sleep? Why look for an indecent joke, a scandalous motif in Olympia? In reality it is only one of the extravagant forms of hashish borrowed from the swarm of droll visions that should still be hidden away in the hôtel Pimodan.[69]

Montifaud's characterization of the painting as a kind of hallucinatory reverie is perceptive. In many of Cézanne's letters to Zola, images of female desire are evoked as apparitions that dissolve

into misty clouds of smoke. In one, he imagines a girl named Justine appearing to him as a vaporous entity.

> *Mon vieux*, your cigars are excellent, I'm smoking one as I write; they taste of caramel and barley. Ah! But look there she is, it's her, how she glides and sways, yes that's my little one, how she laughs at me, she floats on the clouds of smoke, look, look, she goes up, she comes down, she frolics, she rolls, but she laughs at me . . . Cruel one, you enjoy making me suffer . . . but then she disappears, she goes up and up and up forever, finally she is gone. The cigar falls from my lips, straightaway I go to sleep . . . I shall think of her no more, or else glimpse her only on the horizon of the past, as a shadow in a dream.[70]

In another letter written in verse, he imagines his *lorette* appearing to him in the hazy form of an ephemeral reverie:

> Have you never seen in daydreams
> As if through a fog some graceful forms,
> Indistinct beauties whose ardent charms,
> Dreamed of by night, disappear by day;
> As in the morning one sees a vaporous mist
> When the rising sun lights with a thousand fires
> The verdant hillsides where forests rustle . . .
> This is how ravishing creatures with angelic voices
> Sometimes appear before my eyes . . .
> They seem to smile at me and I hold out my hand to them.
> Yet as I approach they suddenly fly away,
> They ascend into the sky borne on the breeze . . .
> They're gone, already the transparent veil
> No longer paints the ravishing shapes of their bodies.
> My dream vanished, Reality returns . . .[71]

The white bed on which Cézanne's *Olympia* is unrobed before him similarly suggests less an actual bed than a hazy, cloudlike form, an external projection of the artist's imagination or reverie of erotic desire. The cloudy form simultaneously functions as a signifer of an object of desire that is always held out of reach, but, perhaps too as a metaphor of its *jouissance*. Many other instances of this trope recur in Cézanne's correspondence. But Montifaud's characterization of the painting as infused with *vapeurs orientales*, her references to Baudelaire's study of opium and hashish *Les Paradis artificiels* (Artificial Paradises, 1860), take us beyond Cézanne's reveries and the immediate source of Manet to one of the primary sources of *Olympia*, which reworks Titian's canonical *Venus of Urbino* (1538) through the Poe-inspired musings of Baudelaire's poetry.

There is little doubt that Baudelaire was much on Cézanne's mind during this period. Baudelaire had been at the forefront not only of discussions of Delacroix, but of the heated discussions of Wagner arising from the debacle of *Tannhäuser*'s performance in Paris in 1861, which galvanized and divided the Parisian artistic community. Baudelaire's poetry became deeply connected with the 'degraded' sensual imagination of Wagner's modernism. Cézanne's enthusiasm for both the poet and the composer was well known and the basis of his friendship with the German musician Heinrich Morstatt, to whom he wrote in 1865 of his admiration for the composer's 'noble tones'.[72] Along with Zola, he had joined the Wagner society in Marseille, and attended performances of the overtures of *Tännhauser*, *Lohengrin* and *Der fliegende Holländer*.[73] A number of paintings prior to and following *Une Moderne Olympia* have references to subject-matter, themes and staging effects associated with Wagner's operas. The gloomy setting of the enigmatic *Baigneuses* (1870) may well allude to the staging of Venus's underground grotto as recorded in published descriptions of the Paris performance. More explicitly *Une Pastorale*, beyond its immediate references to

Manet, is closely related to Fantin-Latour's *Tännhauser: Venusberg,*
shown at the Salon of 1864. In their correspondence, Marion and
Guillemet also mention Cézanne's lost *Ouverture de Tannhäuser*
(1869), an ambitious picture of which there may have been several
versions (inexplicably, Cézanne's *Jeune fille au piano* of 1868 has long
been mistaken for one of them).[74]

The novelty of Wagner's music made his work a touchstone
for artists who felt that contemporary academic painting had
domesticated the art and myth of the antique, and the composer
became the focus of redefinitions of art in more individualized
terms. What was known of Wagner's ideas on art encouraged such
parallels. His belief, for instance, that a 'natural' *force vitale* could
only be harmed by discipline and education allowed him to be
associated with the emphasis on the expression of *tempérament*
among French artists. In his influential article on the composer,
Baudelaire remarked:

> What appears to me to characterize above all, and in an
> unforgettable way, the music of Wagner is nervous intensity,
> violence in passion and in will-power. The music expresses now
> in the suavest, now in the most strident tones all that lies deeply
> hidden in the heart of man . . . by the passionate energy of his
> expression he is in our day the most genuine representative of
> modern man. And all the technical knowledge, all the efforts,
> all the compositional strategies of this fertile mind are in truth
> no more than the very humble, the very zealous servants
> of this irresistible passion . . . Whatever subject he handles
> . . . everything that is implied by the words 'will', 'desire',
> 'concentration', 'nervous intensity', 'explosion', is perceptible
> through his works.[75]

Baudelaire, whose article was at once a defence of Wagner and
a call to other artists to join in realizing his destiny, went on to add:

In matters of art, I confess I am not opposed to excess: moderation has never appeared to me the hallmark of a vigorous artistic nature. I like those excesses of robust health, those overflowerings of will-power, which stamp themselves on a work like burning lava in the crater of a volcano, and which, in ordinary life, often accompany the phase, so full of exquisite delight, that comes after a great moral or physical crisis.[76]

The terms of this description provide a framework for conceptualizing key aspects of Cézanne's oeuvre in this period, terms malleable enough to be applied to the various artistic and literary figures he most admired: Delacroix, Rubens, Victor Hugo and not least Baudelaire himself were all figures that could be associated with these objectives. This might also explain the theatricality of *Une Moderne Olympia*, which substitutes a stage set complete with curtain and elaborate backdrop setting for the intimacy of Manet's boudoir. The various revisions to the original painting, the alternative range of quotations and reference points brought to the work, the distinctively coarse and vibrant handling, bolder colour and more declarative brushwork were in accordance with using Manet's painting for the purposes of demonstrating a personalized aesthetic that emphasized the unconstrained emotion of the artist as opposed to the 'dispassionate neutrality' or 'objectifying' tendency Zola associated with Manet. The graceful elegance he had characterized as a marker of the latter's 'Parisianism' is replaced by the rugged style derived from the *École provençale*, whereas the modernity referred to in the title conforms to Baudelaire's association in his essay on Wagner of *l'énergie passionnée* with *la nature moderne*.[77]

Cézanne's dialogue with Manet's *Olympia* both acknowledges Manet's importance for modern painters, including himself, and contests the terms of this key work of the modern tradition. Manet's influence is mediated and his painting transformed through the

terms that had informed Cézanne's own mode of painting of the
time (Delacroix and Rubens; Courbet and the *École provençale*).
Allusions to Delacroix are particularly prevalent in many of
Cézanne's most ambitious works of this period, including the
variations on *Le Déjeuner sur l'herbe* and *Olympia*. The self-portrait
featured in *Une Pastorale* is taken from the figure of Sardanapalus in
Delacroix's *La Morte de Sardanapale* (The Death of Sardanapalus,
1827). The composition of *Une Moderne Olympia*, with its figure
positioned at the apex of the steeply inclined bed, is also taken
directly from Delacroix's picture (the diagonal orientation of the
bed is reversed from right to left), and the figure of Sardanapalus
himself informs the conception of the artist or beholder in the
foreground. More generally, Cézanne's dialogue with Manet
belonged to a particular contestation over the imagined future of
modern art that pitted Baudelaire's Wagnerian modernism against
Manet's cool objectivism.

The title itself suggests renewal. As early as 1866, painters in his
circle saw him as attempting to rival and supersede Manet, a rivalry
that seems initially to have acquired a personal enmity, though he
later described to Zola Manet's untimely death at the end of April
1883 as a 'tragedy'.[78] In a letter to Oller, Guillemet, who worked
closely with Cézanne during this time, wrote:

> Courbet is becoming classical. He has painted splendid
> things, but next to Manet he is traditional and Manet next
> to Cézanne will become so in turn . . . let's trust only ourselves,
> build with loaded brushes, and dance on the belly of the terrified
> bourgeoisie.[79]

He added that the audaciousness of Cézanne's painting made
Manet look like Ingres. Are we to see *Une Moderne Olympia* as less an
homage than a painting that sought to assert the younger painter's
presence at the expense of his precursor? Inevitably here one must

turn to one of the most important accounts of influence, Harold Bloom's theory of poetry, *The Anxiety of Influence*. Though published in 1973, it remains a controversial and much misunderstood reference point in conceptualizing the affiliations and generative relations between past and present works. Often misrepresented as a defence of the traditional concept of the author, Bloom's account replaces the positivist concern with source-hunting based on the mimetic relation of two works with an antithetical concept of influence as discontinuity and rivalry between a poet and his precursors. In doing so, Bloom offers a critique of authorial sovereignty.

For Bloom, the affiliation of the young poet with his antecedents is characterized by a struggle of origination, to have 'named something first' that has been 'always already named'.[80] Bloom's agonistic account of influence is couched broadly in Freudian and Nietzschean terms, and parallels the Oedipal drama in which the paternal figure of the precursor poet represents, whether consciously or unconsciously, a threat that must somehow be overcome in order for the poet's own desire for artistic incarnation to be realized. The poet's will to power, his desire for poetic identity, can only be learnt by 'recognizing, however unconsciously, the power of another poet'.[81] The poetic 'will' is essentially 'that already possessed language of precursor poets'.[82] Put another way, the poet must repress the recognition of his own belatedness and with it the awareness that his 'unconscious is largely made up of the language of other prior poets'.[83] Locked into a filial rivalry, the younger poet seeks to disarm this recognition through a series of revisions, displacements and misprisions of a precursor's work, which is necessary to allow a space of imagined originality to emerge. These misprisions or strategies of misreading of the precursor work, which Bloom terms revisionary ratios or relational events, amount to a fluid series of interrelated methods of reducing, displacing, amplifying and countering the potentially repressive force and 'guilt of indebtedness' associated with the precursor work.

The series of variations on Manet's work both acknowledge and question the authority of his painting. The obsessive restaging of *Olympia* does seem to have something of a primal scene about it, the picture has an ambience of guilty looking: Cézanne is pictured looking away, not at, the body of *Olympia*. In doing so, was he also refusing to be the captive of Manet's painting? Seeing the picture in this way reveals perhaps what was at stake in this ambivalent and prolonged dialogue with Manet, as well as going some way to explain the many alterations and displacements Cézanne makes to the original in these variations. These revisions contest the artistic language and mode of address of its precursor source. But they are also a dialogue in which a certain self-formation is produced. Through this dialogue in painting with Manet, Cézanne constituted and affirmed his own artistic identity. Looked at in this way, we can make sense of how Cézanne came to usurp the implied position of Manet as the painting's original beholder, and in what the modernity of his modern *Olympia* resided.

3

Pissarro, Landscape and Impressionism

The 1870s are typically regarded as a watershed moment for Cézanne in which his 'mature' style first emerged. Working closely with Pissarro in Pontoise and Auvers, the argument goes, Cézanne mastered his *tempérament*, abandoned the *cuillarde* style and hallucinatory visions of his narrative paintings and embraced a more patient, submissive way of working before nature that saw landscape painting become the focus of his art.[1] This period certainly marked a moment of reassessment. Cézanne had begun to doubt what he had achieved in the previous decade and to question what kinds of experiences art could make manifest and how painting might express such contents of experience; questions that were to have protracted and far-reaching consequences for his painting. The artistic persona he had constructed had become a fetter to his progress, inhibiting the expansion of his art. Consequently, we witness important changes in his working methods, artistic preoccupations and choice of motifs. This decade would see him increasingly drawn to more tangible natural motifs, immersing himself in the act of painting directly from nature. But his artistic evolution followed a far less uniform and linear development than this suggests. Figure painting remained integral to his most ambitious work, and there is much that links his early nudes and late bathers. If landscape painting took on greater importance for him, it was neither new to him nor did it entirely supplant the artistic preoccupations of the previous

decade. Submission to nature was counterpoised with assertion of will; new directions would be haunted by the ambitions of the past. Never entirely confident of the realization of his aims in painting, Cézanne continually looked forward and back in thinking through the direction of his art.

Already in 1866 Cézanne had planned large landscape pictures painted *en plein air* to exhibit at the Salon and wrote to Zola declaring his intention to work only out of doors.

> You know all the paintings done indoors, in the studio, will never be as good as the things done outdoors. In showing outdoors scenes, the contrasts between the figures and the ground are astonishing, and the landscape is magnificent. I see some superb things, and I must resolve to paint only outdoors. I've already told you about a canvas I'm going to try, it will show Marion and Valabrègue leaving for the motif (a landscape of course). The Sketch that Guillemet thought was good, that I did from nature, puts all the rest in the shade. I do think that all the old master paintings showing things out of doors were simply done with style (chic), because that kind of painting doesn't seem to me to have the look of truth and above all of originality offered by nature.[2]

These remarks already anticipate the role landscape would later play in Cézanne's painting and reveal how closely he associated qualities he felt existed in nature with the guiding principles of his art. During the 1860s and early '70s, as he continued to move back and forth between Paris and Aix, he explored the possibilities of landscape painting in a series of northern and southern settings. But because Cézanne destroyed many early works after the sale of the family estate in 1899, it is unclear precisely what role landscape painting had played in the 1860s. The pictures that

survive show his familiarity with the Mediterranean motifs of Provençal painters, especially François-Marius Granet, and the more informal landscapes of the Barbizon painters of the forest of Fontainebleau, particularly Daubigny, Corot and Courbet. His painting in this decade varied sharply in effect, expression and working practices. Some pictures exhibited the visionary and dreamlike effects present in his 'narrative' paintings while others corresponded to the new *plein airisme* of the Barbizon painters.

What is clear is that by the early 1870s *plein air* landscape painting had become increasingly important for him and began to influence his work across all genres. His circumstances at the time influenced this. At the outbreak of the Franco–Prussian War in 1870, Cézanne went into hiding in the south, first to Aix and Marseille and then to the cottage rented by his Mother in L'Estaque, in order to avoid conscription into the French army. The following January he was declared a draft dodger. The Franco–Prussian War resulted in the dispersal of the group of artists and writers he had established around him during the previous decade. Temporarily detached from the Parisian art scene and no longer with the Louvre at his disposal, Cézanne adopted a more direct method of working directly from nature, producing a series of pictures overlooking the expansive bay of the port of L'Estaque. Most of Cézanne's letters from the first years of this decade are lost, and it is clear from Zola's correspondence with Paul Alexis that news of him was difficult to come by. In July 1871 Zola acknowledged his first letter from his friend in many months and recounted his experiences of the war.

I was very glad to get your letter, as I was beginning to worry about you. It's now four months since we heard from one another. Around the middle of last month I wrote to you in L'Estaque, then I found out you'd left and that my letter might have gone astray. I was having great difficulty finding you . . . You ask for my news. Here is my story in a few words . . . I got

to Paris on 14 March. Four days later, on the 18th the insurrection broke out, postal services were suspended . . . for two months I lived in the furnace: cannon fire day and night, and towards the end shells flying over my head in the garden. Finally on 10 May, I was threatened with arrest as a hostage; with the help of a Prussian passport I fled and went to Bonnières [northwest of Paris] to spend the worst days there. Today I'm living quietly in Batignoles, as though waking from a bad dream.[3]

Cézanne had by then temporarily resurfaced at the Jas de Bouffan, but his instinct was also to go back to Paris, where Zola had now resettled, and in the aftermath of the bloody suppression of the Commune he returned there for a short time, initially staying with Solari in his house on the rue de Chevreuse before finding modest accommodation for himself, Hortense and his soon-to-be-born son on the rue Jussieu, the incessantly noisy old wine port of the Halle aux Vins quarter.

The Paris Cézanne returned to vividly bore witness to the conflagrations of the previous two years, its landscape visibly scarred by the prolonged Prussian siege on the capital. During the early years of the Third Republic it was a very different city from that of the previous decade. The political and cultural climate reflected this. 'A new Paris is in the process of being born . . . it's our reign that's coming!', Cézanne recalled Zola telling him.[4] Flushed by a sudden upturn in his career, Zola had, as Cézanne quickly realized, completely misjudged the situation. In the aftermath of the bloody suppression of the Communard insurrection, the new political administration would be far more repressive than the final years of Louis-Napoléon's Empire. These years would see an acceleration of the consumerism, entrepreneurial capitalism and destruction of the older quarters of Paris begun under the latter. The Parisian art scene Cézanne had left behind had disintegrated and the one

replacing it would be characterized initially by far greater sobriety and state interventionism.

Following France's swift and humiliating defeat at the hands of Prussians and the deep divisions left by the suppression of the Commune, the Republic's early years saw a *rappel à l'ordre* (call to order) in all areas of political, social and cultural life.[5] In these years landscape painting acquired a new critical and redemptive dimension that may well have attracted Cézanne. During the Second Empire landscape painting had gained some official support and patronage. Daubigny was appointed to the jury of the fine arts section of the Exposition Universelle of 1867. But despite its increasing popularity, the fortunes of landscape painting fluctuated.[6] In a political climate of renewed austerity, arts policy of the early years of the Third Republic fostered a return to traditional values in painting, focused on an ill-fated revival of history painting.[7] Though in time landscape painting would gradually be annexed to new patriotic notions of nationhood, it initially fell into official disfavour. 'Pure' landscape painting, long advocated by critics on the liberal side of the political spectrum as a freer, more democratic form of painting, was attacked by some conservative critics, who regarded its attraction for contemporary painters as instrumental in the decline of classical painting and the historical subject-matter they regarded as expressions of the 'true' French tradition. They regarded the revival of history painting as a way to regenerate patriotism and foster national reintegration in the aftermath of the divisive events of the war.[8]

It is only in the context where the experiences and values associated with landscape painting could be affiliated with an alternative way of life than that associated with the modernity of the contemporary metropolis that we can understand what drew Cézanne and Pissarro into such a close and productive friendship in the 1870s. This collaboration was to be as profound as it was enduring for both painters. They had met some years before the

war at the Académie Suisse in the early 1860s, introduced by the Puerto Rican painter Francisco Oller, who for a short time acted as Cézanne's mentor. Oller was to show at the first Impressionist exhibition, and it is likely that it was through him that Pissarro and Cézanne were introduced to Frédéric Bazille and consequently to many other artists associated with Impressionism. Recalling his initial meeting with Cézanne, Pissarro wrote: 'How far sighted I was in 1861 when I went with Oller to see this curious artist at the Académie Suisse where Cézanne was doing some figure studies ridiculed by all those impotents.'[9]

Pissarro forged a connection with Cézanne that few had managed outside the close-knit circle of Provençal artists and writers with which Cézanne surrounded himself. The war's dispersal of Cézanne's little band no doubt had a hand in drawing the two men together. Though each artist was by nature obdurate, self-willed and recalcitrant, their coming together saw them put aside their individualism in order to develop their art in dialogue with each other, each responding to the other's ideas and painting. For Cézanne, Pissarro represented a shining example of an independent painter. Pissarro was well read, eloquent, theoretically minded, worldly, non-conformist and, as Cézanne inaccurately believed, self-taught. He was a militant artist who in his painting and lifestyle set himself apart from the world of academic art, Salon commercialism and bourgeois taste. Their friendship was consolidated by similar tastes in literature – each admired the writings of Baudelaire, Verlaine and Flaubert – but above all by what Cézanne admired in and intuitively understood he could learn from Pissarro's painting. But what Pissarro's painting looked like at the time is not entirely clear. Much of what Pissarro had produced in the first years of the 1870s had been destroyed or lost as a result of the war, leaving us with only the evidence of the works produced shortly before and after.

Lucien Pissarro recalled Cézanne and his father animatedly discussing theory together, though their artistic dialogue was

conducted as much in paint as it was in words and much of what each learned from the other was never discussed between them; in some respects the strongest impact each would have on the other would not manifest itself for many years to come, as the evidence of the pictures and the statements they made about each other testifies, for each artist was to find himself returning to questions the other's art had posed for him much later on. The most theoretically minded of the Impressionists, Pissarro was to be a strong guiding influence on Cézanne's choice of motifs and approach to painting them. Later, around 1903, Cézanne told the archaeologist Jules Borély, 'Pissarro was like a father to me . . . a man to go to for advice, and something like *le bon Dieu*.'[10] Gasquet recalled Cézanne saying: 'Pissarro had an enormous influence on me . . . all of us come out of Pissarro . . . He was the first Impressionist.'[11] And Louis Le Bail recalled him stating that 'had Pissarro continued to paint as he had in 1870 he would have been the strongest of us all.'[12] Other than Monet, no other contemporary artist was held by Cézanne in such esteem. Their closeness was reflected in the fact that half of the 21 Cézanne paintings Pissarro owned were gifts from the artist; the others in his collection, which included many drawings he had purchased, reflected his admiration of a talent few at the time recognized.

What bound them together was not only the affinity they felt towards each other, but a shared understanding about the relationship that art might have to the wider social and political nexus. Both saw themselves as outsiders estranged from a world of industrialized progress. They also shared a belief in the oppositional nature of their painting to the forms of life commonly associated with the metropolitan bourgeoisie.[13] For Pissarro, nature was accorded a moral value and annexed to the construction of a set of value systems that were differentiated from those associated with city life and capitalist economic and social relations. The modern city was associated with new exhilarating experiences, but also with

atomization, impersonality and rootlessness. By contrast, the countryside was typically represented as a harmonious, purifying and restorative realm in which mankind and nature still lived in an unalienated and intelligible relation to each other. Rural nature was thus conceived as having its own distinctive forms of experience, social relations and temporality through which the painter could achieve a sense of 'centred subjectivity'.[14]

Of course, in many respects, the very notion of nature that Pissarro and Cézanne were committed to was rooted in the class views of the metropolitan bourgeoisie and its nostalgia for an imagined way of life that it had, in some ways, invented. But for Pissarro, the commitment to this alternative way of life gave focus to his art and drew his painting into a productive dialogue with radical leftist politics. Pissarro's commitment to anarchism was a serious one. His letters express his views on the 'capitalist nightmare', his belief in the necessity of revolutionary action and his reflections on the writings of Prud'hon and Kropotkin. His aim of harmonizing his painting and politics is also vividly present in his correspondence. Although he rejected the idea that painting should illustrate his political beliefs, it is clear that for Pissarro the freedom art might afford the artist could be a demonstration of an unalienated form of labour to set against the conditions of capitalist social and economic relations. Both landscape painting and the adoption of a way of painting that differentiated itself from that associated with classical painting and the increasing commercialism evident at the Salon were integral to his attempt to establish a parallel relationship between his art and revolutionary politics. Technique and working methods would be the cornerstone of this: 'Build, paint thick and dance on the belly of the horrified bourgeoisie', Guillemet recorded him saying.[15] But for a brief interlude in the 1880s, when – faced with the increasing public success of Monet and Renoir and the commercial adulteration of Impressionism – he turned to the *pointilisme* of

Neo-Impressionism (a self-consciously styled avant-garde grouping that included anarchist sympathizers) Pissarro continued to regard Impressionism as consistent with the anti-authoritarian, anti-mystical and liberationist social philosophy to which he was committed. For Pissarro, Impressionism's 'all-over technique' and abandonment of traditional skills and pictorial hierarchies, combined with its choice of subjects from the common realm of experience, were qualities consistent with this philosophy, whose origins looked back to the writings of Jean-Jacques Rousseau. It is in this framework that we can best understand Pissarro's concepts of harmony and unity, terms common enough in aesthetic theories of the time, but grounded for Pissarro not simply in compositional terms, but in nature itself.

For Pissarro an immanent unity and harmony existed within the natural order, which could be set against the cultural alienation, accretions and distorted social relations of modernity. 'The big problem to solve', he wrote, 'is to bring everything . . . into an integral whole, that is to say harmony.'[16] It was through immersing his art in this conception of nature that Pissarro imagined a new art was possible, one that was freed from the burden of the art of the past and offered a metaphorical parallel with the conditions of social freedom. Finding ways to achieve harmony in his art could thus have wider social implications for Pissarro, implying an existence that could be set against that under capitalism. To put this another way, the unity that Pissarro was seeking was the overcoming of the divisions between art and life. Cognizant of this, Cézanne would later remark that the study of nature 'modifies our vision to such an extent that the humble and colossal Pissarro finds his anarchist theories substantiated'.[17]

Pissarro's influence on Cézanne is clear in the statements he subsequently made about seeking to realize 'a harmony parallel to nature', an aspiration that makes itself increasingly felt in his painting as the decade progresses but whose elusiveness seems so

often behind his many complaints about his failure of realization. Cézanne restlessly explored various modes of handling and composition that might achieve such pictorial unity, though rarely with much certainty. His earliest works from their collaboration still show the loose and rapidly worked handling of the previous decade. However, despite the technical variations present in Cézanne's art throughout the 1870s and early '80s, one sees him gradually slowing his way of working and adopting a more attentive and workmanlike approach to painting. It is perhaps here that Pissarro's influence was most marked and enduring. 'It was only . . . when I met Pissarro, who was indefatigable, that I got a taste for work', he later told Émile Bernard.[18]

This new taste for work was matched by a new image of himself as a worker, an image that stood in opposition to the idea of the artist fostered by the Academy. In contrast to the varied personas evident in Cézanne's self-portraiture of the previous decade, the image of the artist as a worker prevails in the portraits each artist made of the other. In his pictures of Pissarro, Cézanne emphasized the forceful presence of the artist, in a way previously confined to his own self-portraits. It is as though the painter's own identity was intersubjectively merged with that of the elder artist. When Pissarro painted his portrait of Cézanne, he accentuated the coarse rustic characteristics of his appearance, much as Cézanne's self-portraits of the time do. Though most of their self-portraits and portraits of each other are simple, direct and set against plain backdrops, the inclusion of details in their backgrounds defines a field of values, communicating public and private meanings that resonate in relation to the person portrayed. In the most interesting portrait Pissarro made of Cézanne, he posed him against a backdrop that included Pissarro's own painting *Route de Gisors* (1873), a caricature by André Gill of the former Republican president Adolphe Thiers and another by Léonce Petit of Courbet posed with a glass of beer and proletarian clay pipe in his mouth. Pissarro humorously

Camille Pissarro, *Portrait of Cézanne*, 1874, oil on canvas.

adjusted Courbet's pose from the original to suggest he was toasting Cézanne.[19] These images indicate shared lines of aesthetic and ideological affiliation that Pissarro understood to exist between the artists. The Impressionist painting and the image of Courbet signalled an allegiance to an empirical approach to painting nature, while the juxtaposition of Courbet and Thiers, as Theodore Reff has suggested, alluded not so much to the political situation of

1874 – Thiers was no longer president and Courbet was in exile in Switzerland – as to their roles in the Commune. Pissarro kept his portrait of Cézanne in his studio for the rest of his life.

Letters from Cézanne to Pissarro among others at this period confirm his sympathies toward the left and his interest in the author and journalist Jules Vallès and the poet and novelist Jean Richepin, both ardent Communards. In a letter to Zola dated 23 June 1879, Cézanne referred to Jules Vallès' semi-autobiographical novel of the Commune *Jacques Vingtras* as 'magnificent', while Richepin's terse and blunt language and depiction of the rootless and nomadic margins of society must have struck a chord.[20] In a letter to Coste in July 1868, he also expressed his sympathies for Henri Rochefort, the Republican politician forced into exile after being condemned by a military trial to life imprisonment for his vocal sympathy with the Communards.[21] In a volte-face, Rochefort would later become a reactionary Boulangist and author of a vicious polemic about Cézanne entitled *L'Amour du laid* (The Love of Ugliness).[22] A letter to Pissarro dated 2 July 1876, after mentioning reading the left-wing journal *La Lanterne de Marseille*, goes on to state his hopes of seeing Dufaure, notorious for his murderous treatment of the Communards, dismissed from the Senate.[23] Though in later life Cézanne distanced himself from such radical views (by the 1890s Cézanne had exchanged radical newspapers like *La Lanterne de Marseille* and *Le Hanneton* for Catholic conservative newspapers such as *La Croix* and *Le Pèlerin*, if Vollard is to be believed), there is no reason to see these references as insincere or loosely held, or to discount the way such oppositional politics fed into his thoughts on painting.

During the 1870s the two artists painted regularly together in Pontoise and Auvers-sur-Oise. Cézanne moved there in the summer of 1872 to be closer to Pissarro and his family, who had uprooted to Pontoise, northwest of Paris, after the Franco–Prussian War. Cézanne was to remain there for the next two years. He daily walked the

Paul Cézanne, *Vue de Louveciennes* (View of Louveciennes), 1872.

3 kilometres (2 miles) between his house and Pissarro's in order to paint with him nearby and spent a great deal of time at the Pissarro family home. Over the next decade, the two artists would continue to work together periodically, sometimes for a matter of weeks, occasionally for far longer. Though it would be an exaggeration to say they painted side by side, they often worked on particular motifs that allowed them to compare their results, sometimes setting up their easels a few feet from each other. There are groups of works on motifs in the rue de la Citadelle, Maison des Mathurins, Jardin de Maubuisson and finally in the hills of Le Chou, which provide telling evidence of the way each responded to the other's particular treatment of their motif. One of the first things Cézanne did on arrival was to make a copy of Pissarro's *Louveciennes* (1871).

Many years later, Lucien Pissarro recalled that from time to time Cézanne would simply watch Pissarro working away. *Une*

Peintre au travail (A Painter at Work, *c.* 1874), a rare depiction by Cézanne of an artist painting in nature, probably commemorates the expeditions they made into the forests in the vicinity in search of the dense, natural motifs they favoured. The painting conveys the painter's solitary immersion in nature that was integral to their art. Not that they were always alone. Photographs from this time show that they were occasionally joined by other painters, among them Dr Gaschet, Edmond Béliard and Armand Guillaumin, a painter Cézanne much admired though relatively little is known of their friendship.[24]

Cézanne's letters to Pissarro testify to the importance of this collaboration with him. Even when they no longer painted together, it is clear that their discussions about painting and the experience

Photograph of Cézanne (centre) and Camille Pissarro (at right) in the region of Auvers, *c.* 1874.

of working together in Auvers guided Cézanne's thinking. Despite the very different lighting, climatic conditions and terrain of the bay and surrounding countryside in Provence at L'Estaque and Aix, he continued to apply the principles the two artists had developed when painting in Auvers. In a letter dated 2 July 1876, he wrote to Pissarro of his progress painting there.

I must tell you that your letter surprised me in L'Estaque, by the sea. I haven't been in Aix for a month. I've started two little motifs of the sea, for Monsieur Chocquet . . . It's like a playing card. Red roofs against the blue sea. If the weather turns favourable perhaps I'll be able to finish them off. So far I've accomplished nothing. But there are *motifs* that would need three or four months' work, which could be done as the vegetation doesn't change here. There are the olive trees and the pines that always keep their leaves. The sun is so fierce that objects seem to be silhouetted, not only in black or white, but in blue, red, brown, violet. I may be wrong, but this seems the very opposite of modelling. How happy the gentle landscapists of Auvers would be here . . . one must do landscapes two metres at least, like that one of yours that was sold to Fore [*sic*: Jean-Baptiste Faure].[25]

In the same letter, Cézanne wrote to Pissarro urging him to come south, though he never did. During the following decade, for reasons that are unclear, the relationship with Pissarro became more remote. By then Cézanne was firmly based in Provence and began to lose touch with many of his former friends. Nevertheless, Cézanne continued to explore the principles he had learned with Pissarro and from time to time returned to key paintings by him that he particularly admired, especially those dating from the late 1860s. Was it possible that in order to develop further the implications of what he had learned from Pissarro, Cézanne needed

to distance himself from him? This is a question to which I will return. But despite the distance that now lay between them, both artists recollected their time together fondly, each feeling that he had benefited deeply – artistically and personally – from their association. Despite the virulent anti-Semitism stirred up by the Dreyfus affair, which notoriously led Degas and Renoir to shun the Jewish Pissarro, Cézanne remained loyal to the memory of his friend, even though he too was caught up in the anti-Dreyfusard hysteria. When he exhibited at the Société des amis des arts in 1902, he chose to appear in the catalogue as a 'pupil of Pissarro', and this description was repeated at the posthumous exhibition of him in 1906 at the same venue.

Nine years Cézanne's senior, far more worldly, grounded and self-assured, Pissarro's art was already far more mature. He had initially exhibited as a pupil of the Danish though Paris-based artist Anton Melbye, under whom Pissarro worked briefly. But his approach to painting was primarily shaped by the plein-airism of Daubingy – who lived not far away – Millet, Courbet and Corot, of whom he sometimes exhibited as a follower. It was in encouraging a deepening of the engagement with these painters that the influence of Pissarro was most immediately visible on Cézanne. In contrast to the more dramatic and expansive vistas he chose in the south, Cézanne's motifs in the north focused on more prosaic and understated subjects that drew on but extended the motifs pioneered by them in the 1850s and '60s.[26] In particular, these painters had rejected the conventions of the classical *paysage composé*, and the alternative model represented by the Dutch tradition, in favour of painting fragments of nature, emphasizing the subjective response of the painter to the motif rather than the inherent qualities of the motif itself. Daubingy's choice of subjects and degree of attentiveness to questions of light and atmosphere challenged the boundaries of what traditionally constituted a legitimate landscape subject and the very conception of what

a motif was. This was to have a profound influence on contemporary landscape painting. These characteristics of Daubigny's painting, combined with his unorthodox techniques, led him to be characterized by Joseph-Louis Lagrange as the leader of the 'school of the *impression*' long before the term was associated with the artists with whom it subsequently came to be linked.[27]

These more informal types of landscape subject gained increasing legitimacy among contemporary painters, though they continued to draw criticism from conservative critics who saw the abandonment of poetic themes and historically redolent motifs as symptomatic of a decline of judgement, taste and traditional values in French painting.[28] The 'undiscerning' presentation of nature in the motifs of many contemporary painters led to the charge of having misrepresented the truth of nature and thus failed to grasp the point of landscape painting.[29] Critics understood that the empirical basis of such landscape painting implicitly critiqued

Georges Manzana-Pissarro, *The Impressionists' Picnic in 1881*, *c.* 1900, pen and ink on paper.

the idealist notions that structured the classical metaphysics of *la belle nature*. Disagreements about what constituted a fitting motif reflected differences about whether it was the motif's inherent qualities or the painter's treatment of his subject that should be the focus of the picture. In contrast to the classical notion of the 'well-chosen' motif, Pissarro and Cézanne preferred motifs that lacked any strongly suggestive point of reference while maintaining a sense of site specificity that resisted reducing the landscape to a particular mood or poetic evocation. Consistent with the Barbizon painters, their choice of viewpoints avoided hierarchical points of interest. The 'arbitrariness' of their motifs was combined with a painterly technique that gave to each component of the composition a relatively equal emphasis and even-handedness.

In Pontoise Cézanne and Pissarro mostly depicted discrete fragments of nature.[30] The choice of 'informal' compositional viewpoints was most apparent in the series of 'screen of trees' motifs (a line of trees arranged across the foreground plane) that they often favoured in the 1870s. Following Pissarro's lead, Cézanne began to employ such motifs as a visual counterpoint to his views of the town, selecting vantage points where the trees acted as a curtain 'filtering' perception by neutralizing identification of other reference points in the landscape. In this way, a premium was placed on the process of perception itself as a richly complex field of exploration rather than any associational content of the landscape; elements beyond the trees are often radically fragmented and occluded to the point of illegibility. The use of compositional cropping and novelty of angle and viewpoint evident in Pissarro's and Cézanne's work from these years further distinguishes it from the pictorial rhetoric of inherited academic models of landscape painting.

The preference for such motifs indicates their resourcefulness in presenting the painters with a varied series of compositional, spatial and perceptual questions that were crucial to achieving the

pictorial unity they sought.[31] In *L'Étang des soeurs, à Osny, prés de Pontoise* (*c.* 1875–7), the screen of trees interweaves foreground and background into unison. The viewer is drawn into the process of perceptual deliberation on the surface of the canvas, which is built up out of a series of separate touches of paint. While their painting was grounded in the notion of capturing effects found in nature, the collaboration between Pissarro and Cézanne was as much about the question of style, of how to paint, as it was about the motif itself. By choosing discreet motifs devoid of strongly associational content, the painters drew attention to their particular manner of painting. Here again Pissarro's influence on Cézanne is most immediately felt in the changes gradually visible in the latter's style. Pissarro encouraged Cézanne to work in a more flexible and responsive manner in relation to what he could observe before him. Cézanne's pictures over the next decade saw him temper the brusque qualities and impetuousness of his *cuillarde* style, which he had already begun to feel was too limiting, and develop a more deliberative and scrutinizing approach to painting.

Pissarro fostered an attitude to the motif that was decentred and unhierarchical, building up the image by working on all areas of the canvas simultaneously in order to capture the essence of the motif without becoming distracted by detail. He encouraged Cézanne to lighten his palette and work predominantly with primary colours, allowing optical fusion through colour modulation to take the place of conventional modelling. This avoided the problem of the dull and muddy effects of mixing modern mass-produced pigments, but also led to an approach to the motif that was less imitative and more expressive of the overall effect of an impression. Under Pissarro's influence, Cézanne abandoned as far as possible the role of line in defining contours and the use of chiaroscuro, instead giving form to his *sensations* of nature through the aggregation of small colour patches (seeing nature in 'stains of colour', as Pissarro put it). Drawing with the brush largely usurped the conventional

role of line drawing, which Pissarro argued was an abstraction and inappropriate to convey the unbounded flux of nature.[32] By depicting the landscape as a mass of colour and tone, Pissarro and Cézanne sought to bracket any conscious preconceptions in order to capture the mere retinal impression the eye naturally sees. The adoption of these techniques placed an onus on the overall effect and interrelatedness of the motif.

Empirical support for this approach could be found in the discourses of perceptual psychologists and the observations of other landscapists. Artists had long acknowledged that outdoor light and atmospheric conditions demanded only a very limited use of conventional chiaroscuro. Nevertheless, most painters chose to confine the use of colour contrasts to particular passages of their painting, with a view to maintaining aesthetic clarity of articulation of objects and spatial relations. As critics would later remark, Cézanne's abandonment of conventional perspective and elimination of the transitional tones that created an orderly passage from light to dark and from one hue or value to another resulted in spatial ambiguities and visual 'distortions', conflating foreground, middle ground and background. Cézanne's adoption of a far viewpoint from which to observe his motifs, combined with his commitment to rendering them as much as possible in terms of colour touches alone, meant that he removed from contiguous elements of the composition their 'figurative sense as spatially distinct objects'.[33] The resulting paintings presented an interplay between two-dimensional and three-dimensional spatial relations. Seen from afar, the picture yielded a representation, but from up close the picture surface dissolved into a field of colour relations and tactile brushwork, laying bare its painterly facture. Consequently, the viewer experiences not so much the presence of the motif as the artist's presence in giving form in paint to his *sensations* of the motif in a distinctively individualized manner of seeing and handling.

More generally, the Impressionist notion of *sensation* drew on contemporary scientific investigations into the psychology and physiology of vision. During the nineteenth century the psychological study of vision, perception and emotion shifted from the realm of metaphysics to that of the natural sciences. Empirical investigations by French positivist philosophers such as Taine, Comte and Littré abandoned classical models of vision and provided a materialist explanation for the nature of perception. The basis of their research was directed at redefining the relationship between perception and cognition.[34] Knowledge of the external world, they argued, was dependent upon *sensations*. As Richard Shiff has shown, the *impression* was understood as the point of intersection of subject–object relations. In one respect, as the *phénomène primitif*, the primordial fact or event of perception, it was regarded as something direct, primary and objective and equated with the immediate effect of an experience or the 'lively' and 'raw' sensory data.[35] Yet *sensations* or *impressions* were subjective in two key respects: first, because the *impression* was processed through the consciousness of a perceiving subject; second, because each subject had a unique psychological and physiological make-up, the *impression* of an object on any given observer would never be exactly the same, but would differ in accordance with their particular *tempérament* or personality. The *impression* or *sensation*, as it came to be understood by artists, was regarded as referring both to an effect of nature and an effect of the artist. Therefore perceptions could not be 'objectively' verified in an absolute sense, but only compared and contrasted with those of others. These new theories of visual perception encouraged painters to regard the perceptual as a field of exploration in its own right.

Although technically Pissarro and Cézanne shared much in common with their Impressionist colleagues, the rustic landscape motifs they favoured during their collaboration distinguished their work from the metropolitan subjects privileged by Monet

and Renoir at the time. While later historians have narrowed the understanding of Impressionism to a homogenous group of artists whose artistic aims focused on capturing the fugitive contingencies of nature, as contemporary critical responses to the Impressionist exhibitions suggest, Impressionism in the early 1870s was still a broad and fluid movement that contained alternative tendencies. Even an artist like Monet, quintessentially associated with a fleeting, atmospheric vision of nature, experimented with markedly different kinds of composition and finish during this decade. The different groupings of artists that critics discerned at the series of Impressionist exhibitions implied recognition of distinctive tendencies of motif and conception coexisting within Impressionism.

While criticism at the Impressionist exhibitions tended to focus on artists' technique, some critics noted the differences in motifs chosen by Pissarro and Cézanne and those of their fellow exhibitors. Pissarro was singled out as representing a strand of Impressionism focused on *la vie agreste* (the rustic life).[36] Cézanne's landscapes, too, implied a kind of attentiveness and temporality associated with rural life. By contrast, as Meyer Schapiro argues, the mode of perception of artists like Monet and Renoir in the 1870s 'naturalized' the perceptual habits and manners of the aimless, strolling urban *flâneur* and the bourgeois consumption of the spectacle of nature.[37] Though these contrasts would grow less noticeable once Monet, quickly recognized as the leading Impressionist landscapist, abandoned his metropolitan subjects towards the end of the 1870s, critical differences of conception informed the distinctive tendencies within the movement.

But if Pissarro and Cézanne represented a distinctive mode of Impressionism during this decade, it was one marked nevertheless by crucial distinctions between them. These differences are registered in subtle variations in theme, subject and mode of composition. While Pissarro made reference to changing patterns

of economic activity and the onset of urbanization within Pontoise, Cézanne's choice of motifs presented a view of the countryside as tranquil and unchanging.[38] The fulcrum of Pissarro's painting from first to last was the peasant, the figure whose presence made that landscape intelligible. Cézanne studiously avoided depicting figures whose presence might dilute the contemplation of the spectacle of 'pure nature' and imply alternative ways of experiencing and viewing the landscape. Even when he painted the village or local houses, these motifs, unlike Pissarro's, were pictured devoid of any social life or the markers of modernization. As this implies, at the heart of Cézanne's painting at Auvers and Pontoise was an insistence on an adulterated contemplation of 'pure' nature. It was around his vision and his alone that the spectacle of nature was organized. Hence Cézanne's choice of secluded vantage points was intended to facilitate a solitary communion with nature that Pissarro's art implicitly rejected in favour of a more social ideal. These differences point to crucial divergences in the artists' conceptions of their painting, but other technical differences reveal that a more critical dialogue was ensuing between the painters which explains why each, though acknowledging the debt each owed to the other, insisted he had kept to his own personal *sensation*. Despite their close working relationship, Pissarro and Cézanne's respective art was in key respects moving in fundamentally alternate directions. To understand why requires returning to the copy Cézanne made of Pissarro's *Louveciennes* and to Pissarro's portrait of Cézanne as Courbet's successor, and revisiting that comment Le Bail recalled him making that 'had Pissarro continued to paint as he had in 1870 he would have been the strongest of us all.'[39]

In the late 1860s and early '70s arguably the two most important painters influencing Pissarro had been Corot and Courbet. Lucien spoke of Cézanne and his father taking up Courbet's palette knife technique and emulating the material solidity his art had come to stand for. The materialism Pissarro so admired in Courbet

was juxtaposed with his growing attraction to atmosphere and those elements in the landscape that were most contingent-light. Pissarro's art at this point was defined by a dialectical relationship between a commitment to the solidity of the substance of things in nature and a growing preoccupation with the fugitive levity of their illumination. It was, as T. J. Clark has argued, precisely this fragile equivalence that made Pissarro's art so exceptional and so difficult to emulate.[40] But by the mid-1870s, under the influence of Monet, Pissarro had begun to abandon the materialism of his 'Courbetesque' paintings of the late 1860s and to place more emphasis on luminous effects within the landscape, lightening his painterly style, the better to suggest the ephemeral aspects of his motifs. His pictures often depicted illumined spaces conveying a particular season, or time of day, the lightness or heaviness of the atmosphere, or a certain climatic condition. These landscapes were now suffused with the shimmering transparency of light. Painting conceived in this way would increasingly be about those aspects of the landscape that could not be reproduced by the mechanical eye of photography, about everything in nature that was unique, momentary and contingent. It would require the painter to improvise techniques that expressed these qualities of nature.

Cézanne's painting, by contrast, had a greater density and despite its commitment to Impressionism's concerns with illumination, only minimally incorporated those elements of the Impressionist fleeting play of light and reflection around which Pissarro's work was now increasingly organized. The materialism of Cézanne's painting was not grounded in the objective actuality of a time of day, a passing climatic condition or a specific temporal moment. Though these effects can sometimes be found in his work, he generally preferred even and stable lighting and avoided fugitive climatic effects or even shadows in his landscapes. Cézanne's 'copy' of Pissarro's *Louveciennes* reflects this. In place of the dialectical interplay of light and material structure, Cézanne's version is by

comparison clumsy and crude, indicative of the struggle to come to terms with the interplay of those elements that he so admired in Pissarro. The solidity of the picture is amplified endlessly, the landscape compressed, airless, flattened out and unoccupiable. The result is by comparison a picture that points to what Cézanne could and did eventually take from Pissarro, the materialism that he had adapted from Courbet.

It is hard to imagine a clearer expression of Cézanne's reservations about the direction Pissarro's art was now taking and what he was leaving behind. The suppleness, certainty and sureness of touch of Pissarro's *Louveciennes* has been replaced by a self-consciousness, doubt and uncertainty – a scepticism conscious of the limits of the language of painting – registered most forcefully in the shifting and unstable space that makes it so difficult to pin any object down. Although smaller than the original, the copy is far more monumental yet far more fragile-looking in relation to its equivalence between the phenomenal world of nature depicted and the aesthetic form the picture takes. Every solid seems thicker, weightier and more solid than in the Pissarro, yet paradoxically its solidity seems less grounded in actuality, more a matter of paint on a surface. In the copy, everything seems marked by equivocation and ambiguity; solids and voids interleave and seem impossible to disentangle from each other. As Clark puts it: 'Everything is vectors and possibilities, prisms and precipices.'[41] Cézanne's picture, half homage and half critique, is the return of everything that Pissarro later repressed in his painting, a restoration of Courbet's weighty solidness that Pissarro's Impressionism had begun to leave behind, but also a problematizing of what that materialism in painting rested on.

These differences in conception between Pissarro and Cézanne are evident in paintings produced during and after their collaboration, in which Cézanne returned to key works by Pissarro and the choice of landscape pictures shown at the Impressionist exhibitions seems to have been intended to draw comparison

between their work.[42] At the show of 1874, he exhibited two landscapes: *Étude: Paysage à Auvers* (Study: Landscape in Auvers, *c.* 1873) and *La Maison du pendu, Auvers-sur-Oise* (The House of the Hanged Man, Auvers-sur-Oise, *c.* 1873). The latter, with its thick, dry paint and weighty material solidity, was regarded by his peers as exemplary of Cézanne's landscape painting and stood in direct contrast to the airy lightness and scintillation of Pissarro's *Le Verger* (The Orchard, 1872) and *White Frost* (1873), both exhibited at the exhibition. Though it is impossible to be sure which landscapes Cézanne showed at the 1877 Impressionist exhibition, it is likely that he exhibited works from L'Estaque, where the contrast between Pissarro's development and his own would, in many respects, have been even more marked.

By the late 1870s Cézanne was attempting to bring greater organization and unity to his pictures. From his letters of this period it is clear he felt a problem existed between his *recherches sur nature* that often led to unorthodox rendering and what in his judgement made for a satisfactory representation of his motif, a problem of synthesis that would persist at the heart of his painting. In 1878, in a letter to Zola, he wrote, 'I work but achieve little and without sufficiently communicating the general sense of the motif.'[43] As this implies, while *sensations* of nature remained the starting point of his paintings, the 'constructive stroke' style that emerged towards the end of the decade was an attempt to communicate greater order, clarity and unity in his painting through retaining something of Courbet's materialism. Though it is often seen as marking a transition away from Pissarro's work, it was in fact a reclaiming of the latter's experimentation with achieving pictorial unity in some of his pencil drawings in the 1860s.[44] This approach is evident in *Le Château de Médan* (1880), which might be seen as the logical outcome of the results of the *Louveciennes* 'copy' after Pissarro. The painting was vainly intended to demonstrate his new compositional method to Zola, whose house is depicted in the painting. But Zola

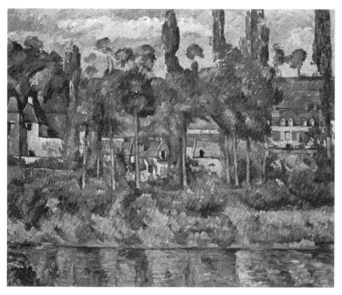

Le Château de Médan, 1880, oil on canvas.

had already become disenchanted with his early enthusiasm for Impressionism and progressively distanced himself from the modern movement.

Cézanne felt deeply hurt by how remote their friendship had become by this time. He wrote to Zola on several occasions asking to visit, only to be put off with thinly veiled excuses. Cézanne still had few admirers, while Zola's recognition as one of France's leading novelists and commercial success continued to grow. This had driven a wedge between them. They now occupied very different spaces. Zola moved in vaunted, haute-bourgeois social circles, while Cézanne was increasingly isolated. By this time, even the notoriety he had enjoyed in Paris was a fading memory. Zola's correspondence with Cézanne, by turns irritable and condescending, though punctuated by occasional moments of remorse, indicates how much their relationship had declined.

In a series of letters over the course of 1878, Cézanne sought to placate his friend and find common artistic ground. In several rather tentative letters he praised *Une Page d'amour* (A Love Episode), the eighth novel of Zola's epic twenty-volume series *Les Rougon-Macquart*, which Zola had recently published.

> Anything I say to you about it [*Une Page d'amour*] is . . . only to give you an idea of what I can grasp of the work. It seems to me a picture that's painted more delicately than the previous one [*L'Assommoir*], but the temperament or creative force is still the same . . . the build-up of the hero's passion is very carefully done. Another observation I have . . . is that the settings are done in such a way as to become imbued with the same passion as drives the characters, forming an integral whole. They seem to come alive . . . and to share in the sufferings of living beings.[45]

The general tenor of the letter and the terms of the last few sentences in particular bring to mind Cézanne's own figure paintings and were probably intended to remind Zola of shared artistic aims. But Zola was already growing increasingly disenchanted with what Duranty had referred to as 'the new painting'. *Le Château de Médan*'s grandeur must have seemed a symbol of the divisions between them. Cézanne's choice of viewpoint, picturing Zola's house at a distance from across the divide of the river and half-concealed by the screen of trees arranged before it, brings spatial equivocation to the picture and detaches the viewer from the scene, creating an insurmountable divide between the vantage point from which it is painted and the landscape and house beyond. The water in the foreground extends across the picture like a curtain of glass. All of this makes the house appear remote and its ostentation understated, as though in painting it Cézanne had unconsciously sought to diminish its presence and registered his alienation from it. The resulting painting is paradoxical, combining

massive solid structure with impossible, ungraspable articulation, a juxtaposition of presence and obliteration; simplicity of form gives expression to anything but simplicity.

The painting points to certain conclusions Cézanne had drawn by the early 1880s from his time working with Pissarro. It is perhaps best seen as an attempt to give form to the differences that had arisen between their respective conceptions of painting. Its materialism suggests what had originally attracted Cézanne to Pissarro's work of the 1860s, a materialism Pissarro's art had subsequently left behind. That it should have taken so long for Cézanne to have been able to develop a way of moving forward from those differences points to what a difficult and protracted process that was and perhaps why, in order to develop in this direction, he had to assert his distance from Pissarro to work through the complex legacy the latter's work had for him.

Le Château de Médan is a demonstration of one of the routes this legacy took for him. The 'constructive stroke' is used relatively uniformly across the picture surface, modified only in its direction and compactness to create a sense of depth, surface variety and compositional interest. By building up the painting in small touches of parallel brushstrokes arranged in different directions across the surface of the canvas, Cézanne brought a new structural solidity to his painting, though an equivocal one, more overtly made of the materialism of paint than the translation of actual *sensations* of nature.[46] The picture is divided into five horizontal bands of broadly equal width, with a different patterning of stokes (vertical, diagonal, horizontal) on each plane – the river, the bank, the background hills – adjusted only in the line of houses and the sky where the brushwork is looser and more varied. A tauter employment of brushwork and more controlled use of colour contrasts to modulate the objects and depth relations of his paintings is visible throughout.

A few years later, tiring of the constricted simplification and almost automated approach to painting, Cézanne would abandon

this method, loosen his technique and provide for more variation of expression. He would unify his pictures more through coordinated tonal harmonies and rhythmic brushstrokes and allow himself again the kind of immersion in the phenomenal *sensations* of nature he had had in the years immediately before. But the late style of Cézanne could perhaps not have emerged without this moment of extreme structural reduction in his art and the dialogue with Pissarro's painting out of which it emerged. It is perhaps only by understanding Cézanne's dialogue with Pissarro as entailing a decisive critical dimension – one that sought out, whether intentionally or not, within the confident assertiveness of Pissarro's art, the equivocation and ambiguities inherent within it and amplified them – that, as Clark has argued, we can understand how Cézanne's art became organized around uncertainty and interminability, or how the Impressionist desire to put down as simply as possible the raw data's impression on the retina resulted in an art of equivocations, contingencies and paradoxes.

4

Portrait of a Woman

We don't know when they met, but in 1869 Cézanne wrote to his
sister Marie that he was in love with a young woman. Three years
later, her name appears with his for the first time in a document
dated 4 January 1872, where she is described as Hortense Amelie
Fiquet, 'twenty-two years old, without profession and unmarried',
the mother of Cézanne's newborn son Paul.[1] Cézanne's letters tells us
little of what it was he saw in her. With no surviving correspondence
of Hortense from these years, it also remains a mystery what
attracted her to the ungainly, unkempt and sometimes uncouth
Cézanne. His desire to settle down with Hortense has sometimes
been seen as influenced by Zola's deepening relationship with
Alexandrine Gabrielle Meley, of whom he was greatly fond. Cézanne
was a witness at their marriage ceremony in May 1870 and this may
have encouraged thoughts of settling down himself. Nevertheless,
Cézanne and Hortense did not marry until many years later and
while close friends and his mother knew of his 'wife and family',
as he customarily referred to them, their relationship and the
birth of his son remained hidden from Cézanne's father for fear
of disinheritance. When, in the spring of 1878, his father opened
a letter to his son from Victor Chocquet referring to 'Madame
Cézanne et petit Paul', Cézanne wrote several times to Zola of his
worries his allowance would be reduced and pleaded with his friend
for loans to support his wife, who was ensconced with their son at
21 Vieux Chemin de Rome in Marseille. In April he wrote:

Despite honour of treaties, I've been able to secure only a hundred francs from my father, and I was afraid that he might not give me anything at all. He's heard from various people that I have a child, and he is trying to surprise me by every possible means. He says he wants to rid me of it.[2]

When several other letters from Hortense's father, including one addressed to Madame Cézanne, were diverted into the hands of Louis-Auguste, he was forced to make increasingly 'violent denials'.[3] Despite Louis-Auguste's growing suspicions, he only discovered the relationship and existence of his grandson incontrovertibly many years later, or perhaps he merely tolerated his son's pretences, satisfied with the compromised position in which it left Cézanne. When journeying to Aix, Cézanne routinely left his family in the nearby village of L'Estaque, in the little fisherman's cottage they had taken refuge in during the Franco–Prussian War.

The immediate post-war years were a difficult period of adjustment for the couple to the new circumstances they faced. In autumn 1871, with the war over and life slowly recovering from the aftermath of the bloody repression of the Commune, Cézanne and Hortense, now three months pregnant, returned to Paris. They initially stayed with Solari in his apartment near the Jardin du Luxembourg, before finding modest rooms in the rue Jussieu, near Les Halles aux vins, a quarter already well known to them. On 4 January 1872 Paul was born. Achille Empéraire was trusted with communicating the news to Cézanne's mother. Raising a family on the small allowance from his father was a continual struggle. Achille wrote: 'Paul is badly set up, and besides there is so much noise it could wake the dead . . . I find him abandoned by everyone. He hasn't a single affectionate or intelligent friend left – the Zolas, the Solaris and others. They're not there anymore.'[4] Tensions had already surfaced with Zola after he, Gabrielle and his mother briefly took shelter with Cézanne and Hortense in L'Estaque after fleeing

Paris during the Prussian assault. Consequently, they had quickly moved on to Marseille. Zola evidently could not stand Hortense, and his fictionalized portrait of her in *L'Oeuvre* is far from flattering.

In the difficult and somewhat claustrophobic conditions in which Cézanne and Hortense lived, he struggled to work. The now-destitute Achille was also temporarily lodging with them. This contributed to the decision to move to Pontoise, where they rented accommodation across the river Oise from the painter Édouard Béliard, with whom he sometimes painted, before in the autumn, at Dr Gachet's beckoning, moving to the village of Auvers-sur-Oise, close to the latter's house. The austerity of these years is confirmed by the fact that Cézanne ended up settling his grocery bills by trading a painting for payment. The modest and dimly lit lodgings they lived in further encouraged Cézanne's commitment to painting *en plein air*. In Auvers, Cézanne regularly spent his days painting with Pissarro and occasionally with other artists in the region. He spent a a great deal of time at Pissarro's house as well as at Gachet's, where he liked to listen to Madame Gachet play the piano. But Gachet's son Paul recalled that Hortense rarely accompanied him on his visits to them, or to the Pissarros.[5] Cézanne was consumed by the new developments in his art that working with Pissarro brought him and the new artistic circle he had established around him, and Hortense became a background figure in his life. A feature of the relationship from this time on was how much time Hortense would spend alone with their child. As time wore on, Cézanne and Hortense were to spend longer and longer periods apart. Nevertheless, it is in these years that Hortense's presence is first registered in Cézanne's art. Many of the pictures he produced during this time are small, tender paintings of her or Paul. The most intimate show her nurturing their son, unquestionably the most affectionate pictures he ever painted.

The birth of Paul consolidated the relationship between Cézanne and Hortense but also altered it. In Cézanne's youthful correspondence with Zola, they discussed their fantasies, desires

and ideals but differed decidedly. Whereas Zola saw the notion of romantic love as something to be sought out in the life around them, Cézanne was bohemian, sceptical and entrenched in his belief that an unbreachable gulf existed between the romantic ideals and images that stimulated his imagination and the banal realities of the world around him.[6] 'I'm wet nursed with illusions', Zola recalled him stating.[7] In a letter to Cézanne, Zola wrote, 'you have two loves at heart, one for women and one for the ideal'.[8] His erotic fantasies are given form in many of the verse letters he wrote to Zola.

Yes, in a thrice she won my heart. I throw myself at her feet,
Lovely legs; emboldened with guilty lips
I plant a kiss on her quivering bosom;
But instantly I am seized by the chill of death,
The woman in my arms, the rose-tinted woman,
All of a sudden disappears and metamorphoses
Into a pale cadaver with angular frame . . .
Its bones rattling, its eyes hollow and empty . . .
It was embracing me, horror![9]

There were many such idealized imaginings of reveries disappearing, metamorphosing, turning into rotting flesh as dream gave way to dawning consciousness. The pattern was clear. Love was an illusion and all the more desirable for it. That last exclamation of the horror of its actual embrace seems poignant in the light of Cézanne's later remarks to Bernard of his loathing of being touched. Love was an ideal, but he primarily viewed it as a spur to the imagination rather than something that was found in actual reality. Or perhaps it could only be found temporarily there; a momentary and passing illusion. Desire was an ephemeral pleasure, intoxicating but a force that could drain the body of its creativity and energy. Its incarnation brought the press of the flesh and with it fear, shame, loathing and death. He carried with him from childhood a deeply

embedded association between temptation and guilt. From early on, his poetry and painting took up themes of the conflict between love, desire and the vocation of art. Cézanne's early letters and imagery of love reflect how he was trapped between the image of a *lorette* (courtesan) or *grisette* (a chauvinistically bourgeois term reflecting how working-class girls were seen as easy sexual prey) who would provide him with unfettered libidinal pleasure ('I held in my arms my lorette, my grisette, my sweet saucy wench that I was fondling her buttocks more besides', he writes in a letter recounting many such dreams and imaginings) and the ideal of a domestic companion who would aid his aspirations to be an artist.[10] Both these ideals in their own way implied a kind of instrumentality and detachment in his human affairs. Hortense never quite represented either and his imagery of her gradually came to reflect this. For many writers the years immediately after the birth of Paul are synonymous with the end of his romance with Hortense, even though they remained a couple. Although Cézanne's affection for his young family continued to be expressed in his many drawings of Paul and Hortense, his letters rarely refer to her, and correspondence between them does not survive despite the long periods in which they were separated. In a letter to Pissarro from Aix in 1874, he mentions how worried he is that he has been 'weeks without news of my little one', but makes no mention of Hortense.[11] Over the passing years this would be a characteristic feature of his correspondence.

By January 1874 Cézanne, Hortense and Paul had returned to Paris, perhaps in anticipation of the first Impressionist exhibition, though his correspondence seems ambivalent about the exhibition, and despite participating, it is unclear whether he attended the show or not. Around the same time, Cézanne received a letter from his parents strongly urging him to return to Aix; he had been absent now for almost three years. In the surviving draft of his reply, he stated: 'Once I am in Aix, I am no longer free, and when I wish to return to Paris, it means a struggle, and although your opposition to

my return is not absolute, I am troubled by the resistance I feel from you.'[12] In the same letter, he pleaded his allowance be raised to 200 francs per month, arguing this would allow him to return home for longer stays. Subsequently Cézanne passed the summer at the Jas du Bouffan while Hortense and Paul remained in Paris.

In autumn 1876 Cézanne moved his family again into a modest, rather claustrophobic fourth-floor apartment in the rue l'Ouest, located in the newly built-up outskirts of Paris, close to the Cemetery of Montparnasse, where they lived until 1879. It was here that he painted one of his most enduring images of Hortense and most important portraits of her, *Madame Cézanne in a Red Armchair* (*c.* 1877). The painting shows Hortense seated, set against the distinctive lozenge-shaped wallpaper that decorated the apartment's three rooms. Hortense is placed slightly off-centre to counter the potentially deadening formal symmetries of the composition with its strong geometrical accents in the skirt, chair and background. Her hands are clasped together in a gesture that Cézanne repeatedly favoured in his portraits. He used to clasp his hands together with his fingers intertwined to demonstrate to his young admirers the effect of integrated unity he sought to achieve in his painting. The motif of hands touching also heightens awareness of the relation between haptical and optical in these pictures, which translate optical *sensation* into physical touches of paint on the surface of the canvas.[13] Whether the posing of his models with their hands clasped was intended to act as a metaphor for Cézanne's artistic aims, a subconscious element of these paintings or simply the natural pose a figure might adopt when sitting for the long sessions Cézanne demanded, remains a matter of conjecture.

Although it is a relatively small painting, Hortense has a commanding presence, despite the quiet contemplativeness of her expression and summary rendering of her features. The heavy impasto surface combined with the bulk of the figure and voluminous armchair in which she sits, which seems almost to

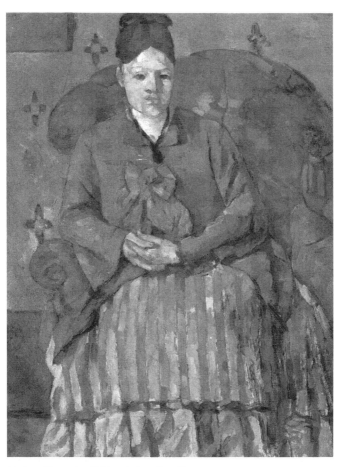

Madame Cézanne in a Red Armchair, c. 1877, oil on canvas.

extend and amplify the sitter's body, all contribute to this effect. The painting left a profound impression on the poet Rainer Maria Rilke when he saw the picture at the 1907 Salon d'Automne. He wrote to his wife:

> In my feelings the consciousness of her presence has grown in exaltation which I perceive even in my sleep; my blood describes her in me, but the verbal expression passes by somewhere outside and will not be called in . . . In this red armchair, which is a personality, a woman is seated, her hands in the lap of a dress with broad vertical stripes . . . (and it is the first and final red armchair of all painting) . . . this chair is painted quite powerfully round the delicate portrait.[14]

Rilke's description of how the painting impressed itself upon his consciousness in ways difficult to describe in language captures the complexity of the effect of the portrait, which seems to express itself as much through the visual *sensations* produced across the surface of the picture as through the image of Hortense herself. This was the first of his female portraits to rival the more assertive and individualized portraits of the male figures that had dominated his portraiture to date and must have suggested to him the expressive possibilities of female portraiture that he had hitherto largely ignored. The tone of his portraiture henceforth would be quieter, more contemplative than before, regardless of the gender of the person portrayed.

Although during the formative period of his artistic career self-portraiture had dominated his earlier work in this genre, by the late 1870s these self-portraits with their assertive address to the viewer began to recede. Hortense was by far his most frequent model in the second half of his career, at a time when their relationship was believed to have already substantially cooled. These pictures of Hortense are some of the most innovative and important portraits Cézanne painted in the late 1870s and '80s. He made at least

27 paintings of her and many more drawings. Though they are his most diverse group of portraits in terms of colour, tone, background, handling and format, they predominantly portray Hortense in a melancholy or sombre mood, consistent with Cézanne's portraiture in general. Unlike the wives and mistresses of other Impressionists, who were included in a variety of types of picture, with the exception of some drawings, Hortense only features in portraits, and from the 1880s mostly in studio portraits, the environment in which Cézanne felt he had most control over his motifs. But while Cézanne generally favoured neutral greyish-blue backgrounds (that signified the studio as the place of production) in his portraits, and presented the minimum distraction from the figure, by the 1880s he was increasingly experimenting with painting his sitters in more varied settings and against more decorative backgrounds, often using a floral-patterned curtain he kept in his studio as a backdrop.

It is interesting that in one of the portraits in which Hortense looks most at ease, she is depicted outside the studio environment. In *Madame Cézanne in the Conservatory* (*c.* 1891–2), the bright setting of the conservatory at the Jas du Bouffan and the inclusion of a lush tree and plants that frame her enliven the picture and soften the geometry of her oval face. For once, she stares confidently back at the viewer. Ruth Butler has suggested that the sombre mood of many of Hortense's portraits 'may reflect her isolation and her feelings of being caught up in a place not of her choosing'.[15] But reading particular meanings into the picture in this way poses problems about how we understand the semantics of these paintings, how we interpret particular details and features of them, what kind of evidence they provide of the feelings and emotions of the sitter and the extent to which Cézanne allowed his sitters to define themselves. Any such readings need to take into account the general conditions of production of these portraits, which were rarely commissioned and therefore made for the artist rather than the sitter.

Although it is not a virtue that is commonly associated with her, Hortense must have shown extraordinary patience to model so frequently for him. The interminably long sessions he required from his sitters and the demands he placed on them ('I pose like an Egyptian sphinx', Zola remarked of posing for a portrait) has long been the subject of Cézanne lore.[16] The books one occasionally sees his sitters holding in their hands would certainly have been well thumbed by the conclusion of these sessions. There was surely an element of provocation in the discomfort Vollard recalls he was subjected to when having his portrait painted:

> Upon arriving, I saw a chair in the middle of the studio, arranged on a packing case, which in turn was supported by four rickety legs. I surveyed the platform with misgiving. Cézanne divined my apprehension. 'I prepared the model stand with my own hands. Oh, you won't run the least risk of falling, Monsieur Vollard, if you just keep your balance. Anyway you mustn't budge an inch when you pose!'[17]

Vollard claimed he posed for 115 sittings in total before Cézanne, apparently close to completion, abandoned the painting, complaining he could not find the right tones for the remaining few passages of primed canvas. This tells us much about the scrupulous and exacting method of Cézanne's painting, a method that had no guiding rules, but involved continual improvisation, intuition and re-adjustment. Cézanne stated that each brushstroke required him to reconsider the particular total effect and the overall harmony of the painting anew. It also indicates how taxing sitting for him must have been. It is no wonder therefore that so many portraits were left unfinished and that he resorted to specially constructed life-size mannequins for some of his late work. Geffroy similarly claimed he sat daily for Cézanne for three months for his portrait. During these wearying sessions Cézanne could remain 'inactive' for long periods

as he observed his model and considered his next action. Gasquet, who also sat for his portrait, recalled that twenty minutes could pass between brushstrokes.[18] The conditions of extreme constraint, the notorious rants directed at Vollard and others when they slipped out of the pose, the conditions of complete silence it is said he insisted his sitters observed, all made posing for Cézanne an unenviable labour, and those conditions leave their mark on how little the sitter is able to impose himself on the portrait. This was not by chance. Cézanne abhorred professional models, no doubt wishing to get beyond the professional pose to a more natural state in which the sitter's self-consciousness was overcome. Yet this has led to the pictures being regarded as depersonalized and even dehumanized. Fritz Novotny wrote:

> In the development of older art it is impossible to find a similar contrast to that offered us by the end of the nineteenth century, when Van Gogh painted the 'portrait' of a chair while another leading artist, Cézanne, was eliminating even from the representation of the human countenance every trace of psychology and feeling . . . It is this characteristic [of aloofness] which gives his pictures, for those who approach them for the first time, a cold, rigid, almost repugnant character, and renders their comprehension difficult.[19]

For how many hours did Hortense model for the portraits Cézanne painted of her? Was she obliged to sit for the artist as part of her 'indentured servitude', or was this something to which she willingly submitted? Do Cézanne's many portraits suggest a relaxed intimacy between the couple, or do they contain evidence of the tensions between them? Was the frequency with which he painted her simply due to the convenience of her presence or was it his way of being close to her? Was Hortense the most patient of the limited number of sitters who could bear to endure all this or, despite her

apparent low regard for his painting, was she pleased to find herself immortalized in paint, a muse of sorts for him? As so often with Cézanne's life, one can only speculate, but the answers are unlikely to be simple and straightforward.

By the time Cézanne and Hortense married in 1886, many years after their relationship began, it is said they had long become remote from each other. The mysterious draft of a love letter found on the back of one of the drawings that Cézanne penned in the spring of the previous year was not to his future wife.

I saw you, and you let me kiss you, from that moment I have had no peace from profound turmoil. You will forgive the liberty that a soul tormented by anxiety takes in writing to you . . . how could I remain so oppressed by dejection? Is it not better to give expression to an emotion than to conceal it? . . . Is it not a relief from suffering to be permitted to express it? And if physical pain seems to find some relief in the cries of the afflicted, is it not natural, Madame, that psychological suffering should seek some respite in the confession made to the object of its adoration?[20]

It remains unsolved who the letter was intended for, but what is clear is the deep and painful sense of loneliness and isolation it reflects. The secret affair, if one can call it that, ensued over the next six months, with Zola acting as the increasingly vexed intermediary of their correspondence, although it soon fizzled out; its details remain obscure. It appears to have been a case of unrequited love, to judge by the tone of the postscript of a letter Zola wrote to his friend in July that year: 'I haven't received anything for you in some time.'[21] In another letter to Zola, Cézanne hinted at Hortense's own 'adventures'. Despite all this, on 28 April 1886, in a modest civil ceremony in the *mairie* (town hall) in Aix attended by both his parents, Hortense became Cézanne's wife. The next morning, they registered the union in the Baroque parish

church of Saint-Jean-Baptiste. For Hortense this was finally an acknowledgement of a relationship that had remained partially hidden for seventeen years. Yet the marriage reflected no late reconciliation between them. Hortense and their son lived in Gardanne, a village neighbouring Aix, where Paul attended school. Cézanne continued to reside at the Jas de Bouffan with his sister Marie and his mother. Cézanne's will, made four years before they married, included no provision for Hortense, dividing his estate between his son and the mother to whom he remained devoted and who, due to her progressive physical and mental decline, was increasingly dependent on him.

Many of the most important and tender late portraits of Hortense date from shortly before the marriage. *Madame Cézanne with Hortensias* (1885), a half-rendered sketch, pairs Hortense resting her head on a pillow, her eyelids heavy having just awoken from sleep, with an adjacent large blooming hortensia rendered with a delicate watercolour wash. The drawing, completed a year before they married, is one of his most affectionate portraits of his wife and he would repeat the pun of Hortense/hortensia in a later portrait. Perhaps the impending marriage had awoken dimmed memories and conflicted feelings in him, though such feelings probably remained residual throughout their life together, deepening and becoming more complex and difficult to express over time.

It has been suggested that a group of three companion portraits by Cézanne of Hortense wearing a blue dress were undertaken to commemorate the marriage and may even show her in her wedding dress, though the uncertainty of the dating of these pictures make this interpretation open to question.[22] The version in the Staactliche Museum in Berlin certainly offers a more elegant, intimate and sensuous image of Hortense than in many of Cézanne's portraits of her. But the full set of pictures offers widely different representations of their subject. In the Philadelphia Museum of Art version, where Hortense is posed in three-quarter profile, she is rendered less

Madame Cézanne with Hortensias, 1885, watercolour on paper.

flatteringly, appearing severe-looking, remote and bored; her pinched features make her appear considerably older. In a related drawing in the Boijmans Van Beuningen Museum in Rotterdam, Hortense wears the same brocaded dress and ornamented hat, as though, as Joseph Rishel has remarked, 'dressed for a special occasion', yet appears quite miserable. Was her 'unhappy expression', as Rishel has suggested, 'prompted by her husband's having prevailed upon her – yet again – to pose', or, as Butler has implied, a reflection of the fact that while the marriage may have brought clarity and respectability to Hortense's relationship with Cézanne, it 'surely did not bring joy into [her] life'.[23]

The reasons behind the marriage may have been less to placate Hortense than to bow to family pressure. Cézanne's mother wanted freer access to her grandson Paul and his illegitimate status had long been a contentious issue both for her and for Cézanne's sisters. Yet the marriage only seemed to exacerbate his family's opinion of Hortense as a 'gold-digger' and unworthy companion. Perhaps in marrying, Cézanne

also hoped to mollify Louis-Auguste, whose health was fast deteriorating and who would die six months later in October. Louis-Auguste's death freed Cézanne from financial worries. While his father lived he was fond of depicting Louis-Auguste as a tyrant, but in death Cézanne wryly characterized him with newfound admiration, as a 'man of genius' who left him 'an income of twenty-five thousand francs'. Hortense was to benefit from Cézanne's newly acquired affluence, the artist dividing his income in three between his wife, his son and himself. However, Cézanne was not beyond curbing her excessive spending, perhaps brought on by years of living within limited means, or even controlling her movements through his power over her financial affairs. In doing so, he was acting in a manner reminiscent of the father he had once loathed, though his friends evidently thought otherwise, and continually complained of her behaviour.

Hortense found life in provincial Aix stiflingly dull and isolating and visited Paris as often as she could. The Provençal writer Paul Alexis, a friend of both Cézanne and Zola, who he would later write a biography of, recounted in a letter to the novelist that in 1890 Cézanne was furious with Hortense for having 'dragged him all over Switzerland' in what seems to have been a visit to her father before heading off with her 'constant companion', young Paul, to Paris. Backed by his mother and sister, Cézanne, he added, had felt 'strong enough to stand up to her' and brought her back to Aix 'by cutting her allowance in half'.[24] Arranging for her furniture to be transported to a house on the rue de la Monnaie, off the Cours Mirabeau, Hortense was left with no doubt that though she might visit Paris from time to time she was expected to reside in Aix. It was only after inheriting a 39-acre (16-ha) estate in the Jura, Switzerland after her father's death in 1899 that she became more financially independent. But despite Cézanne's actions, by 1894 Hortense and son Paul were back living on the rue des Lions-Saint-Paul on the Right Bank of Paris. The last portraits Cézanne made of Hortense

Madame Cézanne, *c*. 1905, photograph.

have been dated to this period. *Madame Cézanne in a Red Dress* (*c*. 1893–5), with its ornate furnishings, may well have been painted in Hortense's new apartment.

By this time Hortense was growing increasingly unpopular among Cézanne's fractious family and friends, many of whom, if Alexis is to be believed, detested her and held her in outright contempt, customarily referring to her as *la boule* (presumably shorthand for 'ball and chain') and Cézanne's son as *le boulet*. Coste characterized Cézanne as being caught up like a naive child in the middle of an increasingly quarrelsome set of relations between the family and Hortense. In 1899 his long-time friend and patron Chocquet and his wife, Marie, were among the few friends that welcomed Hortense's company. In a sombre reply to a letter of

congratulation from them in May, Cézanne indicated that all was not harmonious in the marriage:

> Your fine letter, along with that of Madame Chocquet, is evidence of a fine equilibrium in your way of life. I am so struck by the serenity I see in you. Fate did not provide me with a similar lot; it's my only regret concerning the things of this earth.[25]

In 1897, after a long decline, Cézanne's mother died, leaving him bereft and plunged into a deep depression, which worsened when the division of her estate between her three children forced the sale of the Jas du Bouffan in the autumn of 1899. As a result, Cézanne lost not only his main studio but a house full of memories of his childhood and youth. Subsequently he rented an apartment on the rue Boulegon, only a few doors away from where his father had established his bank. The close relationship between Cézanne and his mother had long been a source of friction with Hortense. His mother's passing and the deep impression it left on him exacerbated the resentment Hortense harboured about the relationship. In his journal, Maurice Denis recorded a story André Gide had told him:

> Having lost his mother, whom he greatly loved, Cézanne decided to consecrate a room in his apartment to her memory. He brought together various ornaments and objects that reminded him of her . . . One day, in a fit of jealousy, his wife destroyed all these souvenirs. Accustomed to his wife's foolishness, Cézanne came home, found everything gone, left the house, and stayed away in the country for several days.[26]

If true, this anecdote says a great deal of the smouldering bitterness Hortense must have felt towards Cézanne's mother, and the deeper impact it had on her relationship with Cézanne.

The picture we have of their relationship in these later years is a complex and contradictory one. While noting in passing the family's reluctance to speak of Hortense, Paule Conil, one of Cézanne's nieces, recalled in retrospect Hortense's exceptional humour and extraordinary patience with Paule's habitually agitated uncle, whom she would read to for hours on the many nights he could not sleep.[27] Vollard also mentions Cézanne's restless nocturnal habits, such as checking the weather and the progress of paintings he was working on.

> Carrying a candle he would go and review the work in process. If he felt good about it, he would go at once to share his satisfaction with his wife. He would awaken her and afterward, to make up for having disturbed her, he would invite her to play a game of draughts before going back to bed.[28]

Although these reminiscences presumably come from when they were living together, letters from the last months of his life to his son express warm sentiments towards Hortense, albeit in passing. When, in the summer of 1906, he heard from Paul that Hortense was ill, he wrote:

> I deplore the state in which your mother finds herself. Give her every possible care, try to make her feel comfortable, keep her cool and find any appropriate entertainment . . . I embrace you both with all my heart.[29]

Conceivably by this time Cézanne could only show affection for Hortense when separated from her and through some intermediary. During the last twenty years of his life, Cézanne became withdrawn, neurotic, irascible and saturnine. He was prone to turn suddenly on old friends and colleagues, dismissing the 'portentous intellectuals, the ignoramuses, cretins and rascals' around him.[30] Those close

to him often commented on his unpredictable moods and how he would distance himself from them for reasons that remained mysterious. His irritability was deepened by his declining health. In 1890 he was diagnosed with diabetes. Increasingly preoccupied with anxieties about death, he reconverted to Catholicism; a crucifix hung on the wall of his bare studio. If at the start of the decade he had forced Hortense and Paul to settle in Aix, by the end of it he was content that they should remain in Paris. Though he may not have provided for Hortense in his will, the deed of purchase for the studio at Les Lauves was registered in both their names. Perhaps, as Butler has argued, we should not read too much into her exclusion from the will. Cézanne placed great trust in his son's dealings with Vollard, referring to him as a man with a more 'practical sense of life' than either he or Hortense possessed. Worried by her spending and knowing his son's devotion to his mother was matched only by Cézanne's devotion for his own, he would have expected his son to take responsibility for her financial affairs and exert a moderating influence over them if necessary. Yet if so, he was again exercising a controlling influence over her affairs.

Hortense has typically been portrayed as a woman preoccupied with fashion and socializing, who showed little interest in Cézanne's art and when she did venture an opinion, was reproached by the artist for talking nonsense.[31] Her inertia and lack of cooperation, it has been said, made her a 'counter-muse', a progressive hindrance to the artist. But the legend that she failed to arrive at Cézanne's deathbed because she did not wish to cancel a dressmaker's appointment has been shown to be a malicious invention. The telegram sent by his housekeeper to his son Paul informing them of his grave illness did not arrive in time.[32] This image of Hortense as a frivolous woman with little interest in her husband's painting is arguably called into question by the many portraits she sat for and by the existence of letters that reveal her interests in art and nature and show her acting as an intermediary in Cézanne's business

affairs. In a letter to Marie Chocquet, she comments on being
in Vevey, 'where Courbet did that lovely painting you own', and
remarks on her husband's experiences painting the landscape.[33] In
another letter to Bernard in 1905, she authorizes the publication of
illustrations of Cézanne's paintings, expresses her interest in reading
his book on the South of France and mentions in passing that she
is being pressed to send works for 'exhibitions in November'. Yet
the motivation behind her involvement in these matters remains
ambiguous. It is alleged that Hortense and her son sold off much
of their collection of Cézannes rapidly in order to support their
taste for travel, fashion, high society and gambling. To judge by the
few recorded comments Hortense made about Cézanne's painting,
she was more interested in his emerging reputation than in his art.
Matisse recalled a dinner at the home of Renoir's children in which
Hortense stated: 'Cézanne did not really know what he was doing.
He didn't know how to finish his paintings. Renoir, Monet, they
really knew their *métier* as painters.'[34]

As many feminist art historians have noted, anecdotes like these
account for the fact that, despite her many appearances in Cézanne's
later portraiture, Hortense's presence has been marginalized in
accounts of Cézanne's life and art. The poet Léo Larguier, who was
close to the painter in the last years of his life, though favourably
inclined towards Hortense, believed that she never 'counted for
much' in Cézanne's life.[35] John Rewald wrote that she appeared
not 'to have influenced either his art or his relationship to his
friends'.[36] Yet some art historians have suggested that she had a
far more decisive influence, positive or negative, on the artist than
supposed, especially during the earlier period of their life together.
The sexually explicit violence in Cézanne's early paintings, with
its themes of the antagonism between the sexes, gradually began
to recede around the time he settled down with Hortense. Some
have attributed this to her influence, though whether this was
the result of her becoming the object of his passion, or of fear of

her disapproval, remains in question. Others have argued that Hortense was implicated in the repression of his sexual desires, or that the relationship was passionless. In explaining the repression of sexualized imagery in Cézanne's later painting, Roger Fry, picking up on Zola's characterization of Cézanne as possessing 'an attitude to love more dormant than conquered', singled out Hortense as the cause: '[this] sour-looking bitch of a Mme counts for something in the tremendous repression that took place.'[37] The notion that Cézanne channelled his libidinal energies into his work and was sexually inhibited became a common refrain even among those who had never met him. On hearing of his marriage, Van Gogh wrote to Bernard that Cézanne 'has become a respectable married man . . . if there is plenty of male potency in his work, it's because it didn't evaporate on his wedding night.'[38] Yet we know by his own admission that Cézanne was sexually active and he mentions visits to a local brothel in a letter to Zola.

As Tamar Garb has stated, Cézanne's portraits of Hortense have come to be understood as paintings of 'pure presence', devoid of the psychology, glamour and intimacy customarily associated with representations of female subjects in nineteenth-century portraiture.[39] As such they have seemed to express the distant relationship between the couple. In these pictures Hortense, like many of Cézanne's sitters, looks aloof and lacks the feminine traits associated with conventional portraits of women. Though her penchant for fashion was something much remarked upon and even occasionally pictured by the artist, she is mostly dressed simply and plainly, often without make-up, her hair tied back in a manner that is unflattering. Although in pictures such as *Madame Cézanne in a Red Dress* she holds a plucked flower, a symbol of her femininity, Cézanne rarely pictures her with the customary feminine adornments omnipresent in the portraits of his contemporaries, where a premium was placed on the sensuous qualities of fabrics and the sensual, seductive presentation of female sitters. As with his

images of the female nude, Cézanne's de-sensualizing of the figure and avoidance of facile sentiment differentiated his paintings from those of his contemporaries. Consequently, when his paintings of Hortense and other female sitters were exhibited in public, it was this lack of feminine charm that was often commented on. When *Madame Cézanne in a Red Dress* was shown at the Salon d'Automne in 1907, the critic for *L'Humanité* contrasted Morisot's 'suitably feminine' portrayals of women with Cézanne's *gauche* and 'masculinized' portraits. Undoubtedly the unfinished character of much of the portraiture contributed to this impression. The majority of Cézanne's portraits of Hortense were made during the 1880s, when he was preoccupied with the pictorial organization of his painting. In *Madame Cézanne au fauteuil jaune* (Madame Cézanne in a Yellow Armchair, *c.* 1888–90), we see him simplifying his pictorial grammar in order to establish a symmetrical framework of structural rhymes and echoes that bind its diverse pictorial elements into a close-knit unity. This simplification is most evident in the way he conspicuously reshapes the body and head into semi-geometrical shapes to create visual rhymes with other parts of the composition. But this was one of a group of unfinished studies that may have served as preparations for one of his most ambitious and large-scale portraits of the same title, in which we see anticipated refinements and softening of the picture's geometry. In the latter a more intricate and subtle counterbalancing of elements results in a more particu-larized portrait and 'enlivening' interplay between pictorial harmony and endless points of variety.

Cézanne's depictions of Hortense offer a complex series of contradictions. Sometimes she is portrayed as attractive, sometimes plain; sometimes a woman of fashion, sometimes dressed drably; sometimes she is posed quite assertively, while other pictures portray her bored and impersonally. Her facial features, too, seem to alter from picture to picture, and are sometimes mask-like, sometimes more identifiable. In some, Cézanne asserts the oval

shape of her face and her large, warm brown eyes, while in others her face is more angular and her features individualized. Rather than assert a particular unitary identity for Hortense, Cézanne explores her multiplicity, her 'otherness'; the portraits do not yield a consistent image of her but the many ways in which she might appear, or perhaps more precisely, the many ways she is made manifest in Cézanne's act of painting her.[40]

But what do these characteristics of Cézanne's portraits tell us about his feelings for Hortense? The question may turn out to be framed in the wrong way, for what the qualities of these paintings primarily tell us about is what Cézanne sought to avoid in his portraiture. Cézanne's portraits involved a series of negations of the typical role of portraiture of his time, out of which an alternative conception of portrait painting emerged. Cézanne eschewed the ready codification of the subject according to traditional theories of mimesis and expression, whether in respect of line or colour. It was this 'given' and 'transparently readable' character of representation that Cézanne's painting sought to repudiate in favour of something more exploratory and phenomenological: an exploration of the other produced out of the performance of the act of painting. The body of the other, as Merleau-Ponty puts it, becomes 'the theatre of a certain process of elaboration, and, as it were, a certain "view" of the world'.[41] This inevitably gives an oblique and half-legible character to his portraits, which capture not Hortense herself but the labile process of formation involved in the successive acts of perceiving and materializing her presence before him. These paintings therefore cannot simply be seen as depictions of Hortense, but are in many ways a form of self-painting. That is, they are a record of the artist's way of seeing the model before him rather than of the model itself. Subject and object become indistinct; the painting is not merely an image of the one or the other, but the product of the encounter between them in and through the act of painting.

5

Solitary Pleasures

It is in the Still life that we frequently catch the
purest self-revelation of the artist.
Roger Fry[1]

The 1880s was a period of important changes in Cézanne's life
and art. The death of his father in 1886 freed him from financial
concerns. Cézanne was now a wealthy landowner in Aix and
able to pursue his art with complete independence. Despite his
new affluence, Cézanne continued to lead a simple and modest
existence. His great luxury, he boasted, was being able to buy
expensive paints. The period ushered in the artistic style and
preoccupations of his later work, which was the consequence not
only of the natural evolution of his painting but of the result of this
newfound independence. His painting became more expansive,
wilful and ebullient, free of the constraint of the 'constructive
stroke' that he had used in organizing his pictures for the brief
period of the late 1870s and early '80s.[2] Many works were executed
on a larger scale and revealed a new fluency and ambition in
bringing together his interests in painting directly from nature
with his admiration for the old masters, which now became
more visible across the whole range of subjects he treated, not
just his bathers. This moment when his work was most informed
by tradition was also his greatest period of experimentation.

Furthermore, it is during this period that he settled again in Aix and ceased sending work to the Salon. His slowly growing band of admirers talked about him as an *isolé* (isolated person) who had consciously taken leave of the art world in Paris and whose unique art depended on that separation. Though Cézanne was not the recluse he is sometimes portrayed as – he continued on occasion to paint with friends and companions old and new, even acquiring a small following of younger Provençal artists and writers – solitariness was something that became integral to the conception and interpretation of his art. Visitors were usually discouraged. Nostalgia permeated his reflections of the past; many of his closest friendships now waned. Old friends would occasionally see him fleetingly in the streets of Paris, where he would often stay to study in the mornings at the Louvre or visit his family. But he mostly kept to himself and only occasionally corresponded with them. The last letter he wrote to Zola was to cordially thank him for sending a copy of *L'Oeuvre*. We do not know how he felt about its unflattering portrait of its protagonist, but its publication marked the end of their correspondence. Nevertheless, Cézanne shut himself away and wept bitterly when, on 29 September 1902, he was told of Zola's death. Cézanne's closest confidant over the 1880s became his son, and as tender and doting as his correspondence with young Paul is, few of his most intimate reflections about his life and art are to be found in their letters to each other.

Little of much significance seems to have happened in Cézanne's life to disturb the routine of his painting and when it was interrupted he could be formidably tetchy and prone to outbursts of anger. Anxiety and doubt lingered over whether his art amounted to anything and how his art might be measured against the old masters. All of this weighed heavily on him.

It seems to me I am seeing better and thinking more
clearly about the direction of my studies. Will I reach

the goal I've sought so hard and pursued so long? . . .
while it remains unattained and will disappear only . . .
when I've realized something that develops better than
in the past, and thus becomes proof of [my] theories.[3]

In the socially conservative milieu of his native Aix, he cut
a somewhat unconventional and withdrawn figure. The local
children had long tormented him. Cézanne also had his enemies
in Aix. When – on the sale of Zola's estate in 1903, which included
nine paintings by Cézanne, all from the 1860s – Henri Rochefort
published his incendiary article on the artist, in which Cézanne was
labelled a 'Dreyfusard in painting', someone printed multiple copies
and distributed them around the town. 'Life is becoming deadly
tedious', Cézanne confided to Solari in a letter dated 23 July 1896,
'to relieve the boredom I paint.'[4] If one asks where in these later
years the biographer will discover the life of Cézanne, the answer
is in his work, in the daily pattern of labour that dominated his
life as an artist and the sheltered world he created for himself
in the studio. Traditionally, biography has seen an artist's work
as reflecting his life, but this presents a one-dimensional way of
understanding an artist's life in relation to his art, particularly in
the case of an artist like Cézanne, who devoted himself with such
entirety to painting. In many respects, it was his art that determined
his life, instilling habits and routines of working that preoccupied
him absolutely. While biographers tend to focus on the large events
that happen within their subjects' lives, a life is as much shaped
by the patterns dominating its daily existence that provide it with
continuity and consistency as it is by the events themselves that seem
to change it. When Cézanne stated that Pissarro had given him a taste
for work, he meant that he had come to understand the intensive
and unrelenting labour his art required. Through work, he made
over his life as artistic pursuit, a life devoted to acts of form-giving
(of giving form to his perceptions of nature in painting). The patient

and painstaking observation it demanded of him developed and educated his perceptual faculties and consequently guided the evolution of his painting. Work became his life; it shored up his morale, gave pattern and purpose to his existence and afforded him some measure of self-mastery, agency and self-expression. In a letter to Zola, he wrote: 'I hope you soon recover your state of mind in work, for it is, I think, and in spite of all the alternatives, the only refuge where one can be at peace with oneself.'[5]

The working methods Cézanne developed over the next two decades placed strong demands upon him. He slept little and restlessly and rose early with the dawn to begin painting. Bernard noted the disciplined regime he imposed on himself. 'He got up early, went to his studio, in all seasons from six o'clock in the morning until ten thirty, came back to Aix again to eat, and left again immediately after for the motif in the landscape, until five o'clock in the evening. Then he had his supper and went to bed immediately after.'[6] Though accounts of Cézanne's habits vary in detail, his life followed an unbending routine. Weather permitting, in the mornings he hired a horse and cart to drive him to secluded landscape motifs far from the beaten track of tourists and visitors, and divided his time between painting in the country around Aix and working in the studio on still-life paintings, portraits or his bathers. Although he has come to be seen quintessentially as a painter of the Provençal landscape, the importance of the studio for him as a place of production cannot be understated, nor can the importance of still-life as a disciplining mechanism that daily preoccupied him. This was to play a decisive role in the development of his art.

Meyer Schapiro, contesting the dominant formalist interpretations that by the 1960s had become a restrictive orthodoxy in the interpretation of Cézanne, argued that Cézanne's choice of motifs demarcated specific fields of public and private value that consciously or unconsciously carried associational content.[7] But

what exactly is meant here by referring to still-life as a field of values? At first glance, still-life, regarded as the most impersonal and objectifying genre in painting, might seem to offer little insight into the life of an artist. Traditionally, its supposed detachment from human values placed still-life at the bottom of the hierarchy of genres. In the nineteenth century, still-life was regarded as a technical exercise in mimesis, training for the artist in imitating the world's appearances, simulating the visual and tactile qualities of objects. The technical skills associated with the figure (movement, expression, anatomy and spatial manipulation) were understood as exceeding still-life painting with its shallow space dominated by the frontal plane, its apparent lack of psychological interest and its inanimate objects. But although still-life painting was generally regarded as devoid of the intrinsic value and seriousness of purpose attached to figure painting, the notion that any subject could be of interest on the basis of how the artist treated it, combined with the new emphasis on the complexities of perception associated with modern art, meant that by mid-century it underwent reassessment. Defences of still-life asserted its lack of subject, which made it an ideal vehicle through which painters could express the particular attributes and significance of an artist's style and *tempérament*.[8] Still-life's lack of subject focused attention on the way in which the motif had been painted and what this communicated about the painter. The painter Alfred Stevens argued that one could best judge the sensitivity of a painter according to the manner in which he presented a flower.[9]

Though Cézanne believed figure-painting was the most important subject for art, from early on he produced a number of ambitious paintings that revealed his awareness of different models of still-life painting, most especially the compositions of Chardin, considered France's greatest still-life painter, and contemporaries like Bonvin, who adapted the tradition of Spanish still-life painting to French naturalism. These also show his aim to make still-life

communicate his artistic personality. His early Salon submissions included robustly painted still-lifes, which sometimes shared the strange and hallucinatory qualities found in his early figure paintings. The curious, disparate ensemble of objects that populate pictures such as *La Pendule noire* (The Black Clock, *c.* 1867–9), combined with the intensity of its raking light and distorted mirror reflection, create an atmosphere to his pictures quite unlike those of his contemporaries. Contemporary paintings often alluded to the genteel, fashionable interiors of bourgeois domestic spaces, or carried anecdotal significance. Their ensembles and settings clearly invoked the absent life to which the objects materially belonged and the social customs associated with that milieu. Cézanne's pictures, by contrast, avoided any such references in favour of more enigmatic contexts. In so far as they signified identifiable spaces, these were the bohemian spaces in which the artist lived and worked.

It is possible broadly to date some of Cézanne's still-life paintings by their backgrounds. In some, we see the olive-yellow wallpaper with a lozenge pattern containing a cross-shaped motif that decorated the small apartment he rented in the rue de l'Ouest, Paris, throughout 1877, while towards the end of the decade a number feature floral motifs on the wall. The plain background walls of other works indicates that they were made in his studios in Aix. Though it is often said that Cézanne only painted his studio once – in *La poêle dans l'atelier* (The Stove in the Studio, *c.* 1865), a small painting inspired by Delacroix's *Coin d'atelier* (Corner of the Studio, 1830) – he made the studio the recognizable setting of his still-life painting. The setting of the studio of his later still-lifes is significant, alluding to the artist's place of production and self-consciously foregrounding the fact that these ensembles were artistic motifs specifically composed for painting. Objects are displaced from social use and custom and given an autonomous life. Though this is made explicit by the inclusion of stretchers, palettes, easels and other related objects,

mostly it is implied by the lack of signifiers that would suggest any alternative context. This aspect of his still-life paintings is also registered in the way that they largely avoid any allusion to the seasons, codes and rituals of social customs found in the pictures of many of his contemporaries. But though these compositions might declare themselves as artistic motifs, this does not mean they were entirely devoid of particular meanings or values. They intimately reflected the lifestyle and the milieu Cézanne occupied.

By the 1880s the components of Cézanne's still-lifes had become an almost unvarying assortment. Though diverse, all the objects were products of a local rustic, artisanal way of life quite distinct from the industrial production that was transforming the economic structure of France. They were predominantly composed of fruit pieces: apples appear in more than a hundred paintings, and pears were painted more than 65 times, probably favoured for their variation of tone and lustre. Other fruit (grapes, apricots, peaches, oranges and cherries, among others) feature more occasionally. The agricultural produce of the region was supplemented by an array of ordinary, domestic ware produced by local craftsmen: glazed olive and ginger jars, white faience *compotiers*, straw baskets, roughly textured soup tureens, pitchers, oil lamps, a tin coffee pot, wine glasses, bowls, plates and water jugs. These objects symbolized a country way of life that was already feared to be disappearing – the ethnographic Museé Arlaten was established in Arles to preserve folk objects of local artisanal skill, though they were common enough in the region.[10] In his still-lifes, Cézanne invariably placed such objects on plain wooden tables, or draped them with locally produced plain, white linens or fabrics with floral patterns. Though in the 1870s, with Cézanne concentrating on questions of style, these were often arranged in simple compositions, in his later work these modest, artisanal elements were being used to compose extraordinarily richly coloured and complex compositions. Gasquet recollected Cézanne speaking of

his wish to endow the representation of the material presence of such objects with an intensity of feeling and grandeur in and of themselves.[11] As this suggests, Cézanne sought to portray these familiar and banal objects as something possessing its own beauty and able to provide the material of ambitious subject matter.

The artisanal character of these still-lifes was reflected in the environment in which Cézanne set these paintings. In his lifetime, Cézanne rented many studio spaces and was sometimes forced through hardship to work from his apartment, but after his father's death, he initially had a studio in the Jas du Bouffan and rented studio space in Paris. Cézanne's views of the Jas de Bouffan from this time reveal his strong attachment to his childhood home. They no longer focus on the grounds, as they previously had, but prominently feature the house itself, its facade given a monumental appearance gently framed by the grounds' many trees and vegetation, as though in the wake of his father's death he was symbolically asserting his possession of it. Yet he would not possess it for long. Following the sale of the family estate, Cézanne relocated to an attic studio at 23 rue Boulegon, located close to an apartment he had rented there. In 1902 he commissioned a local architect, Mourges, to build a house with a purpose-built studio on land purchased on the northern outskirts of Aix, along the road of Les Lauves, a short walk away from a valley that looked onto the Montagne Sainte-Victoire.

Unhappy with the ornamented Swiss chalet of Mourges' original design, Cézanne had the building torn down and rebuilt. The revised structure was a humble, traditional *cabanon*, an austere, stripped-down cottage typical of Provence.[12] The building was constructed from local stone coated with sand from the Bibémus quarry. Its pale-ochre facade, red-tiled roof and light-blue shutters were in keeping with the style of local farmhouses. The front had a 6-m (20-ft) terrace divided from the garden by a narrow wall that led down to a canal. Inside, the first floor had a reception and living quarters. The studio was located on the second storey and

Photographs of the exterior and interior of Cézanne's Les Lauves studio.

measured 7 × 7.6 × 4 m (23 × 25 ft wide × 13 ft high). The south wall had three large windows, two of which afforded a panoramic view of Aix with the bell towers of Saint-Saveur cathedral and the Étoile mountain range with its protruding square Pilon du Roi. The north wall was customized and contained a long, narrow slit in the wall for moving large canvases. It had a huge window overlooking a densely wooded plot belonging to a neighbour. As Jan Birkstead has argued, the studio's windows reproduced the structural division in Cézanne's landscape painting between prospect and aspect, the majestic open space of the former's panoramic view and the compressed space of the latter's compacted forest, with the studio as an intermediary, observatory space between them.[13]

Visitors to the Lauves studio, like Bernard, Rivière and Schnerb, commented on how austere and barely furnished it was. Some prints hung on the wall, a few framed but most simply pinned up. The studio also contained a white plaster statuette of a cupid then attributed to Pierre Puget. The furniture was old-fashioned and artisanal: plain chairs and chests of drawers and a scallop-edged table. This plainness reflected the simple lifestyle the artist had adopted, one far removed from the consumerism that had taken root in the capital. The studio was quite unlike the opulent and grandiose studios favoured by successful artists in Paris, whose fashionable and luxurious interiors were designed to impress their patrons. Artists of the time increasingly saw the studio not simply as a workplace but as a space of self-fashioning. Photographs of artists' studios became commonplace in journals, serving to relay a suitably constructed image of the artist to the public. By the end of the century the private space of the studio had become a space of public fascination and fantasy. In the atelier novel it was depicted as a space where alternative lifestyles to those of the 'respectable bourgeoisie' flourished, a place of struggle for success, or of sexual intrigue; the relationship between artist and model was the focus of public fascination.

Traditionally, the studio was represented as a social space, where artists, patrons and others could meet and exchange ideas collectively. But under the sway of Romanticism, an alternative image arose of the studio as a place of solitary retreat, where the artist worked through his theories, separated from the wider society around him.[14] Balzac portrayed it as such in *Le Chef-d'oeuvre inconnu*. Though the image of the artist's studio was of a space apart from bourgeois society, in actuality it symbolized the increasing emphasis the bourgeoisie placed on the interior as a space of freedom and sanctuary, the place where individuality could creatively and intimately best express itself.

By the end of the nineteenth century discourses on modern metropolitan life had become focused on fears about the depleting effect of the conditions of contemporary urban existence, which was widely regarded as producing neurasthenia and a range of nervous disorders. Such concerns spurred new sociological and psychiatric research into neurosis and scientific investigations into various forms of perceptual and attention deficit disorders or anomalies, of which the synaesthesia so often cultivated by writers associated with Symbolism was taken to be a prime example. For instance, the neurologist Jean-Martin Charcot's investigations into the suggestibility of patients under hypnosis seemed to offer evidence of the way in which external influences operated below the threshold of consciousness. His research provided a conception of the subject as neither really defined, permanent or stationary but rather as illusive and floating, multiple and intermittent and as such continually subject to the febrile suggestive power of the external environment.[15] Charcot's characterization of the furtive influence of external factors and unconscious forces on the subject's psyche, and later the investigations of Freud, profoundly compromised the idea of the bourgeois subject as an autonomous individual with a clearly defined personality and the ability to exercise free will.

In the remote countryside around Aix, or alone in his studio, Cézanne was at ease in his solitude and far from the distractions and deleterious effects of modern capitalism. In such surroundings, the studio interior offered a regenerative, sanitized and vitalizing *enveloppement* to counter the perceived anxieties, exhausting pace and overstimulating sensory barrage of the spatially denatured modern city that, it was feared, pacified mental will, eroded nerve fibres and penetrated deep into the subject's psyche. The artist's studio, set in the countryside, thus became conceived of as a self-sufficient realm emblematic of autonomous self-containment, a space at once removed from the contingencies of modernity but whose decor, combining evocations of natural imagery, dreams and allusive fantasy, constructed an alternative space of the virtual that substituted for the frenetic and depleting public realm. In short, this interiority became a place where self-fashioned subjecthood reasserted itself over the divided self that inhabited the public domain.

The limitations Cézanne placed on the presence of others in the studio indicate how much the production of his art was conditioned on undistracted solitude. His need to exert control over the working conditions of production could, on occasion, seem inordinate. Vollard complained that he was made to sit in silence and treated like a still-life when posing for his portrait. Cézanne tended to paint only those he knew well or who were farmhands in his employment. He did not employ female models for his bathers pictures, though whether this was due to personal inhibition or his fear of what his conservative, Catholic family and the town would say is a matter of speculation. But if the studio was essentially a private space where the inhibited and anxiety-ridden Cézanne could feel most at ease and express himself most freely, it was not, Schapiro argued, a place where the artist could be wholly free from the repressed contents of his unconscious. These latent contents left their mark on his still-lifes, gaining veiled expression in his painting, investing it with

hidden meanings and associational valences. His still-lifes were, as Roger Fry put it, 'dramas deprived of all dramatic incident'.[16]

The studio was not only a place for the production of still-lifes, but where Cézanne would work on a range of subject-matters. The compositional convergences that emerged in the last thirty years of his career between his pictures in different genres reveal the fertile interchange between them as he worked from one subject to another. For Schapiro the relationship between the still-lifes and the bathers was a richly complex and dialectical one that offered particular insight into the workings of the artist's psyche. Starting from the premise that Cézanne's imagery of women was informed by an unresolved Oedipal attachment to his mother that never allowed him to reconcile the notion of ideal love with actual sexual relations and possibly also by feelings of guilt associated with his Catholicism, Schapiro argued that still-life progressively became the medium through which these unresolved conflicts were unconsciously expressed. Throughout his life, Cézanne struggled freely to give expression to his sexual desires without anxiety or conflict. And his relations with women were often fraught. Renoir stated that Cézanne once told him: 'I paint still-lifes, women frighten me.'[17] His paintings of the female nude epitomized this, and such pictures could only be resolved or brought about by recourse to an older work on which the painting was modelled, or through the imposition of strict compositional design or a pre-given classical, compositional form from the old masters, which served to contain such expression. While Cézanne's early nudes had included both urban and pastoral subject-matter, freely intermixed male and female figures and contained explicit content and voyeuristic and violent fantasies, by the 1880s his imagery of the nude had become transformed into more tranquil scenes of bathers divided into separate groups of male and female. Though at intervals, violent rape scenes and other disturbing content briefly reappeared, generally this content was

repressed and the eroticism of the pictures was muted and often characterized by what Schapiro referred to as 'classical constraint'.

Around the same time, Cézanne's still-lifes were becoming freer, more intense in saturation, more expansive, exuberant and distinctively ornate, as if these sensual qualities of the pictures had suddenly become amplified. Noting the association in Cézanne's poetry and pictures between the imagery of fruit and sexual desire, a metaphorical association deeply embedded in Western iconography, Schapiro argued Cézanne's favouring of fruit motifs, and in particular apples, had latent sexual meanings that occasionally more overtly revealed themselves. In *Nature morte avec l'amour en plâtre* (Still-life with Figure of Cupid, *c.* 1895), he grouped at the base of the fragmented Puget cupid statuette an ensemble of apples and onions, the latter's stems giving a phallic inflection to their form that contrasted with the more 'female' form of the apples. The personalized nature of the painting is suggested by the inclusion in the background of a painting after a Michelangelo *écorché*, an oblique reference to his nickname at the Académie Suisse. Painters often made associations between the sensual surfaces of fruit and the body, as did writers of the time. Zola had made comparable metaphorical associations between natural forms and sexuality in his novel *Le Ventre de Paris* (The Belly of Paris), where the ripeness and shape of the apples in the fruit market at Les Halles are compared with women's breasts and buttocks.

Still-life therefore, Schapiro stated, became the medium through which Cézanne sublimated and gave acceptable form to his conflicted and guilt-ridden desire. The patient, empirical observation of nature his still-life painting involved served on the one hand to discipline his anxious and violent feelings towards women – a mechanism of self-mastery – but on the other hand to provide a displaced outlet of sensual feelings. In this context, still-life painting, the genre over which Cézanne could exert the most control and self-mastery, paradoxically became the primary means

Still-life with Plaster Cupid, c. 1895, oil on paper mounted on canvas.

through which the artist expressed his sensuous freedom and in a form in which his unconscious feelings remained for the most part veiled. These paintings were also works that contained the vestiges of memories and unresolved unconscious feelings that stretched back to Cézanne's childhood. On his Lauves studio wall hung an Adriaen van Ostade etching of a peasant family in an interior, an image at odds with his normal tastes, but one that Cézanne

nevertheless valued and copied. He remarked to one visitor that it was an image that for him evoked an ideal of happiness, a happiness perhaps lacking in both his parents' marriage and his own. How might this image have informed Cézanne's still-life painting? Given the problematic relationship Cézanne had with his father, was the repetitive act of composing his still-life ensembles on the studio's old artisanal tables – possibly furniture that he had salvaged from the Jas du Bouffan – a way through which he unconsciously revisited the family scene of his childhood? If so, what are we to make of the strange compositional imbalances in some of the still-lifes where objects seem almost to be about to tumble from the table? Could this be construed as a symbolic disruption and disordering of the family table? Recalling Cézanne's youthful poem, 'Le Chant de Hannibal' (Hannibal's Song), in which a young hero is reproved by his father after the hero gets drunk at a banquet and brings a table crashing down, Schapiro argued that the act of ordering and disordering the still-life ensembles on the table symbolically enacted a subconscious tension between disobedience, guilt and reconciliation.

Such arguments must inevitably remain provisional and open to question. One may argue about what access we might have to the private thoughts of the artist or his unconscious associations, and how stable or fluid such contents of the mind were. It might be argued that these readings reveal as much about the hermeneutics of psycho-biography as they do about the artist. But beyond the specific detail of these arguments, the notion that the objects Cézanne painted were invested with both conscious and unconscious memories and associations rather than merely objective props seems uncontestable, even if Cézanne sought, as Gasquet suggested, to paint them as such. But while Schapiro's arguments remain intriguing, they can obscure what is most immediately evident about Cézanne's life as reflected through his art.

In many respects Cézanne's life in the studio and the still-lifes he composed there offer the most illuminating insights into the way in

which his later working life was determined by his art, in particular by the disciplining demands of a genre in which the dialectical relationship between perceiving and representing came to the fore. These pictures could be described as an observatory of visual constellations in which the pleasures of a conscientious *curiosité* are ever present and the pleasures and problems of visual transcription of *sensation* take centre stage. They show the artist seizing every opportunity for enlarging, multiplying, clarifying, analysing and deepening the perception of his motif as he successively looked at it over the duration of a composition. This we know was a lengthy and exacting process. Though technical analysis shows Cézanne's painting procedures varied as to how quickly or slowly he painted, the slow method of working of much of his later painting placed limitations on the progress he could make in the completion of works that required a model or were painted *sur nature* (from nature). Still-lifes could be studied uninterrupted in the studio over a long period and as such are frequently more complete and resolved than his work in other genres. Even so, according to Vollard, Cézanne resorted to wax fruit and paper flowers to replace the actual fruit and flowers that withered and rotted during the long sessions he worked on his paintings; pictures from the 1880s on provide ample evidence of this in the unnaturally regular, geometrical shapes of the depicted fruit and flowers, which are quite unlike the pocked and scarred surfaces of the fruit pieces of Chardin or Courbet.[18] The resulting paintings reflect an optical pursuit that imitates scientific scrutiny in its quest for precision but not in the pictures that result, which instead become a record of the artist's act of looking, his presence and the decisions and deliberations that ensued in the process of the motif's translation into painterly form. To recognize the difficulties involved in that act of translation brings us into an understanding of the problems painting posed for Cézanne and why it was so time-consuming, one might say life-consuming. If later admirers like Roger Fry could find in Cézanne's paintings the perfect

synthesis of aesthetic form, these still-lifes nevertheless more often than not bear witness to the interminable perplexities, indecisions, contingency and disequilibrium that Cézanne so often discovered in the act of painting.[19]

It is precisely this prolonged immersion of Cézanne's painting in the world of optical visual *sensations*, most acutely during the period from 1880 on, that for Maurice Merleau-Ponty gave it the character of a phenomenological investigation, a describing and reflecting upon the process by which perceptual knowledge of the world is acquired and given expression.[20] Cézanne rejected both naturalist painting, with its acceptance of the appearance of the motif as given, and the intellectual idealism of painters who committed themselves to a theory of art as an expression of the imagination, an outward projection of an inner world. Instead he painted the sensible configuration of the natural world as it appears in all its sensuous richness and perceptual complexity, registering the dense materiality of vision as it emerges in relation to our experience of the lived body. This Merleau-Ponty described as the carnality of vision – by which he meant that in *sensation*, the body and eye, nature and the canvas, self and the world became one totality rather than binary oppositions separate from each other. For Merleau-Ponty, Cézanne's reflexive self-consciousness and his desire to draw conclusions from the phenomenological experience of perception in the acts of painting were what differentiated his art from his Impressionist colleagues. The complexity of Cézanne's paintings arose from the fact that he did not so much paint the objects of his still-lifes as the act of perceiving the objects – their 'becomingness' in the act of perception and depiction – searching for ways of truthfully and adequately translating and communicating this in and through the picture surface.

Cézanne's dogged commitment to this objective of incarnated vision necessitated the abandonment of linear perspective and its

mathematical construction of space in favour of painting the visual *sensation* as given in experience. Traditional pictorial perspective is a system that is the product of an exclusive rationalization, of the intellect's arbitration of the lived experience of space and the palpable life of things, a mechanical system that presents the appearance of a domination and mastery of space itself and whose fixed point of view imposes a univocal, omnipotent point of surveillance over the world. Cézanne's renunciation of this system and its restrictive mode of representation led him towards a way of painting based on an acute sensitivity to visual effects in actual perception. The pictures that result are a record of a natural perception unconstrained by the traditional, abstract rules of perspective with its implicitly monocular and static point of view. Painting thus re-envisioned becomes a particularized record of lived perspective rather than the objective, abstract perspective of the totalized visual field. Still-life was integral to this phenomenological character of Cézanne's art, as it is the genre furthest removed from the tradition of perspective, the one in which space is most compressed and where the material relation between the senses, most especially sight and touch, comes to the fore.

In painting this lived perspective, Cézanne draws our consciousness not only to what is present in perception but to the *invisibility* of the visual, that which invariably passes as unnoticed to us but is actually in the visible – that is to say, that which can be seen only when disclosed to us. In this way, Cézanne reveals the world to the viewer uncontrolled by the censoring rational faculties that correct natural vision.

By showing not only the things represented in themselves but the process of how we see them, Cézanne heightens awareness of perception as an object in itself. As a result, one of the most fascinating and enigmatic features of these still-lifes is the many 'distortions' of perspective and spatial inconsistencies evident in almost all these works. In *Nature morte au plat de cerises* (Still-life with

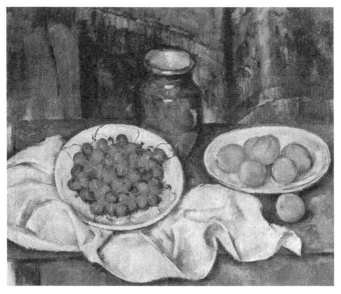

Nature morte au plat de cerises, 1885–7, oil on canvas.

a Plate of Cherries, 1885–7) the consistency of the strictly frontal arrangement is interrupted by a number of 'distortions' in the depiction of the objects and the table on which they rest. The plate of cherries and tabletop are tilted upwards almost vertically, while the ellipse of the plate of apricots is flattened out, forming almost an oval shape. In addition to this, the olive jar in the central background appears to be viewed from two perspectives: the body of the jar is seen from approximately eye-level, but the neck of the jar is viewed from a higher vantage point looking down onto it. The line running from one edge of the table to the other is broken at the point at which the olive jar bisects it. Consequently, the line defining the edge on the left-hand side appears much higher than that on the right. This distortion cannot be reconciled with the portrayal of the front edge of the table that is rendered as a consistent line running parallel to the picture plane.

In another example, *Pot de primevères et fruits* (Pot of Primroses and Fruit, 1888–90), a comparable set of distortions is present in the ellipse of the plant pot and the edge of the scalloped plate. This work also displays a discontinuous line running from one end of the table to the other. X-rays show that initially the artist painted the table top as a straight line running parallel to the picture frame, but later altered the angle of the table to create a line that is discontinuous. These inconsistencies undermine the sense of a single, consistent point of view. Although we initially view the ensemble as though it is at eye-level, we become aware that other spatial cues of the picture do not conform to this vantage point. The ellipses of the flowerpot and the plate on which the fruit sit seem tilted towards us as if we are looking down on them. Similarly the discontinuous line of the table no longer suggests that it has been viewed from one vantage point alone; it appears as if the painter had shifted his point of view in the course of scrutinizing the motif.

When asked by Rivière and Schnerb to explain the distortions in his still-lifes, Cézanne joked that he had a 'lazy eye', but went on to relate his 'incorrect' drawing to his commitment to paint with *sincerité* and 'horror of the photographic eye'.[21] This suggests that he felt it necessary to preserve these distortions despite their superficial incorrectness in order to remain faithful to natural vision and responsive to the perceptual chaos of raw *sensation*. His attempt to see and render his works with *naïveté* required the unlearning of the framework of conventions that conditioned the production of painting but also ways of seeing and ordering the world. According to Borély, Cézanne remarked: 'Today our vision is not what it was, exhausted by the memory of thousands of images in the museums and around us. We do not see nature anymore, we see its representations.'[22] This suggests that he regarded the memories of these images as well as the inherited conventions of systematic perspective as a fetter to seeing, dulling the senses and vital faculties and determining what we can

visualize. It follows that the scrutiny he brought to bear in studying his motifs provided a means by which he revived, trained and tested the sensitivity of his perceptual faculties. For Cézanne, questions of perception were therefore connected to distinctions between forms of 'authentic' and 'inauthentic' knowledge of the world and finding his own 'true' way of visualizing it.

Cézanne's familiarity with contemporary optical theories meant he would have been aware of the artificial basis on which systematic perspective was grounded. As nineteenth-century writings on optics confirmed, the field of vision that the eye could take in through one glance constituted an arc of no more than seventeen or eighteen degrees rather than the expanded field of vision present in pictures with single-point perspective. It seems probable that this consideration influenced Cézanne's choice of a distant viewpoint from which to view his motifs and contributed to the effect of the compression of space in his paintings. Many of the apparent distortions and incon-sistencies present in his pictures, for all the painter's insistence on the subjective nature of his particular vision, can be objectively demonstrated. For instance, the discontinuities in the lines of the tables in his paintings correspond to a visual phenomenon much discussed and illustrated in nineteenth-century texts on psychology and aesthetics, whereby if the trajectory of a straight line is occluded, the point at which it reappears will appear discontinuous.[23] Similarly, Cézanne's remarks to Bernard about the way straight lines appeared to him to fall, or the difficulty he spoke of in discriminating planes and contours, were effects well documented in perceptual psychology, including Hermann von Helmholz's treatises on optics, which he mentions reading in his letters.[24] The recognition that perception was not uniformly constant but ebbed and flowed according to the shifting rhythms of consciousness meant that the perception of objects in the visual

field was not stable.[25] The longer one gazes at an edge, therefore, the more likely one is to become uncertain about its exact coordinates. In Balzac's *Le Chef-d'oeuvre inconnu*, the artist Frenhofer indicated that it was precisely on account of being true to such visual phenomena that he had abandoned the idea of the single closed contour.[26] In a letter to Bernard, Cézanne explained how the apparent abstractions or incompleteness of his paintings resulted from the optical complexities of his *sensations* of nature.

> The *sensations colorantes* that create light are the reason for the abstractions that do not allow me to cover my canvas, nor to pursue the delimitation of objects when their points of contact are subtle, delicate; the result of which is that my image or painting is incomplete . . . But consulting nature gives us the means of achieving this goal.[27]

Cézanne's sensitivity to the way in which the interplay of colours and forms alters the perception of the shape and size of objects accounts in part for why the paintings often contain a myriad of redefinitions of contours. His way of advancing his paintings ad hoc indicates the degree to which he responded to the perceptual complexities his motifs presented to him. From what we know of his methods of working, it is clear that he abandoned the standard formal procedures conventionally employed to develop a painting from inception to completion. As Cézanne believed he could not render his *sensation* initially or all at once, he adopted a more provisional and intuitive way of working that allowed him the maximum flexibility to respond to the motif and make revisions as he progressed. Rather than subordinating the evolution of the painting to a pre-established idea, as was standard academic practice, Cézanne constantly adjusted and readjusted the picture as he progressed.

Cézanne's willingness to remain faithful to natural optical effects that appear in vision led him to retain rather than correct the distortion of conventional perspective. His way of depicting matter as it takes on form in perception gives full weight to the oscillating appearances of objects in space as they actually present themselves to the eye. The prolongation of the act of perception serves to draw attention to how objects do not remain stable within the field of vision. Cézanne's notorious deliberations over the contours of objects, all those broken lines and pentimenti that successively redefine the position of objects in space in his paintings, give recognition to all that is ambiguous and unstable in perception, leaving present the artist's deliberations and decision-making process in the act of painting. They give expression to what the mind rationally censors of vision. The odd disjunctions in scale and point of view in Cézanne's pictures thus register all the adjustments of perspective that arise from the barely imperceptible motions of the body of the painter in viewing the motif from slightly adjusted vantage points or from the mutually reciprocal influence of colour, shape and size of objects in natural perception or the psychology of vision; near and far seem to collapse as Cézanne focuses on different parts of the visual field. The memory of an object looked at is carried over in the perception of another object in the field of vision as the observer looks from one object to the next, or from one part of the visual field to another.

Yet to see all the 'irregularities' of drawing and perspective in these still-lifes as having their source in the transcription of optical *sensations* would be to ignore evidence these works provide as to other reasons for these distortions that supplement the former. Many of the more unusual features of Cézanne's paintings, such as the tilting appearance of some objects or the surfaces of the tables, were in some instances contrived compositional effects designed to achieve a more unified composition. According to Louis Le Bail, who worked with the painter in 1898, Cézanne used coins to raise up

certain objects in his ensembles. He also used books, and occasionally in some later works these objects which prop up the motifs are left exposed.[28] Such distortions mitigated the 'deadening' symmetries of more orthodox still-life pictures, creating an intricate network of correspondences between the forms of objects in his paintings. It is often out of these correspondences that Cézanne sought to achieve a fragile pictorial harmony.

To recognize that these distortions cannot in every instance be explained optically brings us back again to the problem that haunted Cézanne and the doubt Merleau-Ponty saw as permeating his painting. The fact that, as Le Bail suggests, he was prepared to go to such lengths to manipulate the actual appearance of his ensembles in order to communicate his imagined ideal of unity is an indication of how committed he was to this principle. But that commitment existed in a complex relationship with the material problem of reconciling the demands of remaining as true as possible to the phenomenal truth of what he could observe – his *recherches sur nature* – while continually confronting the limitations of the medium in expressing this experience and in a way that created a satisfactory aesthetic effect. If nature contained certain principles of harmony and unity that he sought to give form to in painting, the perceptual *sensations* of his motif, the communication of this harmony seemed so often to rest on a recognition of the necessity of resorting to artifice – the manipulation of the arrangement of the motif in order to guarantee a unity that the protracted scrutiny of the ensemble seemed not to allow. It was perhaps at such moments that the distance between the language of painting, made up of touches and smears of paint, and the world as it instantaneously appeared in its presence before him would reassert itself, where doubt, as Merleau-Ponty characterized it, and contingency would reappear. It is through his still-life pictures that we see how, for Cézanne, the act of observing and painting his motifs brought life into a register of intensity. The demands of

the desire to capture the unity and wholeness of his motifs that they possessed in the instant of looking, and the problems of realization of it when scrutinized over time, explain much of the complexity and struggle of Cézanne's pictures. Life made over into work was the necessary outcome of this.

6

Provence, the Peasantry and Montagne Sainte-Victoire

Cézanne's later years were marked by loss and struggle, by a desire to reclaim the past and overcome the alienation he associated with the modern world. He wanted to realize a style of painting that would express harmony, to find in painting a parallelism with nature. He was never certain he could achieve this, but never quite reconciled to the idea that he could not. His painting was as often about the demonstration of the impossibility of these aims as it was about the assertion of them. Submission continued to alternate with will, unity and totality with contingency and incompleteness, realization with the provisional, empiricism and improvisation with an art influenced by long periods of study after the old masters at the Louvre, individualism with the need to be part of something greater than himself.[1] Though he never replaced the roles in his life played by Zola and Pissarro, in the 1890s Cézanne established close friendships with a group of Provençal writers and artists. The most important of these was with a young poet and critic whose writings on Cézanne were to have an immense bearing on the understanding of his later years. Joachim Gasquet's biography of Cézanne, published in 1921 but conceived and partly written during the Great War, was the fourth full-length book on the painter, though the first from a source who was close to him in Provence during his later life, and as such offered a unique perspective on the artist.[2] Gasquet met Cézanne in March or April 1896, after seeing his paintings at the Société

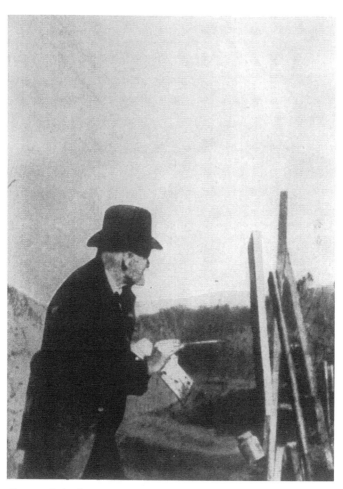

Cézanne painting the Montagne Sainte-Victoire in January 1906. Photograph by Ker-Xavier Roussel.

des amis des arts at Aix, a local exhibition of amateur artists, the previous year. They gradually established a seemingly close and affectionate relationship, Cézanne warming to the admiration of the poet who was the son of the baker Henri Gasquet, a close friend since childhood. There can be no doubt that the admiration between Joachim and Cézanne was not all one-way. Handsome, elegant, with long flowing blond hair, the 23-year-old Gasquet cut a dashing figure. His passionate interest in artistic matters and serious aspirations as a writer perhaps made him an attractive companion and perhaps even a surrogate for Cézanne's son, who was more preoccupied with the hedonistic pleasures of Paris than with spending time in the eminently sedate Aix and showed only a modest interest in his father's art. Moreover, Gasquet's lyrical appreciation of the region's nature and rapturous enthusiasm for the verses of Virgil did much to cement their friendship. Gasquet's poem 'L'Enfant' (The Child, 1900), a reworking of Virgil's fourth *Eclogue*, was dedicated to Cézanne. In a letter to him, Cézanne wrote approvingly of one of the poet's Pindaric verses and his vision of Provence. While vacationing with his family in Talloires, Cézanne wrote to Gasquet requesting copies of *Les Mois dorés*, the review Gasquet had founded:

I commend myself to you and your kind thoughts, so that the links that keep me attached to that old native soil, so vibrant, so harsh, reflecting the dazzling light, and beguiling receptacle of *sensations* – so that these links do not snap, detaching me, so to speak, from the land where I have experienced so much, without even knowing it . . . it would be . . . a comfort to me if you would be good enough to continue to send your review, which will remind me of the distant land, and of your kind youth, in which I've been lucky to play a part . . . I learned with pleasure that Madame Gasquet and yourself will be presiding over the regional and meridional festivals.[3]

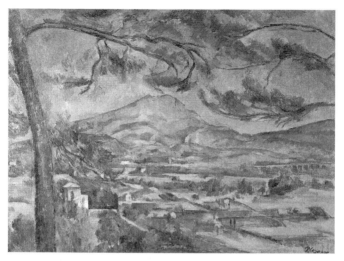

Montagne Sainte-Victoire with a Large Pine, 1887, oil on canvas.

He also wrote to Gasquet's father that Joachim's work had awakened him to 'the present spiritual state in which we find ourselves'.[4] Yet it was as much nostalgia for the world of his youth that drew Cézanne to Gasquet. As Paul Smith has argued, their camaraderie reawakened youthful memories of Cézanne's friendship with Zola.[5] References to particular places in the landscape, most notably to the countryside around the village of Le Tholonet and the Arc valley, where he often met with Gasquet for walks in the landscape, were imbued with deeper personal references, as *locus amoenus*, where in youth he and Zola had composed verses, sketched, bathed in the river or read from their favourite authors. On their walks, Gasquet and Cézanne re-enacted all this, reading passages from Virgil's *Eclogues* as he had in his youth with Zola. Cézanne's letters, from first to last, are filled to the brim with idyllic reveries and reminiscences of long-familiar and picturesque features of the Aixois landscape that he had first explored in his youth. These sentiments and his identification with his native region deepened as

time wore on. His later letters, particularly those to Gasquet, often self-consciously use Provençal dialect.

Gasquet published his first article on Cézanne in July 1896 in the journal *Les Mois dorés*, in which he had already announced his intention to write the artist's biography and mentioned two paintings he'd given him: the *Montagne Sainte-Victoire* (1887) and *La Vieille au Chapelet* (Old Woman with a Rosary, 1896), which hung alongside two works by Van Gogh in the Gasquet house in the cour des arts et métiers. At the time, Gasquet was beginning to make a reputation for himself as a luminary of the Félibrige movement, founded in May 1854, the literary and artistic movement that sought to revive the cultural legacy of Provence. The Félibrige had originally consisted of seven poets of the Avignon area (Frédéric Mistral, Paul Giéra, Joseph Roumanille, Théodore Aubanel, Anselme Mathieu, Alphonse Tavan and Jean Brunet) who sought to preserve the language of the Pays d'Oc, but quickly embraced the work of scholars and artists whose work promoted Provençal life and culture. Under the leadership of Frédéric Mistral, the Félibrige became a broad, inclusive movement able to accommodate diverse styles and subsequently spread across the region and beyond. What linked the artists associated with it was a romantic emphasis on the traditional rural ideals that connected Provence's past to the present. The romanticized imagery of the peasant and the traditional way of life the peasantry was imagined to stand for was at the heart of Mistral's poetry and of his whole ideal of a renaissance of the 'Provençal country' that had, as he saw it, been crushed for the past 500 years under Parisian centralization.[6] Mistral had made the recovery and preservation of Provence's dialect and 'folk life' the basis of a 'return of true values', though to see the Félibrige as simply recovering Provençal cultural traditions would be to underestimate the degree to which it actively created them.[7] Their nostalgia was as much a romantic invention of the past as a recovery of it.

Joachim Gasquet,
1896, oil on canvas.

In an article published in 1898 on Charles de Ribbe's *La Societé provençale à la fin du Moyen-Âge* (Provençal Society at the End of the Middle Ages), Gasquet closely associated Cézanne with the Félibrige, wrote rhapsodically about *Old Woman with a Rosary* as an emblematic image of Provençal peasantry and argued that the historian's impassioned agronomic history of Provence found visual expression in Cézanne's depictions of his native countryside. Cézanne's landscapes, he argued, embodied the 'very soul, the idea of Provence'.[8] Cézanne responded by enthusiastically praising 'the superb lines' in which Gasquet had exalted 'the Provençal blood'. Writing to Joachim's father, Henri, a long-time friend, he added: 'I associate myself with all my heart with the movement in the arts which they [Gasquet and his circle] represent and to which they give its character.' In another letter to Joachim, he praised the seminal role Joachim was playing in the 'renewal of art awakening

in Provence'.[9] There is little reason to doubt his sincerity. Through Gasquet, Cézanne came into contact with an array of Félibres painters and writers: Edmond Jaloux, Louis Aurenche, Emmanuel Signoret, Joseph d'Arbaud, Léo Larguier and Jean Royère, some of whom he continued a correspondence with over the next decade.

This context of the Félibrige deeply informs Gasquet's biography, which is made up of two parts. The first, entitled 'What I know or have seen of his life', charts Cézanne's youth in Aix-en-Provence through to his last years before his death in the winter of 1906. But it is the second part, 'What he told me', which takes the form of dialogues with the artist, that has aroused most interest, as it presents first-hand testimony about Cézanne and his painting. 'What he told me' is divided into three conversation pieces in which Gasquet converses with Cézanne while he paints the Montagne Sainte-Victoire in the Arc valley, visits the Louvre (which dates the dialogue to 1899) and paints a portrait of Gasquet's father Henri in his studio, completed in 1896. Coming from a source closer to the artist than most of the critics who acted as apologists, Gasquet's book provided inside information about Cézanne from the privileged perspective of his closest confidant in the 1890s. Nevertheless, to abstract from these dialogues a theory of Cézanne's art is to read the dialogues against the grain, for they are framed by the dominant belief that his painting could only be understood through a thorough psychological profile of the artist's mind. Gasquet's dialogues with their fractured speech patterns and abrupt shifts in emotional tone were designed to portray the anguish and mental divisions that he believed were reflected in Cézanne's painting and which ultimately explained his difficulties in *realisation*. The conversations are dramatizations, not documents.

The Cézanne that emerges in the book is a paradoxical character, a naïf at times, but one whose discussions about art stray onto subjects as far afield as Darwinism, Eastern philosophy and Schopenhauer; an autodidact of the Louvre, yet fiercely independent;

an artist reluctant to theorize about painting but who nevertheless does so at length. Above all, Gasquet's Cézanne is a painter deeply and mystically attached to his native soil, aspiring to achieve in his art a harmony that parallels that which he perceived as existing in the nature of his native Provence, a landscape the artist describes as engraved on the sensitive plate of his being. It is this relationship to the Provençal landscape that Gasquet is most at pains to articulate. In one passage the artist describes himself as nothing more than a delicate and complex receptacle of *sensations*. In another, invoking the idea of a trans-Mediterranean spirit in painting, Gasquet represents Cézanne as a contemporary Provençal Poussin, forging a renewal of classicism by way of a return to its roots in nature. At one point Gasquet quotes Cézanne as remarking, 'I want to be in touch with a master who takes me back to myself. Every time I emerge from being with Poussin, I know better who I am.'[10] If accurate, this quotation tells us a great deal about how Cézanne's sense of self was deeply connected to the artistic dialogues he conducted through painting (he would later remark to the critic Roger Marx that the artist is not someone who substitutes himself for the past but is a link in a continuous chain stretching back in time), and also how fundamental the engagement with artists associated with the Mediterranean classical tradition was to that sense of self.[11] Cézanne's late work does indeed show him taking on some of the visual and verbal language of the classical tradition. His pictures are often more ornate with consciously baroque inflections. But the expression of this renewal of classicism is no simple matter and Gasquet does not portray it as such. Having discovered that the inherited conventions of painting can no longer simply be repeated, the dilemma of painting becomes one of discovering another moral and intellectual foundation for modern painting – that is to say, in recovering essential qualities of the past, contemporary painting cannot merely be the pale afterglow of them. As the dialogues ensue, Cézanne is depicted as struggling to resolve his painting into

a subdued but shimmering harmony against an absent but always implied backdrop of a dissonant society of mass consumerism.

Gasquet's book became indispensable source material for the writers who shaped the understanding of Cézanne's later work and life.[12] Roger Fry, for instance, took as the epigraph to his seminal monograph on the painter in 1927 Gasquet's quotation from Cézanne that 'art is a harmony parallel to nature', and derived from the book the idea that the 'greater discipline' of Cézanne's later painting was founded upon a repression of his early and still-enduring romanticism.[13] Merleau-Ponty also drew on it in his phenomenological analysis of Cézanne's relationship to nature. Yet though influential, Gasquet's biography has also rightly been considered controversial. Gasquet borrowed heavily from Bernard's dialogues with the artist, *Conversations avec Cézanne*, published in the *Mercure de France* in 1911, a year before Gasquet began his book, and many of its pages carry the voice and views of its author rather than Cézanne. Gasquet's preface claimed he had 'invented nothing' and presented simply what the artist said, but added: 'However objective one would like to be, a little of oneself is always unconsciously creeping in . . . I am afraid that I may be unwittingly guilty of misrepresenting some of his profound teaching.'[14] Jean Royère, a fellow Provençal poet and friend of both Cézanne and Gasquet, described the latter as having the highest faculty for adulterating the things he most admired.[15]

There can be no doubt that for a period the friendship between Cézanne and Gasquet was quite close, but as so often with Cézanne, their relationship was a troubled one. The tone of the incomplete portrait of Joachim, painted in 1896 as a gesture of reconciliation after a momentary rift in their relations, contrasts starkly with the more affectionate portrait of Gasquet's father, Henri, painted around the same time. By 1899 the relationship had undoubtedly become troubled during the period Cézanne temporarily stayed with the Gasquets before moving to his apartment in the rue

Boulegon. Louis Aurenche recalled him looking 'distinctly unhappy' there. Though Cézanne continued to see the poet over the next year, a letter from Cézanne dating from 1901 suggests that they'd ceased to be in regular contact.[16] In spite of the fact that relations remained cordial, after 1904 the poet's name only occasionally appears in Cézanne's correspondence.[17] The promised stack of letters from the painter that Gasquet claimed his book was based upon, and in a note to the original edition had stated he would publish, failed to appear.[18] Those that surfaced did not entirely confirm what he had written. Unlike Vollard, who always took with him a secretary to record his discussions with the painter, Gasquet was recalling from memory conversations that he may have had some fifteen years or more before writing the book. By the time of its publication, most of its biographical information was already well known from Émile Bernard's articles and other recent publications on the artist. Despite the unique quality of Gasquet's overall portrayal, his dialogues are profoundly derivative, woven out of a ragbag of thinly disguised quotations gathered from various contemporary writings on the painter. Their reminiscences are translated into Gasquet's florid idiom and spiced up with his own peculiar synthesis of neo-Platonic and Nietzschean philosophy. The result is a highly eclectic biography, alternately richly suggestive and tellingly awkward in its mismatching of very contradictory contemporary accounts of Cézanne. These contradictions derive not so much from the divisions within Cézanne's own ideas and practice, vividly present as these were, but from an attempt to keep all the terms of the writers he drew upon in play at once. Yet paradoxically, despite these very significant problems, Gasquet's account offers insights into Cézanne's relationship to his native Provence that few contemporary writers were in a position to articulate and much of what he writes about this aspect of Cézanne's painting rings true.

At the end of the 1880s Cézanne began a series of large-scale paintings depicting Provençal peasants. The most important, *Les*

Joueurs de cartes (The Card Players), were a group of five paintings that preoccupied him from the mid- to late 1890s. Though towards the end of his collaboration with Pissarro Cézanne painted *La Moisson* (The Harvest, *c.* 1877), a large, dreamlike landscape with peasants harvesting and relaxing in the foreground, the peasantry was a subject he had rarely treated since. His subsequent return to this subject happened in a period of regional entrenchment when the image of the peasantry took on renewed ideological meaning.

In the 1880s the Republican administration's legitimacy was frequently questioned. The election of 1885 saw the government's majority reduced as economic problems gripped many of the departments across the countryside. By the decade's end the republic faced severe administrative crises, including the Wilson affair and the proto-fascist Boulangist uprising. The relationship between the capital and the provinces became the subject of intense debate. In this volatile political context, the depiction of the peasantry took on renewed significance. Positions from across the political spectrum, from the anarchist syndicalism of Kropotkin to Paul Déroulède's Catholic militarist Ligue de Patriotes, sought to promote alternative rural ideals to the modernization fostered by the Republic. Despite critical differences, these positions shared a vision of a more cohesive, less atomized social order to be set against the industrialized modernization of the Republic.

Though Provence was an increasingly diverse, mixed economy, it remained predominantly agricultural and was severely hit by recurrent crop devastation caused by phylloxera, as well as competition from imported goods.[19] Its less prosperous rural regions became economically depressed and depopulated. Cézanne's depictions of empty and ruined country farmhouses and abandoned quarries shows his awareness of all this. Regional self-consciousness and the inveterate issue of Provençal autonomy was fostered by the belief that Republican policies had failed adequately to address these problems and indeed was in some

respects responsible for them. It was felt that the increasing cultural and economic interface between north and south facilitated by the railways, the mass media, the standardization of secondary-school education and conscription was eroding traditional ways of life. Recognition of the extensive changes taking place in Provence and the economic uncertainties that accompanied them served to strengthen the positions of the extreme left and right within the local political spectrum, which had deep regional roots, and encouraged widespread unrest.[20]

It is in this volatile context that Cézanne revived his concern with painting images of the peasantry of Provence. Depictions of local Aixois, mostly manual labourers in the painter's employment, were to feature as models throughout the last twenty years of his life. Bernard grudgingly acknowledged this, mentioning Cézanne's preference for choosing as his models

His wife and son, but above all the people that follow the old style of the Provençal people, a simple labourer or a dairy farmer, rather than a dandy or some other such civilized person who he abhors for their corrupt tastes and false worldliness.[21]

Gasquet similarly recalled, '[Cézanne's] real passion was for the people, the worker, the farmer, the labourer.'[22] The models for *Les Joueurs de cartes* and many other portraits were farmhands who worked at the Jas du Bouffan. Cézanne's gardener Vallier, who featured in several portraits, complained he was too busy sitting for the painter to do his job. Evidently, Cézanne felt most at ease with such people and admired the values, lack of affectation and way of life he associated with them. He was particularly fond of local craftsmen, and many of his closest friends were artisans. Cézanne also shared lodgings with a local peasant, Eugène Couton, in a house near the Château noir. Though the few photographs of Cézanne from this time show him wearing a Cronstadt (a bowler

hat) and a three-piece suit – albeit a wrinkled, spattered and torn one – descriptions of him often emphasized his modest, peasant-like appearance. Jules Borély described Cézanne as tanned as a 'ceramic pot-maker parched by the sun' and said that he was like 'An artisan who returns from some village, carrying his equipment; the blouse of a glassmaker, pointed hat, game bag from which peers a green bottle neck; in his hands, his huge paint box, his canvas and his easel.'[23] Georges Rivière remarked on Cézanne's preference for plainness in dress in later life, his favouring of a worker's vest and blue frock. Gasquet recalled him as 'peasant-like', chewing tobacco and drinking wine with workers in the local tavern.[24]

There is little doubt that despite the fact that the peasants he admired belonged to a different class and a greatly different way of life to what he was accustomed to, Cézanne felt that a deep affinity existed between his own understanding of himself as a primitive in painting, an artist whose work was immersed in nature and the 'primordial life' he associated with the peasant. For critics, the plain 'workman-like' and unmethodical approach of his painting suggested parallels with the common labourer. Georges Lecomte drew analogies between Cézanne's wilful preservation of the awkwardness of his style and his uneven and 'undisciplined' way of painting according to his *humeur*, and the way peasants worked in the fields.[25] For other less well-disposed critics, such as Camille Mauclair, Cézanne had the *tempérament* of a peasant.

These analogies that critics and admirers saw between Cézanne and Provençal peasantry are paralleled in the images he made of them, which are quite distinct from the contemporary repertoire of peasant imagery. There is little attempt to set the peasant within a characteristic 'natural' milieu, or map the social stratifications that structured the economic and social life of the peasantry. There is nothing of the rhetorical heroism of specialist peasant painters such as Julien Dupré or Jules Breton. Though some of Cézanne's

paintings depict female peasants, these are mainly of older women, not the rustic beauties admired at the Salon. The majority of Cézanne's peasant portraits focus on 'rough male simplicity', as Gasquet put it, and are mostly set in the artist's studio.[26]

The equation the artist made between his own identity and the peasantry is given form in the suggestive relationships he creates between his sitters and the attributes of the austere studio environment. Though some portraits favour plain and austere backgrounds – the peasant posed at a table against the studio's walls – many feature canvases and other studio paraphernalia that create discreet associations between the body of the peasant and Cézanne's paintings. *Paysan debout les bras croisés* (Peasant Standing with Arms Crossed, 1895) draws a visual analogy between the peasant's crossed arms and the crossbar of the upright stretcher, and in *L'Homme aux bras croisés* (Man with Crossed Arms, *c.* 1899) the artist's palette and a stack of canvases behind the seated figure echo the posture of the figure. In *Paysan en blouse bleue* (Peasant in a Blue Smock, *c.* 1897) the peasant, dressed in a blue worker's smock and Provençal red neckerchief, is placed directly in front of a panel that in their youth Cézanne and Zola had painted to decorate the salon of the Jas du Bouffan, setting up multiple suggestive relations between the figure and the scene depicted on the Rococo screen (the peasant is placed in the position that in the depicted screen is occupied by the woman's suitor).[27] In *Le Fumeur accoudé* (Peasant Smoking, 1895–1900), a melancholic peasant leans on a table on which an early still-life by Cézanne – *Pots, bouteille, tasse et fruits* (Pots, Bottle, Cup and Fruits, 1867–9) – rests, and which frames the top half of the peasant, drawing an association between the peasant and the painting of the fruit and wine of the land. These compositional analogies distinguish Cézanne's works that depict peasant labourers from other portraits he painted, implying a level of identification and intersubjectivity rarely otherwise found in his painting. The analogical relation of these pictures is deepened by the way in

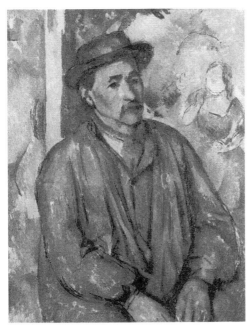

Paysan en blouse bleue (Peasant in a Blue Smock), *c.* 1897, oil on canvas.

which his portraits of Aixois peasants often recall the mood and imagery of his self-portraits. Gasquet stated that when the model for *Paysan assis* (Farmer Seated, *c.* 1900) refused to continue sitting for Cézanne, the artist simply substituted his own face for that of the model.[28] This identification with the peasant labourer went hand in hand with disavowal of the bourgeoisie. To Bernard, he wrote: 'It suffices to have a sense of art and it is without doubt this sense which is the horror of the bourgeoisie.'[29]

Cézanne's statements about the peasantry make clear how closely connected they were to the construction of his artistic identity and to his nostalgia for a way of life that he saw as fundamental. Late in life he remarked to Camoin: 'Renoir paints the women of Paris, but me, I paint the peasant who is passing.'[30] Jean Borély recalled Cézanne's acute awareness of the changes taking place generally

within Provence, his disdain of contemporary fashions and his desire to preserve in memory the continuity of the past:

> Today everything is changing. But not for me, I live in my hometown and I rediscover the past in the faces of the people of my own age. Most of all, I admire the faces of people who have grown old without drastically changing their habits, who just go along with the laws of time. I hate people's efforts to escape these laws. See that old café owner under the spindle tree. What style![31]

As this passage suggests, for Cézanne the old Provençal peasantry offered not so much the image of the continuation of the past as a living tradition, but rather as a way of communing with the memories of his past. The notion of this peasantry as possessing its own distinctive nature, materially embodied in its physical appearance, its style, was what made it such a subject that could and needed to be painted. The peasant still bore the physical traces of a supposed time-honoured way of being that distinguished itself from the consumerism and lifestyle of modern bourgeois life. Cézanne's identification with the Provençal peasantry rested therefore on the notion that this traditional way of life was more attuned to fundamental realities of nature. For Cézanne, the peasant's relationship to the land stood as a form of existence in which man and nature still lived in the kind of intelligible and symbiotic relationship to which Cézanne intuitively sought to give form in his own life and art.[32]

But it is in his landscape painting that Cézanne's relation to his native Provence is most immediately expressed. Today it is as the painter of the Montagne Sainte-Victoire that he is generally famous. Few artists are so associated with a single motif. But while the mountain occasionally featured in his pictures as early as the 1860s, it only became the focus of sustained attention in the mid- to late 1880s, when Cézanne critically revised his choice of landscape motifs. In the 1870s he had regularly spent periods in and around the region

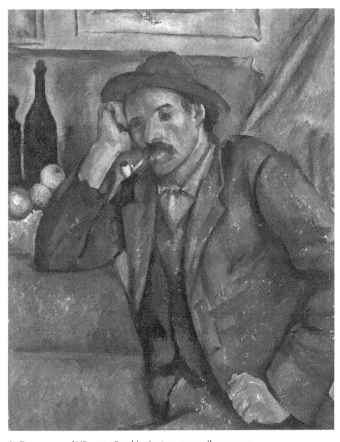

Le Fumeur accoudé (Peasant Smoking), 1895–1900, oil on canvas.

of Marseille, painting the bay and industrial port of L'Estaque. In these pictures, he had explored the conjunction of traditional and modern elements of the landscape, emphasizing the port's modernity, its factories and steamboats. From the mid-1880s he largely cleansed his painting of overt references to industrialization and began to portray a more traditional image of Provence.[33] In 1902 he explained to his godchild Paule Conil why he abandoned L'Estaque:

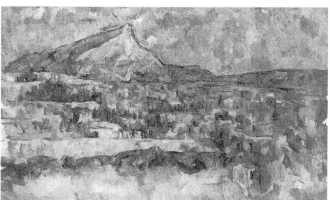

Photograph of Montagne Sainte-Victoire (top). *Montagne Sainte-Victoire*, 1902–6, oil on canvas.

I remember perfectly well the Establon and the once so pictur-
esque banks of l'Estaque. Unfortunately what we call progress
is nothing but the invasion of bipeds who do not rest until they
have transformed everything into hideous quais . . . what times
we are living in.[34]

In the 1870s Marseille had widely been regarded as an alternative
economic and cultural capital. It had become a thriving industrial
port, with a complex urban infrastructure, and symbolized the
image of modern Provence. Presumably that was one of the things
that attracted Cézanne there.[35] However, for many local historians,
Marseille had become a 'satellite' of Paris. It was a symbol of both
the centralization and modernization happening under the Third
Republic and the economic reductivism distorting social relations.[36]
In a letter to Zola, Cézanne wrote:

Marseille is the [olive] oil capital of France, as Paris is for butter
. . . this fierce population . . . has but one instinct, which is for
money. It is said they make plenty of it, but they are ugly – their
ways of communicating are wiping out the distinguishing
features of the different types. In a few centuries it will be quite
futile to be alive; everything will be flattened out.[37]

Despite the distinctive modernity of his style, the landscape
motifs Cézanne favoured in his later years had closer affinities
with the idealized rustic imagery of Provençal writers and artists
identified with the Félibrige. In the last twenty years of his life,
Cézanne's landscapes focused on the countryside around Aix. An
incessant walker, he travelled across the entire vicinity in search of
motifs, most off the beaten tourist path. Beginning with the vicinity
of the Jas de Bouffan, Cézanne worked his way through Bellevue
and Montbriand in the southwest, to the villages of Meyreuil and
Gardanne to the south, on through the route of the rue Tholonet,

the old road leading to the abandoned Bibémus Quarry and the coffer-dam built by Zola's father to the east, and finishing up around the north and northeast, midway towards the Vauvenargues and the vicinity of Beauregard. Though Cézanne's motifs varied widely, from the monumental and majestic Montagne Sainte-Victoire to the most intimate and dense settings of the forests and caves of the park of the Château noir, his choice of motifs accentuated the time-worn features of the Aixois landscape and in the 1880s often presented these in an Arcadian fashion replete with classical inflections. Pine trees, so often alluded to in his youthful correspondence, began to appear as *repoussoir* devices in these pictures. These framing devices were long associated with the classical Arcadian landscape tradition of Claude Lorrain. In his letters he began to refer to *la belle nature*, a term associated with classical landscape.

The Montagne Sainte-Victoire provided not one but many motifs for the painter, and the representations he made of it during these later years reveal the full contrasting diversity of his late style. Cézanne portrayed it from various vantage points, exploring its different 'physiognomies' and expressing a variety of responses to it, which convey alternative effects and moods. The mountain is presented in different lighting conditions, ornately framed by other elements, or presented more starkly and frontally, as Cézanne explored multiple ways of presenting his motif, alternately depicting it from high and low vantage points, up close and far away, centrally or from a sideward angle, adopting positions within the landscape, or alternatively looking out from the terrace of the Montbriand estate situated west of Aix, and owned by his brother-in-law.[38] Sometimes it is the dominant presence of the mountain that is the motif, but other times it is the relationship it has to other natural and man-made elements in the landscape. Cézanne's handling is highly animated or technically more even-handed depending on whether the intention was to convey the force of the mistral

sweeping across the landscape or the tranquillity and Virgilian qualities of the landscape.

The Montagne Sainte-Victoire was a traditional symbol of Provençal identity. It was at the foot of the Montagne Sainte-Victoire that, according to Plutarch, Caius Marius defeated the Teutons a hundred years before the birth of Christ; according to legend, the red earth of the fields had resulted from the blood spilled on the battlefield.[39] It had become a key motif in the repertory of *méridional* painting. Prosper Grésy, Justinien Gaut, Jean-Antoine Constantin and François-Marius Granet, among others, had all painted it.[40] As Gasquet implied, Cézanne's persistent favouring of Montagne-Sainte-Victoire was a way of inscribing himself in his own very individual manner within that tradition. Many biographers have seen the mountain as a symbol for the painter, whether of some implacable endurance, or of an aspiration towards some out-of-reach ambition – Cézanne's letters often spoke of his fears of failing to achieve his aims in painting and he seems to have regarded few works as successfully realized. 'I am too old. I have not realized, and I will not realize now. I remain the primitive of the path I have discovered', Bernard quoted him saying towards the end of his life.[41] Secluded and isolated, the mountain has often suggested a personal identification on the painter's part. No doubt some such views crossed his mind from time to time, but it is the incommensurability of the mountain with human experience to which Cézanne most often gives intense expression. 'What a relief the Mont Ste. Victoire after all the anthropomorphized landscapes', wrote Samuel Beckett:

> Cézanne seems to have been the first to see landscape & state it as material of a strictly peculiar order, incommensurable with all human expressions whatsoever. Atomistic landscape with no human velleities of vitalism, landscape with personality à la rigueur but personality in its own terms . . . [Unlike] Rysdael's

[sic] *Entrance to the Forest* – there is no entrance anymore, nor any commerce with the forest, its dimensions are its secret & it has no communications to make.[42]

The foreground planes of Cézanne's painting, as Beckett observed, invariably offer no entrance into the landscape, thereby marking the divide between the painted world of Cézanne's imagining and the actual world that provided its motifs.

It is also around this time that pine trees emerge, for the first time, as subjects in their own right in a number of pictures of this period. Virgilian references to pine trees are leitmotifs of these later years and were, as we have seen, imbued with memories of youth.

Do you remember the pine that stood on the bank of the Arc, lowering its leafy head over the chasm that opened at its feet? That pine that protected our bodies with its foliage from the heat of the sun, ah! May the Gods preserve it from the fatal blow of the Woodcutter's axe![43]

Cézanne's love of pine trees was something commented on by many writers and artists close to him, as were his occasional fumbling attempts to climb them. His sometime painting companion Joseph Ravisou described Cézanne as painting to prolong the pleasure of living among the trees.[44] Pine trees similarly recur in Gasquet's verse and are a redolent motif in his book on Cézanne, providing a backdrop for the second set of dialogues, where they stand as symbolic silent witnesses to the passing of time, as markers of familiar places, memories of youthful days passed in the countryside and, more impersonally, to the collective history of the region. Indeed it is the landscape, cast in this Arcadian fashion, that repairs the tear in time between past and present, restoring a 'lost plenitude', and which fixes and gives meaning to personal identity by suturing the individual's biography with a collective regional history. This seems

to have its pictorial parallel in the way in which pine trees often unite near and far elements of the vistas of Cézanne's landscape paintings, binding them together into an integrated whole.[45]

Dominant constructions of Provence by Félibrige writers portrayed it as the cradle of Greek and Roman civilization, a place where the perpetuation of the supposed timeless traditions of the Latinate and Hellenistic heritage still prevailed. The representation of Provence became steeped in its relationship to this past, which took on mythical and mystical dimensions. According to this line of argument, a golden age of Latin supremacy by some metempsychosis lay dormant within the landscape itself, merely awaiting resurrection. Provence was 'classic ground'; the roots of the classical traditions lay deep within its soil. Replete with the traces of classical antiquity, the Midi offered a particular historical vista, both timeless and timely, contemporary and ancient, an image oblivious to the signs of economic modernization transforming the region.

The Mediterranean landscape accordingly became embroiled in the cultural politics of French nationalism in the 1880s. Provence was increasingly represented as forming a counterpoint to the northern traditions that, for all their simplifications, were associated with democratic Republicanism and the 'progress' of modern industrialized society. Republicans in turn tended to construct the south as a land of the past, a dead culture, arguing that modern France must take its lead from its northern capital. With its strong regional identity and discontent with Parisian hegemony, Provence became a reified symbol of resistance and an alternative cultural paradigm. At the end of the century, these long-standing associations were increasingly annexed to neo-nationalist, anarchist and regionalist tendencies. For Provençal nationalists, Provence remained a place where the timelessness and 'moral purity' of the traditions of the Latinate and Hellenistic heritage were still perpetuated. Hellenistic and Latinate heritage were conflated into an idealized unity with

racialist overtones. Charles Maurras wrote: 'Latin Italian, Hellenistic, it is the same.'[46] They saw the Republic as severing the true vine of French cultural and political traditions, which they argued had its roots in classical Mediterranean civilization. It was this idealizing vision of Provence that Gasquet evoked in his poetry and which inflects his writings on the painter.

As Richard Shiff has stated, Gasquet's advocacy of classicism was consistent with the aesthetic programme of the Action française, the ultra right-wing royalist movement within which he was for a time a leading light.[47] Maurras, the intellectual force behind the party, had hailed Gasquet's collection of poems *Les Chants séculaires* (Secular Hymns) as the starting point of the classical revival. Gasquet himself was a Catholic, monarchist and fervent chauvinist, though the positions of other Félibres varied widely. We do not know where Cézanne stood in these debates. His friendships with Jean-Marie Demolins, co-editor with Gasquet of the Provençal journal *Les Mois dorés*, and with Gasquet himself, brought him into contact with the more reactionary strands of the Félibrige. Cézanne confided in the painter Charles Camoin that he felt uneasy among Gasquet's salon, which included far-right thinkers like Demolins, Maurras and Jaloux, among others – though why he did not say.[48] While he would have shared their Provençal patriotism, it remains unclear how he felt about the political views they espoused. We know Cézanne was anti-Dreyfus and suspicious of the Republican regime, but the few statements he made about politics in later life tend to be inconsistent, volatile and ultimately difficult to make anything of, least of all in relation to his painting. What he shared with these writers was a romantic vision of the landscape and an idealization of old Provençal traditions. But progressively his vision of the landscape was permeated with an imagery of the darker side of the landscape.

Towards the end of Cézanne's life, this identification with the Provençal landscape, which he often refers to as his land or his

country rather than merely a region, is a constant feature of his discussions of his painting. In the later 1890s, when his health was fast declining as a result of worsening diabetes, his descriptions of the landscape in his letters and his actual paintings allude to cycles of decay and contain intimations of mortality. In Gasquet's novel *Il y a une volupté dans la douleur* (1921), the painter Pierre, reminiscent of Cézanne in many respects, describes the landscape as a soul made of the remnants of the living and the calm of the dead. The land, as Gasquet knew well, was integral to the artist's sense of personal and racial identity, and it was from shared communal reference points in the history, lore and landscape of Provence that the sense of the self's continuity with the past and with something greater than itself was constituted. In Gasquet's biography he has Cézanne remark, 'The landscape is reflected, humanized, rationalized within me . . . I would see myself as the subjective consciousness of that landscape, and my canvas as its objective consciousness.' And at another point Gasquet quotes Cézanne as saying: 'face to face with my motif, I lose myself in it.'[49]

Whether these statements reflect what Cézanne actually said must remain in question, but they reflect well the underlying thinking that informed his painting. The artist's deep and nostalgic attachment to the landscape is also given expression in his letters to other writers and artists, most notably in his correspondence with Joachim himself. In a series of letters to the poet in 1896, Cézanne spoke of the 'links that bind me to this old native soil' and of his deep love for the Provençal landscape 'whence I have imbibed so much without knowing it'.[50] In subsequent letters, he indicates the Provençal landscape's role in shoring up his morale. Such sentiments are most vividly communicated in letters to Joachim's father Henri, in which he reminisces about their youth, interspersing these recollections with images of the landscape of Provence as if such memories and the landscape were impossible to separate from each other.

This nostalgia went hand in hand with melancholic intimations of death. Suffering from the degenerative condition of diabetes, death was much on his mind and is forcefully registered in his letters during the last decade of his life. The slow decline and death of his mother continued to distress him. Coincidentally, Gasquet's mother died the same year as Cézanne's and this may well have drawn them closer together. Numa Coste found him 'very low and often prey to gloomy thoughts'.[51] Death was ever present. His parents' deaths were followed by those of close friends such as Achille Empéraire (1898), Antoine Fortuné Marion and Valabrègue (1900), Alexis (1901), Roux and Zola (1902), Pissarro (1903), Solari and Henri Gasquet (1906). He was prematurely aged in appearance. In addition to his diabetes, which made him testy and meant that, at least in principle, he had to follow an austere diet, he suffered from neuralgia and a weakening nervous system, which he treated with homeopathic remedies and massage, despite his notorious reluctance to be touched – on one occasion he flew into a rage when, having lost his footing, Bernard tried to catch him from falling. Later he explained he had developed a phobia of being touched after being kicked hard in the backside by a *gamin* (kid). He was afflicted by a kidney problem, and swelling in his right foot.[52] He felt old and weary. 'I am as good as dead,' he wrote to Gasquet.[53] Despite his need for solitude, loneliness weighed heavily on him.

He suffered too from the lack of recognition he had long endured, and feared, despite the attention his painting was receiving from younger artists, that he might die obscure, unsuccessful and having failed as an artist. He had hoped to turn Bernard into a 'true follower' but been disappointed. He had admirers but few among the artists of his generation. He was frequently restless and disquieted, and momentary revelation was quickly surpassed by the deeper-lying uncertainties and doubts about his painting and the unprecedented form it was taking. In a revealing letter to Bernard, he wrote:

I find myself in such a state of brain trouble, trouble so great that I fear my feeble reason may desert me at any moment. After the terrible heat we've been enduring, a more clement temperature has brought a little calm to our spirits, and not a moment too soon; now it seems to me I am seeing better and thinking more clearly about the direction of my studies. Will I reach the goal that I've sought so hard and pursued so long? I hope so, but while it is unattained, a vague state of disquiet remains, which can only disperse once I've reached the harbour, that is to say when I have realized something that develops better than in the past, and thus becomes proof of theories, which, of themselves, are always easy; it is only demonstrating the proof that presents serious obstacles. So I continue my studies . . . I always study from nature, and it seems to me that I'm making slow progress. I should have liked you beside me, for the loneliness always weighs on me a little. But I am old and I have vowed to die painting rather than sink into the degrading senility that threatens old people who let themselves be ruled by passions that dull the senses.[54]

His feelings of disquiet and impending mortality were most immediately expressed in a haunting series of paintings of skulls executed towards the end of his life.[55] Though skulls featured in early vanitas pictures from the 1860s, these late paintings differ in tone and treatment, eschewing the *genre noir* romanticism of his earlier works. Arranged in groups of two and three, sometimes in a pyramid, these skulls are more evidently objects of contemplation and reflection. Once again there is a regional dimension to these motifs. Skulls featured in traditional festivities and religious rituals of Provence. In Aix-en-Provence the chapel of the order of the Pénitents Gris preserved a collection of funerary depictions of skulls.[56] Cézanne must have visited this collection, as it houses an anonymous portrait of a woman wearing a white bonnet and holding a rosary on which he based *Old Woman with a Rosary*.

Archaeological digs had unearthed the bones of Aix's ancient inhabitants and revealed the role of the *tête de mort* as an object of veneration in primitive Celtic-Liturgian culture. These excavations were a source of great local interest. Antoine Fortuné Marion, a close friend of the artist since his youth and a geologist and director of the Musée d'histoire naturelle de Marseille, took part in and wrote extensively about them. The unearthed pillar from the Sanctuaire aux crânes, with its arrangement of skulls placed on top of and beside each other, probably influenced Cézanne's own unorthodox compositions of skulls. As many interpreters have suggested, these works must also have provided a motif through which he meditated on his own mortality, of which, as Gasquet suggested, he was already very mindful. His letters document his failing health and the increasing toll the summer heat took on his health, making him anxious, agitated and dejected. In a letter to his son, he remarked:

> It's been unbearably hot for days . . . The pain I feel gets so exasperating that I can't keep it under control any longer, and it drives me to live a withdrawn life, which is the best thing for me.[57]

Painting these skulls was no doubt a way of simultaneously warding off the prospect of death and coming to terms with the inevitable and material fact of it. But death, decay and ruin are the themes of many of his late landscapes as well.

Landscape motifs focused on sites of decay and ruin held a grip on Cézanne in his later years. He frequently sought out evocatively desolate and strongly atmospheric motifs hidden away from the main thoroughfares of Aix. Few artists were so drawn to such secluded motifs. These landscapes, with their dense undergrowth, were the counterweight to the Montagne Sainte-Victoire pictures, and in occasional pictures he sometimes could not resist juxtaposing

them. The Bibémus quarry was a favourite haunt, offering ample scope for exploring a site long abandoned and in the process of being reclaimed by nature. It had the appearance of chaotic ruin, like a vanished city. The airless and claustrophobic pictures of the quarry, with traces of the long-departed mining still visible, often suggest an ongoing cycle of natural decay and renewal; the natural reclamation of man-made aspects of the landscape.

Renoir was not alone in stating that Cézanne used to leave the canvases in which he was disappointed in the landscape, at the mercy of the wind and rain, as if leaving these paintings to be 'reclaimed by the natural environment'.[58] Such motifs, marked as they were by the devastation visited on the landscape, expressed Cézanne's preference in seeking out motifs that conveyed some element of struggle between man or the man-made and nature that paralleled his own struggle to realize his *sensations* in the harsh, demanding environment of the Provençal landscape, a

La Meule et citerne en sous-bois (Millstone and Cistern under Trees), 1892–4, oil on canvas.

persistent theme in his last letters to his son. The quarry becomes an image of a non-place, neither quite nature nor culture, but something in between, a place that might speak therefore of the failure ultimately to find a place or a way of painting. The 'mysterious' shifting quality of these densely forested late landscapes, as D. H. Lawrence described them, seems to speak of a dematerialization or decomposition of form.[59] But above all these motifs are places shadowed by the image of death. As T. J. Clark has argued, 'the view from Bibémus quarry is at one level a view from the tomb.'[60] The rock formations were an all-encompassing entombment, a hole in the ground. It was here that the Sanctuaire aux crânes had been excavated. Nearby was another site that exerted a strong hold on Cézanne's imagination, the Château noir and its adjoining woods.

Built in the second half of the nineteenth century between Aix and the village of Le Tholonet, the Château is an incongruous-looking group of two buildings, set at right angles to each other, with steep roofs and narrow Gothic windows. The main higher building faces south onto the valley leading to the village of Palette. Along the west wing, a series of pillars was built to support an orangery, though this was never completed. The name Château noir remains an enigma, given that the building is built of the orange-yellow stone of the Bibémus quarry close by. It may reflect the fact that its first owner was a coal merchant or its facade was once painted black, though legends about the place abound.[61] It was sometimes known as the Château du diable. Cézanne rented a room there in which to keep his equipment and in the late 1890s, after an unsuccessful bid to buy it, he rented a stone *cabanon* nearby. He would often paint in and around the forest of the Château noir, sometimes taking the young local painter Joseph Ravaisou with him. Initially the grounds of the Château noir provided an ideal, high vantage point from which to view the Montagne Sainte-Victoire, but from 1895 onwards it became a motif in its own right.

Cézanne's depictions of the château present the building in a way that suggests its relation to the quarry, its state of decay, and amplify the mood of uneasiness connected with the place. In contrast to the open expansiveness of the topographical views, these are a discreet and unsettling set of motifs, fragments of nature seen from up close; they are densely compacted paintings in which the persistence and renewal of natural forms emerge as a forceful theme. This is most evident in the works that explore the park around the vicinity of the Château noir. These pictures of the woods and caves present compact, clustered and airless spaces and are among the most delicate and intricate later paintings.

In the paintings of the Château noir, the château's glowing, deep-ochre facade juts out of the dense and unruly vegetation that screens its lower floors. The sombre and deeply saturated tonality evokes a mood of disquiet, heightened by the leadenness of the stormy and dark skies that prevail and the sense of agitation suggested by the brushwork, the irregular pattern of the trees and the overgrown foliage. Sometimes the facade takes on a certain pathos and even dramatic quality as though it was a ruin. This is evident in *Le Château noir derrière les arbres* (Château Noir Behind the Trees, 1895–1900), where the château is isolated and framed through a dense, web-like group of pine trees, whose long, twisted, tentacular branches dramatically project across the foreground, the foliage almost engulfing the decrepit building in a fatal embrace. The house appears forbidding, glowing, skull-like and isolated, as if its ruinous structure was about to be submerged within the wild, overgrown forest.

The remote and mysterious atmosphere of these later landscapes is the other side of Cezanne's landscape painting, pictures at odds with the classical inflections and incommensurability of nature of the Montagne Sainte-Victoire pictures of the 1880s. In these later, more secluded pictures, anthropomorphism reasserts itself; the landscape becomes the object-correlative of a particular emotional state of mind. This is the landscape stalked by the invisible presence

Le Château noir derrière les arbres (Château Noir Behind the Trees), *c.* 1895–1900, oil on canvas.

of death. It is the same darkly 'charged' atmosphere that seems to preside over the Barnes *Grandes Baigneuses* or is present in the aforementioned portrait of Vallier with its haggard, skull-like face in which, Gasquet claimed, Cézanne substituted his own face in place of Vallier's. It is said that the last painting he made before his death was another portrait of Vallier. But Vallier wasn't his only alter ego, as the youth depicted contemplating a skull in *Jeune homme à la tête de mort* (Young Man and Skull, 1995–6) demonstrates. No doubt the confrontations with death staged in Cézanne's pictures were part of reaching back into the past as much as they were the morbid staring down of the future. A poetic fragment sent to Coste in 1863 shows that the Arcadian landscape that dominated Cézanne's imagination was always haunted by the spectre of its other.

> . . . the leaves yellowed by the breath of winter
> have lost their freshness,

At the edge of the stream the plants have wilted,
And the tree, shaken by the fury of the winds,
Swings in the air like a huge cadaver,
Its leafless branches wrenched by the mistral.[62]

Cézanne's later years saw him retrieving aspects of the past that gave form to an imagined ideal of old Provence that conferred meaning and purpose on his life and art. Reclaiming this past made up of 'old style' peasants, revisiting and painting places in the landscape that he remembered from his youth and associating himself with younger Provençal painters and writers aligned to the Félibrige were all, in certain respects, connected to symptoms of an attempt to revive and relive the past in the present. This was his way of belonging to the contemporary world around him, the restoration of a social character to his art, while at the same time taking refuge from it. It was his way of turning back the clock and overcoming the procession of time. Past and present were conjoined in the protracted act of painting and reliving these places and things that had so indelibly imprinted themselves on his imagination.

For a time this gave rise to his most harmonious and majestic landscape pictures, the Provence of the Montagne Sainte-Victoire pictures of the mid- to late 1880s with their classical inflections, the paintings that seem to give the closest expression to his avowed aims in painting. Though he could never quite be a part of any movement, for a brief moment the Félibrige movement gave a broad context to his painting, one quite distinct from that which his painting was acquiring in Paris, a context associated with his sense of belonging to a particular place and the primordial relation he imagined bound him to this place. The Félibrige writers' rhetoric of renewal gave a form to old Provence that was future-minded rather than purely nostalgic: a vision of synthesis of antiquity and the contemporary. But Cézanne's late work pulls away somewhat from this more serene and idealized vision of Provence to something more

unsettled and disquieted, a confrontation with the destructiveness of time and the imminence of death. His later art is one in which the depiction of the places imbued with memories of the past is met with the ultimate impossibility of reclaiming that past. This is found again and again in the disequilibrium of the late works, in their interplay of materialization and decomposition of form.

In an essay fragment on the late Beethoven, Theodor W. Adorno wrote that in some instances in the later years of an artist's life, at a time when he is most in command of his art, his style may come to express itself not in synthesis, harmony and unity, and still less by taking refuge in tradition or by recourse to some imagined, totalizing organic whole, but as an intransigent expression of profound alienation in contradiction with the social order of which he is a part.[63] In such cases, the normal modes of communication break down under the weight of something far more melancholic, pressing and obdurate, and where serenity and reconciliation give way to irresolution and perplexity, by the raw breaking open of form. These were of course always immanent features of Cézanne's painting, but they reassert themselves most forcibly and uncompromisingly in his final years.

Epilogue

It is a fallacy of writing history or biography that it best reveals itself in retrospect, its objects becoming clearer to the historian's gaze only when a certain temporal distance has elapsed between the events described and the writing of them. Time transforms rather than simply reveals the past and leaves us with as many gaps and silences as disclosures and certainties. This is definitely the case with Cézanne, whose art and life were transformed by the position he came to assume in histories of modern art and the myths that arose about his life and personality.

After Cézanne's death, Vollard's shrewd marketing saw the artist's reputation grow and his collectors multiply; his subsequent influence on younger avant-garde painters also gathered apace. The retrospectives at the Salon d'Automne and other subsequent exhibitions in France and beyond considerably broadened his audience. The great flurry of discussion his painting generated led to much emulation, both good and bad. His example opened up artistic developments that were to be decisive for the directions modern painting took in the early twentieth century. Cézanne's legacy was much enhanced by the favour his work found among many of the greatest artists of the modern era – Matisse, Picasso and Braque among them – though it is unlikely that he would have felt at ease with what they made of his work. Each in his own way engaged selectively and idiosyncratically with Cézanne's painting, discarding elements that Cézanne considered

fundamental to his art. But their responses to it had a profound impact on its subsequent history and interpretation. Slowly but surely Cézanne entered into museum collections around the world, as much a result of his influence on modern artists as of the growing appreciation of his art; in this he was the beneficiary of the way avant-garde art, once restricted to a relatively small audience, gradually became accommodated within the twentieth century's burgeoning museum culture and, in the aftermath of the Second World War, the appropriation of modernism as official art in the West. A new myth was supplanting the older one of the intransigent and eccentric artist from Provence: Cézanne as the founder of a modern tradition. From being little known and isolated, he was now one of the most famous artists in the world; his vaunted status as the father of modern art was assured.

This was a measure of success that he could not have imagined in his lifetime, but one that has both changed the perception of his art and, paradoxically, threatens to make it invisible even as it brings greater exposure and awareness of it, occluding what the artist regarded as most fundamental and vital about his painting. Being well known is not the same as being well understood. Although Cézanne's art was in many ways inconceivable without the rise of the museum and his painting more indebted to it than he was prepared to admit, he would probably have viewed such canonization with great suspicion. When Cézanne spoke of an artist as being merely another link in the chain, it was not thus that he envisaged it. Though he felt Pissarro had gone a little too far in advocating burning down the museums, as his continual complaints about Bernard's reliance on the museum suggests, he shared the sentiment that the rise of the museum, while bringing a greater accessibility to the art of the past, was a sign of a certain decay, alienation and marginalization of art in the contemporary world – an abstraction of it from the life around it and to which it responded, and the placing of it within the narrative straitjacket of museological canon formation.

A comparable point can be made about the literature on Cézanne. His art has been written about by many of the finest art critics, philosophers and art historians of the age, though the importance of Cézanne for the history of modernism meant it was often interpreted in terms of what was made of it by later generations of artists, rather than in its own terms. Eventually this resulted in a rigid, repetitious and formulaic character to the interpretation of his art that was quite at odds with the more diverse interpretations that his art initially provoked and out of keeping with the exploratory, often-contradictory and difficult character of his painting. The dominantly formalist way of understanding Cézanne's art that held sway in the mid-twentieth century eventually seemed to put him at odds with the later reaction against modernism at the end of the century. Even today, as we enter into a period of greater heterodoxy, the shadow of this formalism hangs over much writing on Cézanne, testifying to the problem of moving beyond the narrower confines imposed on the understanding of his painting. Cézanne's preoccupation with form was not an end in itself but the artistic means through which he sought to intimate contents and qualities of sensory experience of the world around him, to convey the order and disequilibrium of sensation and to communicate his intuitive apprehension of nature. Artistic self-consciousness of the means of painting was a condition but never the end of painting. It was rather its starting point, the precondition of the encounter with the world. As Fred Orton has argued, the ethics of the whole enterprise required such self-reflexivity as the basis of painting without illusion and deception.[1] Painting and observation, the struggle to communicate on the surface of the canvas the contents of perceptual experience – these were the things his art was made of. Painting was never a passive partner in this, but a productive one; painting was what brought all of this into an intensely intimate experience of revelation. His art was not an inward-looking one.

Cezanne's emphasis on his struggle and his doubts about realization become almost unintelligible when seen simply in formalist terms, and his art consequently impoverished. We do most service to Cézanne when we insist upon the difficult and problematic character of his art and restore something of its intransigence to it; when we, in short, resist the temptation to merely eulogize. Much that is most valuable and original in Cézanne's art arises from the contradictions and tensions at work within it and the problems he posed for himself and sought to overcome in painting, the exacting set of artistic aims that the sceptical Bernard called Cézanne's 'suicide'. Cézanne had said so himself to Rouault when he had warned against the blindness that is born of hagiography and slavish imitation:

Don't set store either by those who spout my name or argue over my wretched corpse, after my death, but rather by the worst, the most imperfect of my works . . . If they give me an ovation, don't believe it; if they try to found a school in my name, tell them they never understood . . .[2]

These words, overblown as they are, nevertheless testify to the seriousness of Cézanne's art and the complexity of his attempts to give material form to the intuitive, sensuous apprehension of his world in all its dense complexity – how to paint sensation in its uniqueness and becomingness. Over the course of his lifetime he continued to dwell on the question of how to make art that could respond to this challenge. As he did so, his art was gradually transformed from his first style, representing the hypertrophied, artistic persona of his Parisian years, to the later richly dense canvases that emerged at the end of the 1880s. These changes of style were accompanied by changes in the life he led and the image of himself he projected to others. Cézanne's artistic career had begun in incendiary fashion, as an art of the fierce imposition of the

will and *tempérament*. He wore the mask of the vertical invader, the belligerent Provençal outsider, coarse and uncompromising, producing paintings whose subject and technique was meant to bring terror to the bourgeoisie; these pictures by Salon standards were entirely unacceptable. His painting slowly and unsurely evolved into something far more deliberative and questioning, more searching and open-ended, an art in which exteriority and interiority, subject and object, will and submission, assertion and doubt were held in a fragile, dialectical relation. In an age of photography and the machine, his was an art of the body and its sensations, of embodied perception – an art above all continually asking itself how to translate the intuited sensuousness of experience into the possibilities and limitations of painting.

These broad changes in his approach were the result in no small measure of artistic friendships, collaborations and dialogues: some actual, as in the case of his important close relationships with Zola and Pissarro; others, as in the case of those with Delacroix, Courbet and Manet, largely conducted in and through painting. There were other friendships too that we know far too little about: those with Empéraire, Guillemet, Guillaumin and Marion, for instance. The biography of Cézanne is marked by gaps in our knowledge and silence on so many matters we would wish he had spoken of. But what the later correspondence does reveal is how much Cézanne's later life was marked by solitude, despite the friendships he established with younger artists and poets and his relationship with his family. His life was shaped primarily by the demands the labour of painting placed on him and concomitantly by solitary immersion in nature. The later work demonstrates how deeply he identified with his native Provence, its customs, its history, its peasants and its soil. His last years were permeated by a strongly melancholic belief in how all that he most valued of this seemed to him to be passing as modernization continued to extend its reach. The later work is a deep meditation on the desire of

painting to overcome the alienation he felt as a result of the historical forces that were changing French society and a kind of fatalism of its inexorability. Immersion in nature and absorption in the act of painting were fashioned by this. The late works are inhabited too by the imagined reclaiming of the past through memory and the feelings of an artist increasingly conscious of his mortality. The late landscapes, in particular, are as much works of the resurrection of past time and intimations of the death as they are responses to the immediacy of the presence of nature in front of him.

Though deeply embedded in the historical process of modernity, modern art, far from simply reflecting the world around it, has often had a complex relation to this historical development, a relationship sometimes confluent and complicit with those processes, but at other times more ambivalent and critical towards them. Modernity and modernization have seemed antithetical to the kind of reflective consciousness and openness to experience modern art has often sought to foster, to the questioning of common assumptions and received wisdom. These are qualities not easily accommodated within its modernity's rationalization, systems of categorization and instrumental thinking. Cezanne's art always sat uneasily and somewhat antagonistically within the contemporaneity of its time. It is unsurprising therefore that as these historical processes have further advanced, the forms of life and inquiry through painting on which artists like Cézanne founded their art should have become more and more marginalized within our culture.

If the terms of Cézanne's art once seemed so vital to the most radical artistic tendencies of the twentieth century, they now appear very remote to our contemporary world, taking on an air of melancholy very much in keeping with the tenor of his late work. The paintings remain compelling, even instructive, but they have become chiefly vestiges of another historical moment, an enterprise 'remote from the temper of our times', as T. J. Clark has argued.[3]

In an age of instantaneity and immediacy, of the unstemmable flow of images and digitized imagery, and increasing speed of information transmission, the kind of dogged nature of Cézanne's whole artistic enterprise – the demanding attentiveness and obsessive scrutiny of it – seems almost antiquated. But the fact that these paintings do remain compelling speaks to the way art's relevance is never simply in its being timely and immediately present to the world in which we live, but in the way it preserves capacities and potentialities that might otherwise be lost. Rather than confirm to us the ways of thinking that characterize our own historical perspective, this untimeliness presents us with possibilities of other forms of thought and experience. In this way, the remoteness of Cézanne's art to us today reveals something of what is lost to us in the present contemporary moment.

References

Introduction: The Myth of Cézanne

1 Émile Bernard, 'Paul Cézanne', *L'Occident* (July 1904), pp. 17–30. See Bernard's letter to his mother dated 5 February 1904, reprinted in *Conversations avec Cézanne*, ed. Michael Doran (Paris, 1986), pp. 24–5.

2 As Frederic Jameson has argued, Cézanne is now a cultural institution, a signifier of the ideology of modernism, and it is impossible to see his work outside of the framework that has encompassed it. Frederic Jameson, *The Modernist Papers* (London, 2007), p. 258.

3 Christian Geelhaar, 'The Painters Who Had the Right Eyes: On the Reception of Cézanne's Bathers', in *Paul Cézanne: The Bathers*, ed. Mary Louise Krumrine, exh. cat., Kunstmuseum, Basel (1989), pp. 275–303.

4 James D. Herbert, *Fauve Painting: The Making of Cultural Politics* (New Haven, CT, 1992), pp. 146–55; George Heard Hamilton, 'Cézanne and His Critics', *Cézanne: The Late Work*, ed. William Rubin, exh. cat., Museum of Modern Art, New York (1977), pp. 139–50.

5 Paul Cézanne, letter to Bernard, 21 September 1906, in *The Letters of Paul Cézanne*, ed. Alex Danchev (London, 2013).

6 Cézanne, letter to his son, 13 September 1906, ibid., p. 371.

7 Cézanne, letter to Bernard, 23 December 1904, ibid., p. 347.

8 Cézanne, letter to Georges Rouault, undated, *c.* 1906, ibid., p. 358.

9 Cézanne, letter to Joachim Gasquet, 30 April 1896, ibid., p. 272.

10 Marc Elder, *À Giverny chez Claude Monet* (Paris, 1924), p. 48.

11 Edmond Duranty, 'Le Peintre Marsabiel', in *La Rue: Paris pittoresque et populaire* (20 July 1867), n.p.

12 Marius Roux, *The Substance and the Shadow*, ed. with an introduction and notes by Paul Smith, (Philadelphia, PA, 2007), pp. xvi–xxvi.

13 Cézanne, letter to Roux, undated draft *c.* 1878–9, in *Letters*, ed. Danchev, p. 191.

14 Clive Thomson, 'Une Correspondence inédite (première partie): Vingt-sept lettres de Marius Roux à Émile Zola (1864–69)', *University of Ottawa Quarterly*, XLVIII/4 (1978), pp. 335–70.

15 Roux, *Substance and the Shadow*, pp. xv–xvi, fn. 19.

16 Thomson, 'Correspondence inédite', p. 344.

17 Ambroise Vollard, *En écoutant Cézanne, Degas, Renoir* (Paris, 1938), p. 100.

18 Maurice Denis, journal entry 1906, in *Conversations*, ed. Doran, p. 93.

19 Aruna D'Souza, *Cézanne's Bathers: Biography and the Erotics of Paint* (Philadelphia, PA, 2008), p. 13.

20 Joris-Karl Huysmans, 'Cézanne', *Certains* (Paris, 1889), p. 43; Thadée Natanson, 'Paul Cézanne', *La Revue blanche*, 9 (1 December 1895), p. 499.

21 Jon Kear, 'Cézanne's Nudes and Balzac's *Le Chef-d'oeuvre inconnu*', *Cambridge Quarterly*, XXXV/4 (2006), pp. 345–60.

22 Léo Larguier, 'Le Dimanche avec Paul Cézanne', repr. in *Conversations*, ed. Doran, pp. 10–11.

23 R. F. Rivière and J. F. Schnerb, 'L'Atelier de Cézanne', *La Grande revue*, XLVI (25 December 1907), p. 811.

24 John Rewald, *The History of Impressionism* (New York, 1946), p. 558.

25 See Camille Mauclair, *L'Impressionnisme: Son histoire, son esthétique, ses maîtres* (Paris, 1904), p. 152; Félicien Fagus, 'Quarante tableaux de Cézanne', *La Revue blanche* (September–December 1899), pp. 627–8; Natanson, 'Paul Cézanne', p. 500.

26 Charles Morice, 'Enquête sur les tendances actuelles des arts plastiques', *Mercure de France*, LVI–LVII (1–15 August 1905), pp. 61–85, 346–59, 538–55.

27 Timothy J. Clark, 'Freud's Cézanne', *Representations*, 52 (1995), p. 101.

28 Ibid., p. 110.

29 Meyer Schapiro, *Paul Cézanne* (New York, 1952); Tamar Garb, 'Visuality and Sexuality in Cézanne's Late Bathers', *Oxford Art Journal*, XIX/2 (1996), pp. 46–60.

30 Mark Gottlieb, 'Poussin's Lesson: Representing Representation in the Romantic Age', *Word and Image*, XIV/1 (2000), p. 130.

31 D'Souza, *Cézanne's Bathers*, p. 16.

32 Émile Zola, *L'Oeuvre* (Paris, 1886), p. 49.

33 Ibid., p. 163.

1 Memories of Youth

1 Marie Cézanne, quoted in Jack Lindsay, *Cézanne, His Life and Art* (New York, 1969), p. 9.

2 See Colin Heywood, *Growing up in France: From the Ancien Régime to the Third Republic* (Cambridge, 2009), pp. 17–35.

3 Alex Danchev, *Cézanne: A Life* (London, 2012), p. 46.

4 Émile Zola, *Manuscripts*, BN NAF 10280 folio 4.

5 Zola, *La Conquête de Plassans* (Paris, 1990), p. 114.

6 Zola, letter to Baptistin Baille, 22 April 1861, in *The Letters of Paul Cézanne*, ed. Alex Danchev (London, 2013), p. 106.

7 Yvonne Knibiehler and Catherine Fouquet, *L'Histoire des mères du Moyen-Âge à nos jours* (Paris, 1980), pp. 138–73.

8 Danchev, *Cézanne*, p. 46.

9 Paul Cézanne, letter to Charles Camoin, 3 February 1902, in *Letters*, ed. Danchev, p. 313.

10 Jules Borély, 'Cézanne à Aix', *L'Art vivant*, II/37 (1 July 1926), repr. in *Conversations avec Cézanne*, ed. Michael Doran (Paris, 1986), p. 20.

11 Joachim Gasquet, *Cézanne* (Paris, 1921), p. 35.

12 Zola, *Oeuvres complètes*, ed. François Bernouard (Paris, 1927), vol. I, pp. 727–8.

13 Meyer Schapiro, *Modern Art: 19th & 20th Centuries. Selected Papers*, vol. II (New York, 1978), pp. 1–5.

14 Zola, letter to Cézanne, 30 December 1859, in *Letters*, ed. Danchev, p. 95.

15 Cézanne, letter to Zola, 9 April 1858, ibid., pp. 46–7.

16 Cézanne, letter to Zola, 29 July 1858, ibid., p. 63.

17 Paul Alexis, *Madame Meuriot: Moeurs parisiens* (Paris, 1890).

18 Frederick Brown, 'Zola and Cézanne: The Early Years', *New Criterion*, III/4 (1984), pp. 15–29.

19 Paul Smith, 'Cézanne's Primitive Self and Related Fictions', in *The Life and the Work: Art and Biography*, ed. Charles G. Salas (Los Angeles, CA, 2007), p. 56.

20 Cézanne, letter to Zola, 9 April 1858, in *Letters*, ed. Danchev, pp. 46–7.

21 Timothy J. Clark, 'Freud's Cézanne', *Representations*, 52 (1995), pp. 96–7.

22 Quoted in John Rewald, *Paul Cézanne: A Biography* (New York, 1948), p. 5; Wayne Andersen, *The Youth of Cézanne and Zola: Notoriety at its Source, Art and Literature in Paris* (Geneva, 2003), pp. 5–7.

23 Zola, *Documents littéraires, études et portraits* (Paris, 1881), pp. 87–90.

24 Cézanne, letter to Zola, 7 December 1858, in *Letters*, ed. Danchev, pp. 71–3.

25 Danchev, *Cézanne*, pp. 56–9.

26 Zola, letter to Baille and Cézanne, 24 October 1860, in *Letters*, ed. Danchev, p. 104.

27 Maurice Merleau-Ponty, 'Le Doute de Cézanne', *Revue fontaine*, VIII/47 (December 1945), pp. 80–100.

28 Zola, letter to Cézanne, 16 April 1860, in *Letters*, ed. Danchev, p. 100.

29 Zola, letter to Cézanne, 3 March 1861, ibid. p. 105.

30 Zola, letter to Baille, 22 April 1861, ibid. p. 106.

2 An Artist of *Tempérament*

1 Ambroise Vollard, *En écoutant Cézanne, Degas, Renoir* (Paris, 1938), p. 75. Author's own translation.

2 Émile Zola, letter to Baptistin Baille, 10 June 1861, in *Correspondance d'Émile Zola*, ed. B. H. Bakker (Montréal, 1978–95), vol. I, pp. 293–4.

3 Cited in Wayne Andersen, *The Youth of Cézanne and Zola: Notoriety at its Source: Art and Literature in Paris* (Geneva, 2003), p. 151.

4 Adrien Chappuis, *The Drawings of Paul Cézanne: A Catalogue Raisonné* (London, 1973), vol. I, cats 174 and 175, pp. 85–6.

5 Joachim Gasquet, *Joachim Gasquet's Cézanne: A Memoir with Conversations* (London, 1991), p. 197; Sarah Lichtenstein, 'Cézanne and Delacroix', *Art Bulletin*, XLVI/1 (1964), pp. 58–67. See also Richard Thomson, 'Rubens, Cézanne and Late Nineteenth Century French Art', in *Cézanne and Poussin: A Symposium*, ed. Richard Kendall (Sheffield, 1993), pp. 113–28.

6 Paul Cézanne, letter to Émile Bernard, 25 July 1904, in *The Letters of Paul Cézanne*, ed. Alex Danchev (London, 2013), p. 342.

7 Ernest Chesneau, *Le Mouvement moderne en peinture. Eugène Delacroix* (Paris, 1861), p. 148.

8 John House, 'Manet's Naiveté', *Burlington Magazine*, CXXVIII/997 (1986), pp. 3–6.

9 On Cézanne's conversance with Stendhal's *Histoire de la peinture en Italie*, see Cézanne, letter to Zola, 20 November 1878, in *Letters*, ed. Danchev, p. 189.

10 Charles Baudelaire, *Écrits sur l'art*, ed. Yves Florenne (Paris, 1971), vol. I, p. 144.

11 Baudelaire, *Oeuvres complètes*, ed. Yves-Gerard Le Dantec and Claude Pichois (Paris, 1961), pp. 1108–51.

12 Hippolyte Taine, *Philosophie de l'Art* (Paris, 1893), vol. I, pp. 44–5.

13 Ibid., pp. 61–2.

14 Stendhal, *Histoire de la peinture en Italie* (Paris, 1868), p. 215; Alfred Johannot, 'Du point de vue dans la critique', *L'Artiste*, 1 (1831), pp. 109–10.

15 Quoted in Achille Piron, *Eugène Delacroix: Sa Vie et ses oeuvres* (Paris, 1865), p. 421.

16 Émile Zola, *Écrits sur l'art*, ed. Antoinette Ehrard (Paris, 1970), p. 101.

17 Ibid., p. 60.

18 Cézanne, letter to Camille Camoin, 22 February 1903, in *Letters*, ed. Danchev, p. 326.

19 Cézanne, letter to Émile Bernard, 1905, ibid., p. 353.

20 See Ambroise Vollard, *Paul Cézanne* (Paris, 1914), p. 22.

21 Zola, letter to Cézanne, 1 August 1860, in *Letters*, ed. Danchev, p. 102.

22 See Nina Athanassoglou-Kallmyer, *Cézanne and Provence: The Painter in his Culture* (Chicago, IL, 2003); Émile Ripert, *La Renaissance provençale* (Paris, 1917).

23 On Loubon, see Aaron Sheon, *Monticelli, his Contemporaries, his Influence*, exh. cat., Pittsburgh Museum of Art, Carnegie Institute (1979), pp. 29–32 and Pierre Brahic-Guirai, *Émile Loubon: Sa Vie, son oeuvre* (Marseille, 1973).

24 Denis Coutagne et al., *Cézanne au Musée d'Aix* (Aix-en-Provence, 1984).

25 Mary Tompkins Lewis, *Cézanne's Early Imagery* (London, 1989), pp. 9–22.

26 Paul de Man, 'Autobiography as De-Facement', *Modern Language Notes*, XCIV/5 (1979), p. 920.

27 Max Nordau, *On Art and Artists* (London, 1907), p. 236. Nordau refers
 here to *Portrait de Madame Cézanne* (1891–2), *L'Homme au chapeau de
 paille* (Gustave Boyer, *c.* 1871) and *Portrait de l'artiste au chapeau à large
 bord* (1879–80), shown at the Salon d'Automne in 1904.

28 Ruth Butler, *Hidden in the Shadow of the Master: The Model-wives
 of Cézanne, Monet, and Rodin* (London, 2010), p. 21.

29 Cézanne, letter to Numa Coste, 27 February 1864, in *Letters*,
 ed. Danchev, p. 114.

30 Lucien Pissarro to Paul-Émile Pissarro, *c.* 1912, Archives of the
 Ashmolean Museum, Oxford.

31 Zola, *The Belly of Paris*, trans. Ernest Vizetelly (Gloucester, 2006), p. 12.

32 Quoted in Alex Danchev, *Cézanne: A Life* (London, 2012), pp. 93–5.

33 Alexander Dumas fils, *Lettre sur les choses du jour*, 6 June 1871, quoted
 in Paul Lidsky, *Les Écrivains contre la Commune* (Paris, 1970), p. 59.

34 Timothy J. Clark, *Image of the People: Gustave Courbet and the 1848
 Revolution* (London, 1973), p. 29.

35 Ibid., pp. 21–35.

36 Théodore Véron, *Dictionnaire Véron* (Paris, 1882), p. 113.

37 Cézanne, letter to Count Nieuwerkerke, 19 April 1866, in *Letters*,
 ed. Danchev, pp. 120–21.

38 Danchev, *Cézanne*, pp. 111–12.

39 Cézanne, letter to Zola, 15 March 1865, in *Letters*, ed. Danchev, p. 144.

40 Jean Prouvaire, 'L'Exposition du boulevard des Capucines, *Le Rappel*,
 20 April 1874, n.p.

41 Vollard, *En écoutant*, p. 40.

42 Antony Valabrègue to Zola, November 1866, quoted in John Rewald,
 Paintings of Paul Cézanne: A Catalogue Raisonné (London, 1996), vol. I,
 p. 100.

43 Valabrègue quoted in John Rewald, *The History of Impressionism*
 (New York, 1946), p. 139.

44 Robert Simon, 'Cézanne and the Subject of Violence', *Art in America*,
 LXXIX/5 (1991), pp. 128–31.

45 See Marius Roux's letter to Zola *c.* 24 June 1867 or 1868, in Clive
 Thomson, 'Une correspondence inédite (première partie): Vingt-sept
 lettres de Marius Roux à Émile Zola (1864–69)', *University of Ottawa
 Quarterly*, XLVIII/4 (1978), p. 344.

46 Baudelaire, *Oeuvres complètes*, p. 899.

47 Prouvaire, 'L'Exposition du boulevard des Capucines'.

48 Quoted in Alfred H. Barr, Jr, 'Cézanne in the Letters of Marion to Morstadt 1865–68', *Magazine of Art*, 31 (May 1938), pp. 288–91.

49 Zola, letter to Théodore Duret 30 May 1870, in Émile Zola, *Correspondance*, ed. B. H. Bakker, 10 vols (Montreal, 1978–95), vol. II, p. 219.

50 Quoted in John Rewald, *Paul Cézanne: A Biography* (New York, 1948), p. 84.

51 Stock, Album Stock, 20 March 1870, quoted in *Correspondance de Cézanne*, ed. John Rewald (Paris, 1978), p. 135.

52 Cézanne, letter to Justin Gabet, 7 June 1870, in *Letters*, ed. Danchev, p. 170.

53 Nina Athanassoglou-Kallmyer, 'An Artistic and Political Manifesto for Cézanne', *Art Bulletin*, LXXII/3 (1990), pp. 488–90.

54 Paul Gachet, *Deux amis des Impressionnistes, le Docteur Gachet et Murer* (Paris, 1956), pp. 57–8.

55 Zola had originally defended Manet in his Salon of 1866 and extended his discussion into a three-part essay solely devoted to him. This was revised and republished in January 1867 in the *Revue du XIXe siècle* under the title *Une Nouvelle manière de peindre*. Zola, *Écrits sur l'art*, ed. Jean-Paul Leduc-Adine (Paris, 1991), pp. 112–19, 139–69.

56 Ibid., pp. 159–60.

57 Ibid., p. 145.

58 Ibid., p. 151.

59 Ibid., pp. 151–3.

60 Danchev, *Cézanne*, p. 89.

61 See Ambroise Vollard, *Cézanne* (Paris, 1924), pp. 21–32. See also Guillemet's letter to Zola, 2 November 1866, repr. in Jack Lindsay, *Cézanne: His Life and Art* (New York, 1969), p. 114.

62 Danchev, *Cézanne*, p. 91.

63 Vollard, *En écoutant*, pp. 40, 46.

64 Karl Madsen review in *Politiken*, 1889, quoted in Merete Bodelsen, 'Gauguin's Cézannes', *Burlington Magazine*, 104 (May 1962), p. 208.

65 Timothy J. Clark, *The Painting of Modern Life: Paris in the Art of Manet and His Followers* (London, 1985), pp. 74–196.

66 Louis Leroy, 'Exposition des Impressionnistes', *Le Charivari* (25 April 1874), p. 3.

67 Jules Castagnary, 'L'Exposition du boulevard des Capucines: Les Impressionnistes', *Le Siècle* (29 April 1874).

68 Émile Cardon, 'L'Exposition des révoltés', *La Presse* (29 April 1874).

69 Marc de Montifaud [Marie-Émilie Chartroule de Montifaud], Exposition du boulevard des Capucines, *L'Artiste* (1 May 1874), p. 311.

70 Cézanne, letter to Zola, 20 June 1859, in *Letters*, ed. Danchev, p. 80.

71 Cézanne, letter to Zola, 29 July 1859, ibid., p. 83.

72 See Cézanne, letter to Heinrich Morstatt, 23 December 1865, ibid., p. 120.

73 Cézanne, letter to Morstatt, 24 May 1868, ibid., p. 134.

74 Barr, 'Cézanne in the Letters of Marion to Morstadt 1865–68', p. 289.

75 Baudelaire, *Oeuvres complètes*, pp. 1235–6.

76 Ibid., p. 1236.

77 Zola, *Écrits sur l'art*, pp. 141–69; Baudelaire, *Oeuvres complètes*, p. 1235.

78 Cézanne, letter to Zola, 19 May 1883, in *Letters*, ed. Danchev, p. 228.

79 Antoine Guillemet, letter to Francisco Oller, 12 September 1866, quoted in Rewald, *Cézanne*, p. 64.

80 Harold Bloom, *The Anxiety of Influence: A Theory of Poetry* (Oxford, 1973), p. 78.

81 Ibid., p. 24.

82 Ibid.

83 Ibid., p. 25.

3 Pissarro, Landscape and Impressionism

1 John Rewald, *Paul Cézanne: A Biography* (New York, 1948), pp. 93–102.

2 Paul Cézanne, letter to Émile Zola, 19 October 1866, in *The Letters of Paul Cézanne*, ed. Alex Danchev (London, 2013), p. 126.

3 Zola, letter to Cézanne, 4 July 1871, ibid. p. 143.

4 Ambroise Vollard, *En écoutant Cézanne, Degas, Renoir* (Paris, 1938), p. 43.

5 Paul Tucker, 'The First Impressionist Exhibition in Context', in *The New Painting: Impressionism, 1874–1886*, ed. Charles S. Moffet, exh. cat., Fine Arts Museums of San Francisco (1986), pp. 101–4.

6 Richard Thomson, *Monet to Matisse: Landscape Painting in France, 1874–1914*, exh. cat., National Gallery of Scotland, Edinburgh (1994), p. 14.

7 John House, *Landscapes of France: Impressionism and its Rivals*, exh. cat., Hayward Gallery, London (1995), p. 8.

8 Ibid., p. 24.

9 Camille Pissarro, letter to Lucien Pissarro, 4 December 1895, in *Correspondance de Camille Pissarro (1865–1903)*, ed. Janine Bailly-Hezberg (Paris, 1989), vol. IV, p. 128.

10 Jules Borély in *Conversations avec Cézanne*, ed. Michael Doran (Paris, 1986), p. 20.

11 Ibid., p. 121.

12 Quoted in John Rewald, *The History of Impressionism* (New York, 1946), p. 458.

13 See Paul Smith, '"Parbleu": Pissarro and the Political Colour of an Original Vision', *Art History*, XV/2 (1992), pp. 223–47.

14 Nicholas Green, *The Spectacle of Nature: Landscape and Bourgeois Culture in Nineteenth-century France* (Manchester, 1990), pp. 128–34.

15 Quoted in Alex Danchev, *Cézanne: A Life* (London, 2012), p. 144.

16 Pissarro, *Correspondance*, vol. V, p. 369.

17 Cézanne, letter to Émile Bernard, *c.* 1905, in *Letters*, ed. Danchev, p. 353.

18 Quoted in Danchev, *Cézanne*, p. 140.

19 Theodore Reff, 'The Pictures within Cézanne's Pictures', *Arts Magazine*, LIII/10 (1979), pp. 90–94.

20 Cézanne, letter to Zola, 23 June 1879, in *Letters*, ed. Danchev, p. 197.

21 Cézanne, letter to Numa Coste, July 1868, ibid., pp. 134–5.

22 Henri Rochefort, 'L'Amour du laid', *L'Intransigeant* (9 March 1903), p. 1.

23 Cézanne, letter to Pissarro, 2 July 1876, in *Letters*, ed. Danchev, p. 160.

24 John Rewald, *Studies in Impressionism* (London, 1985), pp. 103–20.

25 Cézanne, letter to Pissarro, 2 July 1876, in *Letters*, ed. Danchev, p. 158.

26 House, *Landscapes*, pp. 20–22.

27 Ibid., p. 22.

28 Georges Lafenestre, *L'Art vivant: La Peinture et la sculpture aux salons de 1868 à 1877* (Paris, 1881), vol. I, p. 292; Prosper Duvergier de Hauranne, 'Le Salon de 1873: Le Paysage et la sculpture', *Revue des deux mondes* (1 June 1873), p. 860.

29 Charles Bigot, 'Causerie artistique: L'Exposition "impressionnistes"', *La Revue politique et littéraire* (28 April 1877), p. 1046.

30 House, *Landscapes*, p. 23.
31 Joel Isaacson, 'Constable, Duranty, Mallarmé, Impressionism, Plein Air, and Forgetting', *Art Bulletin*, LXXVI/3 (1994), p. 439.
32 Richard Shiff, *Cézanne and the End of Impressionism: A Study of the Theory, Technique, and Critical Evaluation of Modern Art* (Chicago, IL, 1984), pp. 3–54.
33 Ibid.
34 Hal Foster, ed., *Vision and Visuality* (Seattle, WA, 1988), pp. 29–44.
35 Richard Shiff, 'The End of Impressionism', in *New Painting*, ed. Moffett, pp. 61–89.
36 'Jacques', 'Menus propos, Exposition impressionniste', *L'Homme libre* (12 April 1877), n.p.
37 Meyer Schapiro, *Modern Art: 19th & 20th Centuries: Selected Papers* (New York, 1978), vol. II, pp. 92–3.
38 Richard R. Brettell, *Pissarro and Pontoise: The Painter in a Landscape* (New Haven, CT, 1990), pp. 73–98.
39 John Rewald, *Cézanne: sa vie, son œuvre, son amitié* (Paris, 1939), p. 283.
40 T. J. Clark, 'Cézanne and Pissarro in the 1870s', lecture at the Art Institute of Chicago (1 October 2009).
41 Ibid.
42 Ibid.
43 Cézanne, letter to Zola, 14 April 1878, in *Letters*, ed. Danchev, pp. 164–5.
44 Danchev, *Cézanne*, p. 145.
45 Cézanne, letter to Zola, late March/early April 1878, in *Letters*, ed. Danchev, p. 169.
46 Theodore Reff, 'Cézanne's Constructive Stroke', *Art Quarterly*, XXV/3 (1962), pp. 214–27.

4 Portrait of a Woman

1 Ruth Butler, *Hidden in the Shadow of the Master: The Model-wives of Cézanne, Monet, and Rodin* (London, 2010), p. 21.
2 Paul Cézanne, letter to Émile Zola, 4 April 1878, in *The Letters of Paul Cézanne*, ed. Alex Danchev (London, 2013), p. 170.
3 Cézanne, letter to Zola, 14 September 1878, ibid., pp. 178–9.

4 Quoted in Butler, *Hidden in the Shadow*, p. 28.
5 Paul Gachet, *Deux amis des impressionnistes: le docteur Gachet et Murer* (Paris, 1956), p. 60.
6 Frederick Brown, *Zola: A Life* (New York, 1997), p. 97.
7 Zola, letter to Baptistin Baille, August/beginning of September 1860, in *Letters*, ed. Danchev, p. 103.
8 Cézanne, letter to Zola, 16 April 1860, ibid., p. 100.
9 Cézanne, letter to Zola, 29 December 1859, ibid., p. 94.
10 Cézanne, letter to Zola, 29 July 1859, ibid., p. 83. See also Cézanne, letter to Zola, 20 June 1859, and Zola, letter to Cézanne, 14 January 1860, ibid., pp. 79–86, 98.
11 Cézanne, letter to Camille Pissarro, 24 June 1874, ibid., p. 151.
12 Cézanne, letter to his parents, April 1874, ibid., p. 155.
13 Tamar Garb, *The Painted Face: Portraits of Women in France, 1814–1914* (London, 2007), pp. 141–2.
14 Rainer Maria Rilke, letter to his wife, 22 October 1907, in Rainer Maria Rilke, *Letters on Cézanne*, trans. James Agee (New York, 2002), p. 219.
15 Butler, *Hidden in the Shadow*, p. 70.
16 Zola, letter to Baille, August 1861, in *Letters*, ed. Danchev, p. 110.
17 Ambroise Vollard, *Paul Cézanne* (Paris, 1924), p. 135.
18 Gustave Geffroy, *Claude Monet: Sa Vie, son oeuvre* (Paris, 1980), p. 237; Joachim Gasquet in Michael Doran, ed., *Conversations avec Cézanne* (Paris, 1986), p. 124.
19 Fritz Novotny, *Cézanne* (London, 1971), p. 4.
20 Cézanne, letter to an unknown woman, spring 1885, in *Letters*, ed. Danchev, p. 233.
21 Quoted in Butler, *Hidden in the Shadow*, p. 58.
22 Ibid., p. 63.
23 Françoise Cachin and Joseph Rishel, *Cézanne*, exh. cat., London, Tate Gallery (1996), p. 293.
24 Paul Alexis, letter to Zola, 13 February 1891; B. H. Bakker, ed., *'Naturalisme pas mort': Lettres inédites de Paul Alexis à Émile Zola, 1871–1900* (Toronto, 1971), p. 400.
25 Cézanne, letter to Victor Chocquet, 11 May 1886, in *Letters*, ed. Danchev, p. 245.
26 Maurice Denis, *Journal, Journal* (Paris, 1957), vol. I, p. 130.
27 Butler, *Hidden in the Shadow*, p. 78.

28 Vollard, *Paul Cézanne*, p. 94.
29 Cézanne, letter to his son Paul, 25 July 1906, in *Letters*, ed. Danchev, p. 362.
30 Cézanne, letter to his son Paul, 26 August 1906, ibid., p. 369.
31 John Rewald, *Cézanne: A Biography* (London and New York, 1986), p. 114.
32 See Danchev's commentary on Madame Marie Brémond's telegram, ibid., p. 385.
33 Hortense Fiquet, letter to Marie Chocquet, 1 August 1890, ibid., pp. 254–5.
34 Marie-Alain Couturier, 23 June 1951, *Se garder libre: Journal, 1947–1954* (Paris, 1962), quoted in Butler, *Hidden in the Shadow*, p. 77.
35 Léo Larguier, *Cézanne ou la lutte avec l'ange de la peinture* (Paris, 1947) p. 143.
36 Rewald, *Paul Cézanne*, p. 114.
37 Roger Fry, letter to Helen Anrep, 1 May 1925, quoted in Ann Dumas, 'The Portraits of Madame Cézanne', in Dita Amory et al., *Madame Cézanne* (New York, 2014), p. 95.
38 Quoted in Butler, *Hidden in the Shadow*, p. 65.
39 Garb, *Painted Face*, p. 142.
40 Susan Sidlauskas, *Cézanne's Other: The Portraits of Hortense* (Los Angeles, CA, 2009), pp. 8–16.
41 See Maurice Merleau-Ponty, *Sense and Non-sense*, trans. Hubert L. Dreyfus and Paul A. Dreyfus (Evanston, IL, 1964), p. 353.

5 Solitary Pleasures

1 Roger Fry, *Cézanne: A Study in His Development* (Chicago, IL, 1989), p. 39.
2 Theodore Reff, 'Cézanne's Constructive Stroke', *Art Quarterly*, XXV/3 (1962), pp. 214–27.
3 Paul Cézanne, letter to Émile Bernard, 21 September 1906, in *The Letters of Paul Cézanne*, ed. Alex Danchev (London, 2013), p. 373.
4 Cézanne, letter to Philippe Solari, 23 July 1896, ibid., p. 277.
5 Cézanne, letter to Émile Zola, 20 May 1881, ibid., p. 217.
6 Émile Bernard, 'Souvenirs sur Paul Cézanne et lettres inédites', reprinted in *Conversations avec Cézanne*, ed. Michael Doran (Paris, 1986), p. 58.

7 Meyer Schapiro, *Modern Art: 19th & 20th Centuries. Selected Papers*, vol. II (New York, 1978), pp. 1–38.

8 Jules-Antoine Castagnary, 'Salon des refusés', *L'Artiste* (1 August 1863), p. 51.

9 Alfred Stevens, *Impressions sur la peinture* (Paris, 1886), p. 19.

10 Nina Athanassogolou-Kallmyer, 'Cézanne in the Studio', in *The World is an Apple*, ed. Benidict Leca (London, 2014), p. 216.

11 Joachim Gasquet, *Cézanne* (Paris, 1921), pp. 121–2.

12 Athanassogolou-Kallmyer, 'Cézanne in the Studio', p. 216.

13 Jan Birksted, ed., *Landscapes of Memory and Experience* (London, 2000), pp. 80–81.

14 Athanagossolou-Kallmyer, 'Cézanne in the Studio', p. 199.

15 Debora L. Silverman, *Art Nouveau in Fin-de-siècle France: Politics, Psychology, and Style* (Los Angeles, CA, and London, 1989), p. 89.

16 Roger Fry, *Cézanne: A Study in His Development* (Chicago, IL, 1989), p. 40.

17 Schapiro, *Modern Art*, p. 30.

18 Ambroise Vollard, *Cézanne* (Paris, 1924), p. 136.

19 Roger Fry, 'Art: The Post-Impressionists – II,' *Nation* (3 December 1911), p. 402.

20 Maurice Merleau-Ponty, 'Le Doute de Cézanne', *Revue fontaine*, VIII/47 (December 1945), pp. 80–100.

21 R. F. Rivière and J. F. Schnerb, 'L'Atelier de Cézanne', *La Grande revue*, XLVI (25 December 1907), p. 87.

22 Jean Borély in *Conversations*, ed. Doran, p. 22.

23 Paul Smith, *Interpreting Cézanne* (London, 1996), pp. 43–4.

24 Cézanne, letter to Bernard, 23 October 1905, in *Letters*, ed. Danchev, pp. 355–6; Bernard in *Conversations*, ed. Doran, p. 65.

25 Jonathan Crary, 'Unbinding Vision', *October*, 68 (Spring 1994), pp. 21–5.

26 Smith, *Interpreting Cézanne*, p. 46.

27 Cézanne, letter to Bernard, 23 October 1905, in *Letters*, ed. Danchev, p. 355.

28 Louis Le Bail quoted in John Rewald, *Cézanne: A Biography* (London, 1986), p. 228.

6 Provence, the Peasantry and Montagne Sainte-Victoire

1 Timothy J. Clark, 'Phenomenality and Materiality in Cézanne', in *Material Events*, ed. Tom Cohen (Minneapolis, MN, 2001), p. 109.
2 Richard Shiff, 'Introduction', in Joachim Gasquet et al., *Joachim Gasquet's Cézanne: A Memoir with Conversations* (London, 1991), pp. 15–24.
3 Paul Cézanne, letter to Joachim Gasquet, 21 July 1896, in *The Letters of Paul Cézanne*, ed. Alex Danchev (London, 2013), p. 276.
4 John Rewald in Gasquet, *Joachim Gasquet's Cézanne*, pp. 7–10.
5 Paul Smith, 'Joachim Gasquet, Virgil and Cézanne's Landscape', *Apollo*, CXLVII/439 (1999), pp. 11–23.
6 Frédéric Mistral, *Oeuvres de Frédéric Mistral: Les Îles d'or* (Paris, 1889). See also Joachim Gasquet, *Les Chants séculaires* (Paris, 1903).
7 Tudor Edwards, *The Lion of Arles: A Portrait of Mistral and His Circle* (New York, 1927), pp. 37–58.
8 Joachim Gasquet, 'Le Sang provençal', *Les Mois dorés* (March–April 1898), pp. 373–80; Cézanne, letter to Gasquet, 22 June 1898, in *Letters*, ed. Danchev, p. 292.
9 Cézanne, letter to Henri Gasquet, 23 December 1898, and letter to Joachim Gasquet, 25 June 1903, ibid., pp. 292–3, 327–8.
10 Gasquet, *Cézanne* (Paris, 1921), p. 192.
11 Cézanne, letter to Roger Marx, 25 January 1905, in *Letters*, ed. Danchev, p. 350.
12 Gasquet, *Joachim Gasquet's Cézanne*, pp. 15–17.
13 Roger Fry, *Cézanne: A Study in His Development* (Chicago, IL, 1989), pp. 1, 83.
14 Gasquet, *Cézanne*, p. 76.
15 Jean Royère, 'Un Aixois: Joachim Gasquet', *Le Mémorial d'Aix* (15 December 1929), n.p.
16 Cézanne, letter to Gasquet, 17 June 1901, in *Letters*, ed. Danchev, p. 304.
17 Gasquet, *Joachim Gasquet's Cézanne*, p. 13.
18 Ibid., p. 7.
19 Tony Judt, *Socialism in Provence, 1871–1914: A Study in the Origins of the Modern French Left* (Cambridge, 1979), pp. 23–37.
20 Ibid., pp. 33–9.

21 Émile Bernard in *Conversations avec Cézanne*, ed. Michael Doran (Paris, 1986), p. 40.

22 Gasquet, *Cézanne*, p. 72.

23 Jules Borély in *Conversations*, ed. Doran, p. 18.

24 Nina Athanassogolou-Kallmyer, 'Cézanne's Studio', in *The World is an Apple*, ed. Benedict Leca (London, 2014), p. 224.

25 Georges Lecomte, 'Paul Cézanne', *Revue de l'art*, I (9 December 1899), p. 86.

26 Gasquet, *Cézanne*, p. 12.

27 Theodore Reff, 'The Pictures within Cézanne's Pictures', *Arts Magazine*, LIII/10 (1979), pp. 95–8.

28 Gasquet, *Cézanne*, p. 67.

29 Cézanne, letter to Bernard, 24 July 1904, in *Correspondance de Cézanne*, ed. John Rewald (Paris, 1978), pp. 304–5.

30 Charles Camoin quoted in Jean Arrouye, *La Provence de Cézanne* (Aix-en-Provence, 1982), p. 73.

31 Borély in *Conversations*, ed. Doran, p. 21.

32 Charles Harrison, 'Impressionism, Modernism and Originality', in *Modernity and Modernism, French Painting in the Nineteenth Century*, ed. Frances Frascina et al. (New Haven, CT, 1993), p. 189.

33 Jon Kear, 'Leaving L'Estaque: Cézanne's Imagery of Provence in the 1880s', *Art on the Line*, 1/1 (2003), pp. 1–20.

34 Cézanne, letter to Paule Conil, 1 September 1902, , in *Letters*, ed. Danchev, pp. 323–4.

35 Louis M. Greenberg, *Sisters of Liberty: Marseille, Lyon, Paris and the Reaction to a Centralized State, 1868–1871* (Cambridge, MA, 1971).

36 William H. Sewell, *Structure and Mobility: The Men and Women of Marseille, 1820–1870* (Cambridge, 1985), pp. 101–3.

37 Cézanne, letter to Émile Zola, September 1879, in *Correspondance*, ed. Rewald, pp. 173–4.

38 John Rewald, *Cézanne: A Biography* (London, 1986), pp. 158–9.

39 Gasquet, *Cézanne*, p. 12.

40 Paul-Albert Février, 'Histoire des Victoires', in Paul-Albert Février et al., *Le Dépassement de la nostalgie* (Aix-en-Provence, 1990), pp. 63–5.

41 Bernard, 'Souvenirs sur Paul Cézanne et lettres inédites (suite)', *Mercure de France*, LXX/248 (1907), p. 614.

42 Samuel Beckett, letter to Thomas McGreevy, 8 September 1934, in *The Letters of Samuel Beckett*, vol. I: *1929–1940*, ed. Martha Dow Fehsenfeld and Lois More Overbeck (Cambridge, 2009), p. 222.

43 Cézanne, letter to Zola, 9 April 1858, in *Letters*, ed. Danchev, p. 47.

44 John Rewald, *Cézanne: A Catalogue Raisonné* (London, 1996), vol. II, p. 531.

45 Richard Shiff, 'Cézanne's Physicality: The Politics of Touch', in *The Language of Art History*, ed. Salim Kermal and Ivan Gaskell (Cambridge, 1991), p. 160.

46 Charles Maurras, 'Barbares et Romans', *La Plume*, 53 (1 July 1891), pp. 229–30.

47 Gasquet, *Joachim Gasquet's Cézanne*, pp. 18–19.

48 John Rewald, ed., *Paul Cezanne: Letters* (Oxford, 1976), p. 274.

49 Maurice Merleau-Ponty, *Sense and Non-sense: Studies in Phenomenology and Existential Philosophy*, ed. and trans. Hubert L. Dreyfus and Paul A. Dreyfus (Evanston, IL, 1964), pp. 9–12.

50 See letters to Joachim Gasquet, 21 July 1896, 23 July 1896, 29 September 1896, in *Letters*, ed. Danchev, pp. 276–9.

51 Numa Coste, letter to Zola, April 1896/7, quoted in *'Naturalisme pas mort': Lettres inédites de Paul Alexis à Émile Zola, 1871–1900*, ed. B. H. Bakker (Toronto, 1971), p. 296.

52 Alex Danchev, *Cézanne: A Life* (London, 2012), p. 315.

53 Cézanne, letter to Gasquet, 30 April 1886, in *Letters*, ed. Danchev, p. 272.

54 Cézanne, letter to Bernard, 21 September 1906, ibid., p. 373.

55 Theodore Reff, 'Cézanne: The Severed Head and Skull', *Arts Magazine*, LVIII/2 (1983), pp. 84–100.

56 Mary Tompkins Lewis, *Cézanne's Early Imagery* (Berkeley, CA, 1989), p. 40.

57 Cézanne, letter to his son, 12 August 1906, in *Letters*, ed. Danchev, p. 364.

58 Gustave Geffroy, 'Cézanne', *La Vie artistique*, 3 (Paris, 1894), p. 257.

59 Michael Herbert, ed., *D. H. Lawrence: Selected Critical Writings* (Oxford, 1998), p. 279.

60 Clark, 'Phenomenality and Materiality', p. 111.

61 Rewald, *Cézanne*, p. 241.

62 Cézanne, letter to Coste and Joseph Villevieille, 5 January 1863, in *Letters*, ed. Danchev, pp. 112–13.

63 Theodor W. Adorno, *Beethoven: The Philosophy of Music* (Berkeley, CA, 1998), pp. 123–30.

Epilogue

1 Fred Orton, '(Painting) Out of Time', *Parallax*, II/2 (September 1996), pp. 99–112.
2 Paul Cézanne, letter to Georges Rouault, undated, *c.* 1906, in *The Letters of Paul Cézanne*, ed. Alex Danchev (London, 2013), p. 358.
3 T. J. Clark, 'Symptoms of Cézannoia', *London Review of Books* (2 December 2010), pp. 22–3.

Select Bibliography

Adorno, Theodor W., *Beethoven: The Philosophy of Music* (Stanford, CA, 1998)

Alexis, Paul, *Madame Meuriot: Moeurs parisiens* (Paris, 1890)

Amory, Dita, et al., *Madame Cézanne* (New York, 2014)

Andersen, Wayne, *The Youth of Cézanne and Zola: Notoriety at its Source: Art and Literature in Paris* (Geneva, 2003)

Anon., 'Le Salon d'automne', *L'Humanité* (3 October 1907)

Athanassoglou-Kallmyer, Nina, 'An Artistic and Political Manifesto for Cézanne', *Art Bulletin*, 72 (September 1990), pp. 482–92

—, *Cézanne and Provence: The Painter in His Culture* (Chicago, IL, 2003)

—, 'Cézanne's Studio', in *The World is an Apple*, ed. Benedict Leca (London, 2014), pp. 199–233

Arrouye, Jean, *La Provence de Cézanne* (Aix-en-Provence, 1982)

Bakker, B. H., ed., *'Naturalisme pas mort': Lettres inédites de Paul Alexis a Émile Zola, 1871–1900* (Toronto, 1971)

Barr, Alfred H., Jr, 'Cézanne in the Letters of Marion to Morstadt, 1865–68' [1937], trans. Margaret Scolari, *Magazine of Art* (31 May 1938), pp. 288–91

Baudelaire, Charles, *Écrits sur l'art*, ed. Yves Florenne, 2 vols (Paris, 1971)

—, *Oeuvres complètes*, ed. Yves-Gerard Le Dantec and Claude Pichois (Paris, 1961)

Bernard, Émile, 'Paul Cézanne', *L'Occident*, VI (July 1904), pp. 17–30

—, 'Souvenirs sur Paul Cézanne', *Mercure de France*, LXIX/247 (1 October 1907), pp. 385–404

—, 'Souvenirs sur Paul Cézanne et lettres inédites (suite)', *Mercure de France*, LXX/248 (16 October 1907), pp. 606–27

Bigot, Charles, 'Causerie artistique: L'Exposition "Impressionniste"', *Revue politique et littéraire* (28 April 1877), pp. 1045–8

Birksted, Jan, ed., *Landscapes of Memory and Experience* (London, 2000)

Bloom, Harold, *The Anxiety of Influence: A Theory of Poetry* (Oxford, 1973)

Bodelsen, Merete, 'Gauguin's Cézannes', *Burlington Magazine*, 104
 (May 1962), pp. 204–11

Borély, Jules, 'Cézanne à Aix', *L'Art vivant*, II/37 (1 July 1926), repr. in
 Conversations with Cézanne, ed. Michael Doran (Berkeley, CA, 2001),
 pp. 18–22

Brahic-Guirai, Pierre, *Émile Loubon: Sa Vie, son oeuvre* (Marseille, 1973)

Brettell, Richard R., *Pissarro and Pontoise: The Painter in a Landscape*
(New Haven, CT, and London, 1990)

Brown, Frederick, *Zola: A Life* (New York, 1997)

—, 'Zola and Cézanne: The Early Years', *New Criterion*, III/4 (1984), pp. 15–29

Butler, Ruth, *Hidden in the Shadow of the Master* (London, 2010)

Cachin, Françoise, and Joseph Rishel, *Cézanne*, exh. cat., Tate Gallery,
 London (1996)

Cardon, Émile, 'L'Exposition des révoltés', *La Presse* (29 April 1874)

Castagnary, Jules-Antoine, 'L'Exposition du boulevard des Capucines:
 Les impressionnistes', *Le Siècle* (29 April 1874)

—, 'Salon des refusés', *L'Artiste* (1 August 1863)

Chappuis, Adrien, *The Drawings of Paul Cézanne: A Catalogue Raisonné*,
 2 vols (London, 1973)

Chesneau, Ernest, *Le Mouvement moderne en peinture: Eugène Delacroix*
 (Paris, 1861)

Clark, Timothy J., 'Cézanne and Pissarro in the 1870s', lecture at Art
 Institute of Chicago, IL (1 October 2009)

—, 'Freud's Cézanne', *Representations*, 52 (1995), pp. 94–122

—, *Image of the People: Gustave Courbet and the 1848 Revolution*
 (London, 1973)

—, *The Painting of Modern Life: Paris in the Art of Manet and His Followers*
 (London and New Haven, CT, 1985), pp. 74–196

—, 'Phenomenality and Materiality in Cézanne', in *Material Events*,
 ed. Tom Cohen (Minneapolis, MN, 2001), pp. 93–113

Cohen, Tom, ed., *Material Events* (Minneapolis, MN, 2001)

Coutagne, Denis, et al., *Cézanne au Musée d'Aix*, exh. cat., Aix-en-Provence
 (1984)

Couturier, Marie-Alain, *Se garder libre: Journal, 1947–1954* (Paris, 1962)

Crary, Jonathan, 'Unbinding Vision', *October*, 68 (Spring 1994), pp. 21–44

Danchev, Alex, *Cézanne: A Life* (London, 2012)
—, ed., *The Letters of Paul Cézanne* (London, 2013)
Denis, Maurice, 'Paul Cézanne', *L'Occident*, 12 September 1907, repr. in
 Conversations with Cézanne, ed. Michael Doran (Berkeley, CA, 2001),
 pp. 166–80
—, *Journal*, vol. I (Paris, 1957)
Doran, Michael, ed., *Conversations avec Cézanne* (Paris, 1986)
D'Souza, Aruna, *Cézanne's Bathers: Biography and the Erotics of Paint*
 (Philadelphia, PA, 2008)
Duranty, Edmond, 'Le Peintre Marsabiel', *La Rue: Paris pittoresque et
 populaire* (20 July 1867)
Edwards, Tudor, *The Lion of Arles: A Portrait of Mistral and His Circle*
 (New York, 1927)
Elder, Marc, *À Giverny chez Claude Monet* (Paris, 1924)
Fagus, Félicien, 'Quarante tableaux de Cézanne', *La Revue blanche*
 (September–December 1899), pp. 627–8
Fehsenfeld, Martha Dow, and Lois More Overbeck, eds, *The Letters of
 Samuel Beckett*, vol. I: *1929–1940* (Cambridge, 2009)
Février, Paul-Albert, et al., *Le Dépassement de la nostalgie* (Aix-en-Provence,
 1990)
Foster, Hal, ed., *Vision and Visuality* (Seattle, WA, 1988)
Frascina, Frances, et al., eds, *Modernity and Modernism: French Painting in
 the Nineteenth Century* (New Haven, CT, 1993)
Fry, Roger, 'Art: The Post-Impressionists – II', *Nation* (3 December 1911)
—, *Cézanne: A Study in His Development* [1927] (Chicago, 1989)
Gachet, Paul, *Deux amis des impressionistes: Le Docteur Gachet et Murer*
 (Paris, 1956)
Garb, Tamar, *The Painted Face: Portraits of Women in France, 1814–1914*
 (London, 2007)
—, 'Visuality and Sexuality in Cézanne's Late Bathers', *Oxford Art Journal*,
 XIX/2 (1996), pp. 46–60
Gasquet, Joachim, *Cézanne* (Paris, 1921)
—, *Les Chants séculaires* (Paris, 1903)
—, *Joachim Gasquet's Cézanne: A Memoir with Conversations*, trans.
 Christopher Pemberton (London, 1991)
—, 'Le Sang provençal', *Les Mois dorés* (March/April 1898),
 pp. 373–80

Geelhaar, Christian, 'The Painters Who Had the Right Eyes: On the Reception of Cézanne's Bathers', in *Paul Cézanne: The Bathers*, ed. Mary Krumrine, exh. cat., Kunsthalle, Basel (1989), pp. 275–303

Geffroy, Gustave, 'Cézanne', *La Vie artistique*, 8 vols (Paris, 1894–1903)

Gottlieb, Mark, 'Poussin's Lesson: Representing Representation in the Romantic Age', *Word and Image*, XVI/1 (2000), pp. 124–43

Green, Nicholas, *The Spectacle of Nature* (Manchester, 1990)

Greenberg, Louis M., *Sisters of Liberty: Marseille, Lyon, Paris and the Reaction to a Centralized State* (Cambridge, MA, 1971)

Hauranne, Prosper Duvergier de, 'Le Salon de 1873: Le paysage et la sculpture', *Revue des deux mondes* (1 June 1873), p. 860

Herbert, James D., *Fauve Painting: The Making of Cultural Politics* (New Haven, CT, 1992)

Herbert, Michael, ed., *D. H. Lawrence: Selected Critical Writings* (Oxford, 1998)

Heywood, Colin, *Growing up in France: From the Ancien Régime to the Third Republic* (Cambridge, 2009)

House, John, *Landscapes of France: Impressionism and its Rivals*, exh. cat., Hayward Gallery, London (1995)

—, 'Manet's Naiveté', *Burlington Magazine*, CXXVII/997 (1986), pp. 1–19

Huysmans, Joris-Karl, *Certains* (Paris, 1889)

Isaacson, Joel, 'Constable, Duranty, Mallarmé, Impressionism, Plein Air, and Forgetting', *Art Bulletin*, LXXVI/3 (1994), pp. 427–50

'Jacques', 'Menus propos, exposition impressionniste', *L'Homme libre* (12 April 1877), n.p.

Jameson, Frederic, *The Modernist Papers* (London, 2007)

Johannot, Alfred, 'Du point de vue dans la critique', *L'Artiste*, I (1831), pp. 109–10

Judt, Tony, *Socialism in Provence, 1871–1914: A Study in the Origins of the Modern French Left* (Cambridge, 1979)

Kear, Jon, 'Cézanne's Nudes and Balzac's *Le Chef-d'oeuvre inconnu*', *Cambridge Quarterly*, XXXV/4 (2006), pp. 345–60

—, 'Leaving L'Estaque: Cézanne's Imagery of Provence in the 1880s', *Art on the Line*, 1/1 (2003), pp. 1–20

—, 'Le Sang Provençal: Joachim Gasquet's Cézanne', *Journal of European Studies*, XXXII/3 (2002), pp. 135–50

Kendall, Richard, ed., *Cézanne and Poussin: A Symposium* (Sheffield, 1993)

Kermal, Salim, and Ivan Gaskell, eds, *The Language of Art History* (Cambridge, 1991)

Knibiehler, Yvonne, and Catherine Fouquet, *L'Histoire des mères du Moyen-Âge à nos jours* (Paris, 1980)

Krumrine, Mary, ed., *Cézanne's Bathers*, exh. cat., Kunstmuseum, Basel (1989)

Lafenestre, Georges, *L'Art vivant: La peinture et la sculpture aux salons de 1868 à 1877*, 2 vols (Paris, 1881)

Larguier, Léo, *Le Dimanche avec Paul Cézanne: souvenirs* (Paris, 1925)

Lecomte, Georges, 'Paul Cézanne', *Revue de l'art*, I (9 December 1899), pp. 81–7

Leroy, Louis, 'Exposition des Impressionnistes', *Le Charivari* (25 April 1874), pp. 2–3

Lichtenstein, Sarah, 'Cézanne et Delacroix', *Art Bulletin*, XLVI/1 (1964), pp. 55–67

Lidsky, Paul, *Les Écrivains contre la Commune* (Paris, 1970)

Lindsay, Jack, *Cézanne: His Life and Art* (New York, 1969)

Man, Paul de, 'Autobiography as De-facement', *MLN*, XCIV/5 (1979), pp. 919–30

Mauclair, Camille, *L'Impressionnisme: Son Histoire, son esthétique, ses maîtres* (Paris, 1904)

Maurras, Charles, 'Barbares et Romans', *La Plume*, 53 (1 July 1891), pp. 229–30

Merleau-Ponty, Maurice, 'Le Doute de Cézanne', *Revue Fontaine*, VIII/47 (December 1945), pp. 80–100

—, *Sense and Non-sense: Studies in Phenomenology and Existential Philosophy*, ed. and trans. Hubert L. Dreyfus and Paul A. Dreyfus (Evanston, IL, 1964)

Mistral, Frédéric, *Oeuvres de Frédéric Mistral: Les Îles d'or* (Paris, 1889)

Moffett, Charles, et al., *The New Painting*, exh. cat., Fine Arts Museum San Francisco and National Gallery of Art, Washington (1986)

Montifaud, Marc de [Marie-Émilie Chartroule de Montifaud], 'Exposition du boulevard des Capucines', *L'Artiste* (1 May 1874)

Morice, Charles, 'Enquête sur les tendances actuelles des arts plastiques', *Mercure de France*, LVI–LVII (1–15 August 1905), pp. 61–85, 346–59, 538–55

Natanson, Thadée, 'Paul Cézanne', *La Revue blanche*, 9 (1 December 1895), pp. 496–500

Nordau, Max, *On Art and Artists*, trans. William F. Harvey (London, 1907)

Novotny, Fritz, *Cézanne* [1938] (New York, 1971)

Piron, Achille, *Eugène Delacroix: Sa Vie et ses oeuvres* (Paris, 1865)

Prouvaire, Jean, 'L'Exposition du boulevard des Capucines', *Le Rappel* (20 April 1874), n.p.

Ravisou, Jean, *Le Cadet d'Asis* (Paris, 1907)

Reff, Theodore, 'Cézanne, Flaubert, St Anthony and the Queen of Sheba', *Art Bulletin*, XLIV/2 (1962), pp. 113–25

—, 'Cézanne's Constructive Stroke', *Art Quarterly*, XXV/3 (1962), pp. 214–27

—, 'Cézanne: The Severed Head and Skull', *Arts Magazine*, LVIII/2 (1983), pp. 84–100

—, 'The Pictures within Cézanne's Pictures', *Arts Magazine*, LIII/10 (1979), pp. 90–104

Rewald, John, ed., *Cézanne: A Biography* (London, 1986)

—, *Correspondance de Cézanne* (Paris, 1978)

—, *The History of Impressionism* (New York, 1946)

—, *The Paintings of Paul Cézanne: A Catalogue Raisonné*, 2 vols (London, 1996)

—, *Paul Cézanne: A Biography* (New York, 1948)

—, ed., *Paul Cézanne: Letters* (Oxford, 1976)

—, *Studies in Impressionism* (London, 1985)

Rilke, Rainer Maria, *Letters on Cézanne*, trans. James Agee (New York, 2002)

Ripert, Émile, *La Renaissance provençale* (Paris, 1917)

Rivière, R. P., and J. F. Schnerb, 'L'Atelier de Cézanne', *La Grande revue*, XLVI (25 December 1907), pp. 811–17

Rochefort, Henri, 'L'Amour du laid', *L'Intransigeant* (9 March 1903), p. 1

Roux, Marius, *The Substance and the Shadow*, ed. with an introduction and notes by Paul Smith (Philadelphia, PA, 2007)

Royère, Jean, 'Un Aixois: Joachim Gasquet', *Le Mémorial d'Aix* (15 December, 1929), n.p.

Rubin, William, ed., *Cézanne: The Late Work*, exh. cat., Museum of Modern Art, New York (1977)

Salas, Charles G., *The Life and the Work: Art and Biography* (Los Angeles, CA, 2007)

Schapiro, Meyer, *Modern Art: 19th & 20th Centuries: Selected Papers*, 2 vols (New York, 1978)

—, *Paul Cézanne* (New York, 1952)

Sewell, William H., *Structure and Mobility: The Men and Women of Marseille, 1820–1870* (Berkeley, CA, 1985)

Sheon, Aaron, *Monticelli: His Contemporaries, His Influence*, exh. cat., Carnegie Institute, Pittsburgh (1979)

Shiff, Richard, *Cézanne and the End of Impressionism: A Study of the Theory, Technique, and Critical Evaluation of Modern Art* (Chicago, IL, and London, 1984)

Shiff, Richard, 'Cézanne's Physicality: The Politics of Touch', in *The Language of Art History*, ed. Salim Kemal and Ivan Gaskell (Cambridge, 1991)

Sidlauskas, Susan, *Cézanne's Other: The Portraits of Hortense* (Los Angeles, CA, 2009)

Silverman, Debora L., *Art Nouveau in Fin-de-siècle France: Politics, Psychology, and Style* (Los Angeles, CA, and London, 1989)

Simon, Robert, 'Cézanne and the Subject of Violence', *Art in America*, LXXIX/5 (1991), pp. 120–36

Smith, Paul, 'Cézanne's Primitive Self and Related Fictions', in *The Life and the Work: Art and Biography*, ed. Charles G. Salas (Los Angeles, CA, 2007), pp. 45–75

—, *Interpreting Cézanne* (London, 1996)

—, 'Joachim Gasquet, Virgil and Cézanne's Landscape', *Apollo*, CXLVII/439 (1999), pp. 11–23

—, '"Parbleu": Pissarro and the Political Colour of an Original Vision', *Art History*, XV/2 (1992), pp. 223–47

Stendhal, *Histoire de la peinture en Italie* [1817] (Paris, 1868)

Stevens, Alfred, *Impressions sur la peinture* (Paris, 1886)

Taine, Hippolyte, *Philosophie de l'art*, 2 vols (Paris, 1893)

Thomson, Clive, 'Une Correspondence inédite (première partie): Vingt-sept lettres de Marius Roux à Émile Zola (1864–69)', *University of Ottawa Quarterly*, XLVIII/4 (1978), pp. 335–70

Thomson, Richard, *Camille Pissarro: Impressionism, Landscape and Rural Labour*, exh. cat., Birmingham Art Gallery, Birmingham (1990)

—, *Monet to Matisse: Landscape Painting in France, 1874–1914*, exh. cat., National Gallery of Scotland, Edinburgh (1994)

Tompkins Lewis, Mary, *Cézanne's Early Imagery* (Berkeley, CA, 1989)

Véron, Théodore, *Dictionnaire Véron* (Paris, 1882)

Vollard, Ambroise, *Cézanne* (Paris, 1924)

—, *Paul Cézanne* (Paris, 1914)

Zola, Émile, *The Belly of Paris*, trans. Ernest Vizete

—, *En écoutant Cézanne, Degas, Renoir* (Paris, 1938)

Zola, Émile, *The Belly of Paris*, trans. Ernest Vizetelly (Gloucester, 2006)

—, *Correspondance*, ed. B. H. Bakker, 10 vols (Montréal, 1978–95)

—, *Documents littéraires, études et portraits* (Paris, 1881)

—, *Écrits sur l'art*, ed. Antoinette Ehrard (Paris, 1970)

—, *Écrits sur l'art*, ed. Jean-Paul Leduc-Adine (Paris, 1991)

—, *L'Oeuvre* (Paris, 1886)

—, *Oeuvres complètes*, ed. François Bernouard, 50 vols (Paris, 1927)

Acknowledgements

Just as no artist's work is simply the product of their own thought alone, so no book is possible without the work of many others. There are too many authors and colleagues to list here, but the writings on Cézanne, Impressionism and modern art by T. J. Clark, Maurice Merleau-Ponty, Paul Smith, Fred Orton, Meyer Schapiro, Richard Shiff, Aruna d'Souza, Richard Thomson, Alex Danchev, Nina Athanassoglou-Kallmyer and John House stand out as particularly influential on shaping my own responses to his painting. It was while working with John that I first began thinking and writing about Cézanne, and his influence is clear to see on every page. In closing, I would particularly like to thank Amy Salter for her assiduous editing of the text and Reaktion's editorial director Vivian Constantinopoulos, whose advice, encouragement and support was most appreciated.

Photo Acknowledgements

The author and publishers wish to express their thanks to the following sources of illustrative material and/or permission to reproduce it:

The Barnes Foundation, Philadelphia: p. 9; The Burrell Collection, Glasgow: p. 125; Corbis: p. 49 (The Barnes Foundation, Merion Station, Pennsylvania); Courtauld Institute of Art, London: pp. 166, 181; Fitzwilliam Museum, Cambridge: p. 63; The J. Paul Getty Museum, Los Angeles: p. 86; Kimbell Art Museum, Fort Worth: p. 192; Los Angeles County Museum of Art, California: p. 171; Metropolitan Museum of Art, New York: p. 195 bottom; Musée d'Orsay, Paris: p. 84; Museum of Fine Arts, Boston: p. 135; Narodni Galerie, Prague: p. 183; National Gallery, London: p. 109; National Gallery of Art, Washington, DC: pp. 37, 78; Philadelphia Museum of Art: p. 206; private collection: pp. 70, 111, 115, 142; Sammlung Oskar Reinhart, Winterthur: p. 209; The State Hermitage Museum, St Petersburg: p. 194; From *Stock Album 2*, 1870: p. 81.